Phil Baines & Andrew Haslam

Type & typography

Watson-Guptill Publications/New York

First published in 2002 in the United States by
Watson-Guptill Publications
a division of VNU Business Media, Inc.
770 Broadway, New York, NY 10003
www.watsonguptill.com

Library of Congress Control Number: 2001091521

ISBN 0-8230-5524-8

First published in the United Kingdom in 2002 by
Laurence King Publishing Ltd in Association with
Central Saint Martins

Laurence King Publishing Ltd
71 Great Russell Street
London WC1B 3BP
www.laurenceking.co.uk

Design & picture research by the authors
Typeset in Meta and Swift
Printed in Hong Kong

1 2 3 4 5 6 7 8 9 / 10 09 08 07 06 05 04 03 02

Frontispiece New year card 2001 designed &
printed by Susan Skarsgard & Wesley B Tanner.
Photograph Tim Marshall.
Cover Ludlow matrices for 48pt Tempo heavy
designed 1930–42 by Robert Hunter Middleton,
see also page 79. Photograph Tim Marshall.

Definition I

Introduction

Since the advent of personal computers, desktop publishing and the more recent development of the World Wide Web, millions of people have become accustomed to using fonts and working with type, but anyone asked to explain what typography was might feel at a loss, unclear of its boundaries or possibilities.

Typography is concerned with the structuring and arranging of visual language. Type design is concerned with the creation of the units to be arranged, the characters which make up a typeface. Both typeform and typography are designed to convey a message. This latter aspect places typography firmly at the root of the broader discipline of graphic design. The question of how typography is used to convey a message can be divided into two. The first part concerns typography's appearance or style. This differs according to time and place, or designer and client: at times typography may play a secondary or even invisible role, at others it may dominate, reflecting the inspiration of the designer and on occasion even laying claim to be 'art'. Some of these approaches are demonstrated and discussed in this book. The second part concerns the practicalities of working with typography, such as legibility, scale and formatting, and these represent the dominant concerns of this book.

The book is designed partly to give good practical advice to students and partly to be a concise source of information that will take you well beyond your student years. Any book inevitably reflects its author's prejudices, and in this case it also reflects the way we teach. One of our key aims is to be broad in scope, to bring together in one book information that at present is spread throughout many. We hope to provide practical advice in an open-minded, non-dogmatic manner. Perhaps our only demand is that you read our book, move on to other material and then come to your own conclusions.

There is also much factual information in this book, not all of which you will necessarily need at once. We have divided the book into discrete chapters which can be read and understood separately and when needed. In many places, detail is removed from the main text and presented as 'side stories' which can be read independently.

What is typography?

It is important at the outset to point out that certain terms have meant slightly different things at different periods in history. In these digital times, font and typeface are used interchangeably, but in the days of metal type they had quite distinct meanings. Throughout this book we have tried to use words in their original, precise senses, as follows. Type is the physical object, a piece of metal with a raised face at one end containing the reversed image of a character. Font (originally spelt 'fount' in Britain) is a set of characters of a given typeface, all of one particular size and style. Typeface refers to a set of fonts of related design; since the end of the nineteenth century the term has referred to a set of related styles, italic, bold, bold italic and so on.

Having established that typography is concerned with both the creation of typefaces and their arrangement to convey a message, we felt that a clearer definition was needed, something which suggested how type was different from

writing or lettering, for instance. A natural place to start seemed to be the dictionary, but we were somewhat surprised by what we found:

1 the art, craft, or process of composing type and printing from it.

2 the planning, selection, and setting of type for a printed work.

(*Collins concise dictionary*, 1999)

This definition so strongly reflects the traditional craft nature of the subject and its relationship to the printing trade from which it grew that it could have been written a hundred years ago. It seems quite inadequate today, and while it isn't exactly untrue, it is very limited.

We then asked small groups of students studying graphic design and typography to discuss potential definitions of the discipline. Their ideas highlight different facets of the subject:

'The architecture of ideas and the making of language' – revealing typography's role in the building of narrative, creating intellectual spaces through which the reader moves.

'The sculpting of experience' – reflecting the notion that the form of the message influences the reader's interpretation of the content.

'The management of letters' – stressing the typographer's organizational ability, and alluding to the creation of structure.

'The engine of learning' – typography empowering the literate.

'A formal extension to memory' – stressing the documentation and preservation of ideas, which enables reflection.

'Painting with words' – typography as an expressive art in which the emotional content of ideas is reflected in the manipulation of the form of the words.

Such a diversity of definitions reflects the complexity of typography and the extent of its influence; it also demonstrates its continuing need to adapt both to new technology and to its users' vision of the future. Ultimately, the intellectual journey in pursuit of a definition is far more valuable than the point of arrival, or the unquestioning repetition of a previous generation's belief. It is important to familiarize oneself with past definitions, but not to stick to their dogma. All offer a potential point of departure for developing your own profound and groundbreaking work. No definition of the discipline is fixed, rather, each one should be constantly redefined and adapted in relation to practice.

We thought it would be helpful to put forward our own definition in order to stimulate further discussion about the parameters of the discipline:

Typography: The mechanical* notation† and arrangement of language‡.

Following spread Typography surrounds us in Western daily life. It enables, guides and directs us through physical space with signage, time-tables, commercial agreements, advertisements, promotion, tokens of value, receipts, banknotes, tickets and stamps and takes us on intellectual journeys through literature and poetry.

PORTER

Private view ✳ 6 to 8pm Tuesday 6 June 2000

TEST TICKET

83-0606-01 C4-G-P 03/29/94

□!"#$%&'()*+,-./0123456789:□
□;<=>?@ABCDEFGHIJKLMNOPQRST□
□UVWXYZdmox@`abcdefshijklmn□
□oparstuvwxyz{|}~£↓()[]:^_≡□
□→←=□▓▒✳※×∇¢

FIX by moistening only the top and bottom edges
of Label
OPEN by breaking Label instead of tearing flap
and re-use envelope by affixing fresh Label

B. 1167

534822

Vehicles and their contents are parked at the
owner's risk and no liability is accepted for
any loss or damage.

Typography studio

IMPORTANT
THIS MACHINE MUST BE
EFFICIENTLY EARTHED IF
ELECTRICAL ATTACHMENTS
ARE FITTED

CAPITAL LETTERS

NEVER BEGIN a word with a capital letter unless its use can be justified. The principle is that the first letter of a word shall be printed as a capital if the word is a proper noun or a word that is to be understood as a proper noun. In all other cases a lower case letter should be used.

The principal uses for initial capitals are as follows:

After a full point, exclamation mark, or question mark *when such end a sentence.*

For the first word in direct speech, e.g. He asked, 'Where did you put my hat?'

The pronoun *I* and the vocative *O*, e.g. O Heavens!

Nouns that designate any member of the Christian Trinity: God the Father, Providence, the Good Shepherd, Son of Righteousness, Holy Ghost.

Pronouns referring to the Deity should begin with capitals—He, Him, His, Me, Mine, My, Thee, Thine, Thou; but print who, whom, and whose in lower case.

he first letter in each line of poetry copy), hymns, and songs.

cation. This is the name of the figure hich gives human qualities (speaking , to inanimate or non-human things, h, where is thy sting?

f historical events and periods, e.g. es, the Reformation, the Great Fire Victorian period, Georgian, Treaty s.

f streets, roads, etc., as Stamford algar Square, Waterloo Road, Bird-Norbury Avenue.

nd titles: Assistant-Adjutant-Gen-resident, Vice-Chairman, Lt.-Col.,

Figure, Numb
each begin with
Act when refe
Acts of a play.

Geographical
Continent, (*but*
Western Hemisp

Titles of cour
Duchess of Kent
Smith, J. Smith,
of Canterbury.

Associations a
Institution, Lon
Church (the),
Press (the).

Names of ob
proper nouns a
case initials: bru
french polish, g
morocco leather
vandyke brown.

ITALIC TYPE shou

Titles of news
Daily Herald, *
word *The* is part
italic, e.g. *The T*

Names of shi
roman, as it is o
of the title or r
Revenge; also p
H.M.S. *Formida*

Words in cop
often done for e

Words or lette
adjective *good*, t

Words and
(unless anglicize

8

London Buses

Route 77

42030 40903 22579 15791

Fare: Adult Single £1.00

Not Transferable

Valid From Stage: 16
Valid To Stage: 7
Waterloo Stn

At: 09:09 On: 22/01/2001

Route is Operated By:

Retain Ticket for Inspection

Twickenham to London Waterloo

		Monday to Friday							
		58	47	58	68	58	38 ❶	21	58
Twickenham	dep	0525	0555	0612	0622	0642	0650	0654	0712
London Waterloo	arr	0554	0624	0636	0652	0709	0713	0726	0739

		Monday to Friday							
		87	58	21	38 ❶	87	58	21	38 ❶
Twickenham	dep	1611	1623	1626	1639	1641	1653	1656	1709
London Waterloo	arr	1641	1647	1656	1700	1711	1717	1728	1730

		Mondays to Friday			
		58	38	68 E	38 E
Twickenham	dep	2315	2320	2330	2351
London Waterloo	arr	2341	2343	2359	0014

		Saturday							
		21	38	87	58	21	38	87	58
Twickenham	dep	1826	1839	1841	1853	1856	1909	1911	1923
London Waterloo	arr	1855	1900	1911	1920	1925	1930	1941	1947

		Sunday							
		21	58	21	58	38	21	58	21 A
Twickenham	dep	0700	0730	0800	0830	0856	0900	0930	0940
London Waterloo	arr	0728	0758	0828	0858	0919	0928	0958	1008

* **Mechanical** Referring to the science of machines, the precise automatization – be it physical or digital – of a task, working through a structured process towards a defined aim. The idea of the mechanical suggests one of the prime differences between typography and lettering: typography means writing using repeatable units, lettering is unique. This idea of manufacture is discussed in Chapter IV.

† **Notation** A graphic system of documenting a discipline through a symbolic code. In this book, that code is the Western or Latin alphabet. Its evolution is explained in Chapter III.

‡ **Language** Embracing both spoken and written codes: groups of sounds which in various combinations form words with tacitly labelled objects or ideas; arrangements of words which signal complex meanings to groups familiar with the code. Language is the subject of the next chapter.

In this definition we have strived to get away from the specifics of printing and reassert the function of typography: to document, preserve and replicate word-based knowledge and to place it firmly at the core of modern communication design.

Debates within typographic design education have traditionally focused on the appearance of typography in relation to message. They have tended to examine aesthetic and technical considerations such as font selection, hierarchies, spatial arrangement, grids and style. While such discussions are pertinent to all that we do as designers, they perhaps overlook the obvious: that typography is intrinsically visual language.

It is a strange anomaly within the education system that a subject – language – and the notational system devised for its recording – typography – are taught in unrelated institutions. Universities teach anthropology, linguistics, language development, languages and literature, while art and design schools teach typography. Yet typography is to language what maps are to geography, scores are to music and algebra is to mathematics. Surely a subject and its related system of documentation should be investigated together? It is, in our view, vitally important that typographers should begin to understand the features of language while at the same time learning the conventions for its notation and the technical processes for its reproduction.

Language, through type, envelops us in the urban environment. Its messages have so penetrated our psyche that it is almost impossible to imagine a world without type – a world without books or libraries, magazines or maps, road signs, television or advertisements. Like the wheel, electricity and the internal combustion engine, typography underpins modern Western life. Every day we wake up to type: from our first glimpse of an alarm clock, through the tuning of a radio, to the brands of shampoo, toothpaste and cereal we use, we are bombarded by typographic messages all vying for our attention – and all this before we have even glanced at a newspaper.

Type today carries a multiplicity of messages in the most diverse range of formats. Johann Gutenberg, who died a poor man, could hardly have envisaged the profound ramifications of his modular lettering invention, type.

Function II

Language: the spoken system

This chapter investigates the subject of language – the subject that typography notates. It explains how our physiological make-up enables us to communicate through two principal language systems: speech and writing. The different ways in which we speak and hear, and read and write, are determined by the nature of these two systems. This examination of language aims to provide a firm foundation to underpin the book's subsequent chapters on form, manufacture and design, and structure.

Taking our lead from contemporary linguists, we have divided our examination of language into three parts: phonology, grammar and the lexicon. Phonology examines the sound system by identifying the phonemes that make up our speech and the intonation we put upon them. Grammar analyses how the ordered structure of language supports meaning. The lexicon records the words within a language, cataloguing the extent and tracing the origins of its vocabulary.

The penultimate section of this chapter examines information theories which trace the development of two philosophic views of language: structuralism and post-structuralism. Both have affected the form of type and the structural arrangement of typography through their influence on the design movements of modernism and deconstructivism.

The origins of written language and its offspring, typography, lie in the spoken word. Speech preceded writing, though no one can be certain of when the first words were uttered. Speech enables complex ideas to be shared within a group; tasks can thus be organized collectively. Biologists confirm that whales, dolphins and chimpanzees, all social animals, have a 'vocabulary' of more than 30 words.

The speech system, called phonetics, can be divided into three principal elements: articulatory phonetics, or the way we create sound; acoustic phonetics, or the physical properties of sound; and auditory phonetics, or our perception of sound. Speech can be broken down into its constituent building blocks, termed phonemes; these are the smallest units of sound that make up the spoken language. Every spoken language consists of phonemes, although the number and nature varies between languages. Phonemes have no meaning in themselves, but are combined in endless patterns to represent objects and ideas. The four letters / w | o | r | d / have no meaning in themselves, but pronounced in English they represent a unit of speech. When we speak we blur the separate phonemes of a word into one another. This blurring also occurs between words. In speech, words are run together, while pauses come at the end of a phrase or sentence when we wish to make emphasis, take breath or invite a response from the listener. This continuous blurring of phonemes within and between words is particularly evident when we listen to a language that we do not understand. Speech presents language as a continuum; it is our brain that separates it into individual words. In the words of linguistics expert Steven Pinker, 'Speech is a river of breath, bent into hisses and hums by the soft flesh of the mouth and throat.'

The Cardmaster tape recorder (**top**) designed as a learning aid to reading, enables the user to hear and see both speech and writing simultaneously. Simple cards can be prepared by a teacher, *eg* blue (**middle**) which when played through the recorder enables the child to make a link between the phonemes of speech and the letters and shapes of words. However, when a sentence is recorded and then plotted onto the card (**bottom**) in real time, the difference between the way we speak and the way we represent speech typographically is visualized. Phonemes blur into one another, causing the space between words to disappear.

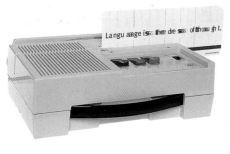

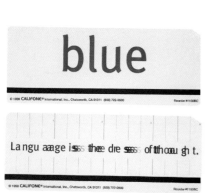

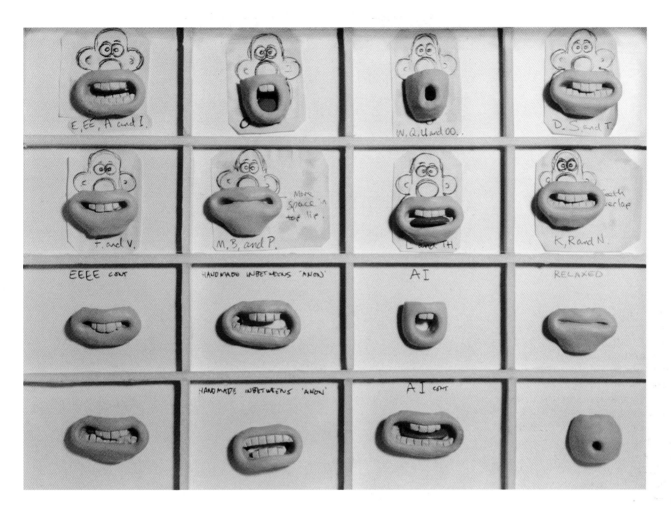

The English language has between 42 and 45 basic phonemes – the exact figure depends on which accent is being analysed and which linguist has been responsible for the analysis. The order of phonemes, and their emphasis, varies depending on whether the subject is speaking American, Australian or British English, or any of their regional variations. In Britain and the US, linguists have developed additional symbols for phonetic transcription, as the 26-letter alphabet has insufficient characters. However, the two systems use some of the same symbols to represent different phonemes. For our purpose it is more helpful to present the phonemes of English using alphabetic combinations, based on phonetic literacy schemes devised for children.

It should be noted that when examining the spoken word linguists use the terms vowel and consonant in a different way than when we refer to the written word. Spoken 'vowels' are phonemes made with an open voice tract, while 'consonants' are formed by constricting the voice tract.

The animator Nick Park created a set of interchangeable mouths recreating the lip shapes of human speech for Wallace, one of his animated plasticine characters.

Phonemes

English 'Good morning'

 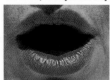

g goat, gap, digger **oo** look, foot [short oo] **d** dog, dip, sudden

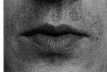 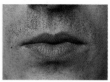 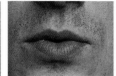 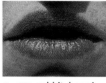 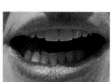 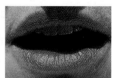

m man, mill, shrimp **o** orange, on, spot **r** run, rabbit, barrel **n** nut, nip, spin **i** ink, indian, drink **ng** bring, sing, gong

The lip movements of English, French, German and Spanish phonemes when saying 'Good morning' in each language. Every spoken language is made up of phonemes, the smallest units of sound. European languages share some common phonemes, though the total for each language differs. English has between 42 and 45 phonemes: **a** ant, **ai** aim [long a], **ar** art, **b** bat, **c** cat, **ch** chop, **d** dog, **e** egg, **ee** eel [long e],

French 'Bonjour'

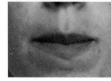 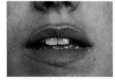 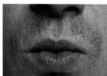 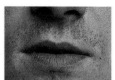 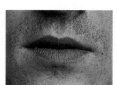

b bonbon, Brigitte **on** Toulon, onduler **j** ajouter, jouet **ou** Lourdes, rove **r** agir, voir

German 'Guten morgen'

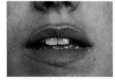 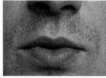 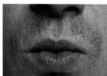 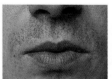 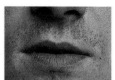

g Garten, sagen **u** Mund, Ungarn **t** Luft, Turm **e** Entwurf, machen **n** Namen, nein

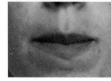 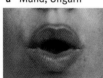

m Lamm, Milch **o** Orgel, Norden **r** Praline, Regen **g** Garten, sagen **e** Entwurf, machen **n** Namen, nein

Spanish 'Buenos dias'

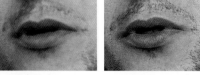 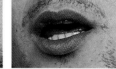 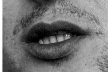

b autobus, barra **u** cuarenta, guarda **e** cerveza, nelio **n** nada, noche **o** copa, oro **s** siesta, sepia

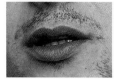 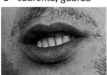 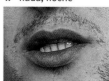 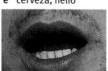

d crudo, desperado **i** villa, iglesia **a** ahora, cama **s** siesta, sepia

er kerb, **f** fog, **g** goat, **h** hop, **i** ink, **ie** pie [long i], **j** jelly, **k** king, **l** leg, **m** man, **n** nut, **ng** song, **o** orange, **oa** oak [long o], **oi** oil, **oo** look [short oo], **oo** moon [long o], **or** order, **ou** out, **p** pig, **q** queen, **r** run, **s** sand, **sh** ship, **t** top, **th** this [voiced th], **th** thin [unvoiced th], **u** up, **ue** due [long u], **v** van, **w** wind, **x** x-ray, **y** yell, **z** zoo.

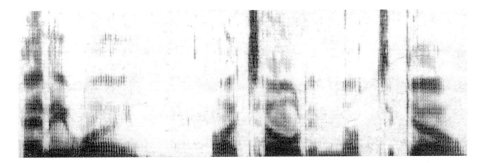

A speech spectrograph is a machine which provides linguists with a visual impression of speech. The image is plotted against a horizontal axis representing time. The acoustic frequency is shown vertically and the intensity is represented by a greyscale. Spectrograph analysis provides linguists with visual evidence of both regional and international speech variations, and the individual character of each person's voice. Like fingerprints, iris patterns or DNA, our voices and precise patterns of speech are unique. The spectrograph can show how the smallest units of speech, phonemes, combine vowels and consonants to create syllables. By positioning type along the time axis at the bottom of the spectrograph image we can see how, in speech, the time gaps between syllables are as important as the spaces between words. In speech we do not create words as single units in the way that we do typographically.

A spectograph image of speech plots an individual's variation of speed, volume and intensity.

e ni w ei ai t oa ldhim n o to g o

e / n / i / w / a/ i / / A / i / / / t / oa / l / d / / h / i / m / / n / o / t / o/ / g / o /

An'yway I to'ld h'im n'ot to go.

Anyway I told him not to go.

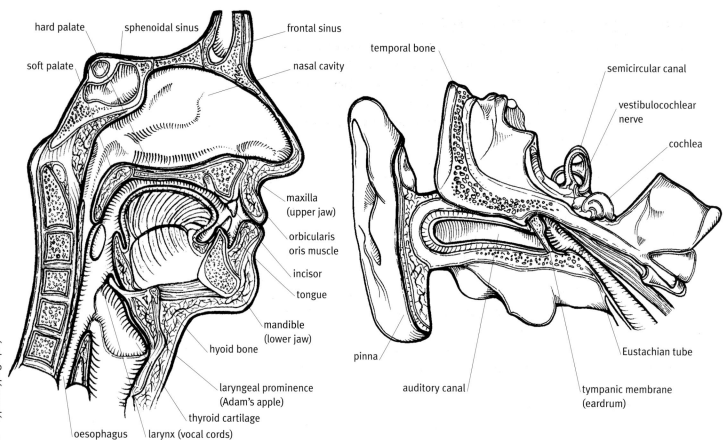

hard palate sphenoidal sinus · frontal sinus · nasal cavity · temporal bone · semicircular canal · vestibulocochlear nerve · cochlea · soft palate · maxilla (upper jaw) · orbicularis oris muscle · incisor · tongue · mandible (lower jaw) · hyoid bone · laryngeal prominence (Adam's apple) · thyroid cartilage · oesophagus · larynx (vocal cords) · pinna · auditory canal · Eustachian tube · tympanic membrane (eardrum)

How do we speak?

We produce speech when we breathe out. We can make sounds when we inhale, but have little capacity to control them. Exhaled air travels from the lungs to the larynx. When we choose to speak we subconsciously engage the larynx, not using the larynx allows us to breathe silently. The larynx comprises a variable aperture and vocal cords that vibrate, creating sound waves. The sound waves pass below the soft palate at the back of the mouth to the hard palate and over the tongue. The initial position and controlled movement of the tongue create variations in the sound wave. These are amplified by the shape of the mouth and refined by the position of the lips. The sequential control of vocal cords, tongue movement in relation to teeth, hard and soft palate and lip formation, create the phonemes of speech. With a single breath we can enunciate a series of sentences consisting of many phoneme combinations produced in a continuous sequence.

We are restricted from talking continuously by our lung capacity and the need to inhale. We control volume by the amount of air we exhale. The more air passing through the vocal cords the louder our voice; this is why we take a deep breath before shouting. Pitch is controlled by the aperture in the larynx: constricting the aperture produces a high pitch while opening the larynx creates a low pitch.

How do we hear?

Having looked at how we produce and transmit the phonemes of speech, it seems appropriate to examine how we receive them. Having two ears enables us to locate the direction from which a sound is transmitted; if that sound is speech we usually turn to face the speaker so that we can watch the supporting gestural signals.

The ear has three principal elements: outer, middle and inner. The main part of the outer ear is the pinna, which is shaped to collect sound waves and direct them into the auditory canal. They travel at the speed of sound (*c.*340m per second) until they meet the eardrum. This consists of a membrane (the 'tympanic membrane'), which is made to vibrate by the sound waves. Beyond the eardrum lies the middle ear. Here, vibrations are converted into the oval window through the mechanical movement of three tiny bones: the malleus (Latin, 'hammer'), the incus (Latin, 'anvil') and the stapes (Latin, 'stirrup'). The inner ear contains the semicircular canals which control our sense of balance, and the cochlea, a small shell-shaped organ filled with fluid. This contains the corti, an organ containing tiny hairs and nerve cells. The mechanical movement of the middle ear causes the fluid to move around these hairs. This stimulation is picked up by the nerve endings and moved on into the brain, via the auditory nerve, in the form of electrical pulses.

Language: the written system

In most cultures the notation of language precedes the notation of other disciplines such as geography or music. The ability to preserve language is an important foundation for a society's cultural development. However, some examples exist that do not support the primacy of language notation: for example, Inuit cultures, which have no written language, produce driftwood carvings recording the topographic features of ice floes when viewed from the sea. This example initially appears to run counter to the general belief that humans record first what is most essential to their development – usually language. In the case of the Inuit, geography has evidently been notated before language – perhaps because survival takes precedence over cultural development.

Writing fuelled the growth of literature, enabling ideas to be disseminated among the literate. This process allowed people all over the world to share common ideas. As a consequence, people with peculiar or idiosyncratic opinions could begin to link or exchange their views. In short, writing – through the preservation of knowledge – enabled intellectual disciplines such as theology, science and economics to develop.

Before examining writing systems in more detail we need to clarify a subtle difference in terms. Language is often used generically to mean 'script'; however, the two words are not interchangeable. A script may be linked specifically to one spoken language (such as Korean), but most scripts can be used to write several languages. The Western alphabet is a script used to record the majority of European languages.

Written and spoken language

Spoken language	Written language
Primary: individuals and languages develop speech before writing	Secondary: follows speech
Acquired: absorbed spontaneously	Learnt and constructed
'Natural'	'Artificial'
Original	Copy
Interior to the mind	Exterior to the mind
Organized in time	Organized in space
Aural: is heard	Visual: is read
Three-dimensional, situational	Two-dimensional, planar
Ephemeral	Permanent
No equipment	Requires equipment
Often devalued	Prestigious, 'valued'
Addressee generally present	Addressee generally absent
Dialogue	Monologue
Feedback immediate	Feedback delayed
Spontaneous, shared development of ideas	Considered, planned narrative, revised and edited
Quick	Comparatively slow
Characterized by pauses and fillers: oh, er, um	Characteristically cohesive and coherent
Syntactically fragmented: sentences lack clear boundaries	Syntactically cohesive: sentence boundaries clearly defined and reinforced through punctuation

The written form of a language is visible; the spoken is invisible. But the differences between the systems extend beyond form – as the table opposite illustrates. The linguist Ferdinand de Saussure, writing at the turn of the nineteenth century, defined two forms of writing systems: the alphabetic and the ideographic. This initial simplification can be helpful in describing what the written symbols represent. Ideographic systems are based on pictorial symbols that represent meanings, and thus have a semantic basis; whereas alphabetic systems are based on letterforms that represent units of speech and have a phonetic basis.

Ideographic forms are pictorial, and are derived from simple drawn pictograms. A pictogram is a symbol which represents a person or object. The viewer recognizes the two-dimensional graphic representation of a three-dimensional form because of his or her previous experience of the object. Simple pictograms can represent objects or actions, nouns or verbs; but to represent more abstract concepts, complex ideas or narratives they must work in combination. Ideographs encapsulate. A concept or idea is visually encapsulated by an 'ideograph'. For example, a figure can be drawn to represent a man: this is a pictogram. If we wish to communicate the idea of a man reading, we might draw an open book in the hands of the man: an illustrative pictogram. If we draw a separate symbol of a book beside him, we invite the viewer to make a connection between the two symbols: we have developed a rebus system. If we were to use the symbol of a book to represent a library, however, then our pictogram has become ideographic: a symbol that represents not merely an object but a concept.

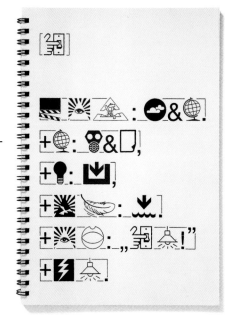

The first chapter of Genesis set in pictograms, by Juli Gudehus. The overall sense within the narrative can be deduced by people speaking different languages, although the exactness of the meaning of individual symbols is less accurate.

1 Pictogram of a man, an image represents an object or person.

2 Ideogram, symbolizing the concept of reading.

3 A rebus system, a pictogram of a man followed by a book to symbolize reading.

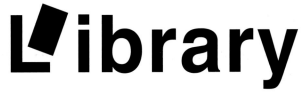

4 Logo, a letterform and symbolic book to represent a library.

5 Logotype, a word and symbol combined to illustrate meaning.

All symbolic systems or codes rely on the author and the reader sharing a common cultural experience and a familiarity with the forms and conventions of representation. The symbols to the left may at first appear to be widely understood in the West, but on careful examination they are full of ambiguity. **1** The pictogram works on the basis of a drawing representing an object, the figure symbol may be intended to be a man but could represent a woman or human beings. The viewer may have cause to wonder why the figure has been sliced in two or is up to his chest in sand. **2** The ideogram for reading attempts to encapsulate an idea which has a visual form, but more complex abstract ideas *eg* time or morality may prove virtually impossible to represent. **3** The rebus system seeks to convey meaning by combining simple pictograms on the assumption that the reader will make a link between the two objects. A symbol for a man followed by a book may be intended to mean reading but could equally be interpreted as man owns book. The logo (**4**) and logotype (**5**) for library which makes use of the initial capital 'L' as a shelf from which a counter form representing a book is being borrowed utterly fails when libary is replaced by bibliothèque.

Ideographic systems based on pictograms require the development of many symbols, as each individual idea is generally represented by a separate symbol. In purely ideographic writing systems, pictures are linked with meaning but have no relationship to the phonemes of speech. It is theoretically possible, therefore, to 'read' ideographic systems without being able to speak the language. Eastern languages such as Chinese and Japanese are ideographically based. Chinese students can today 'read' the words of Confucius written 2,500 years ago as easily as they can contemporary street names – but were his voice to have been recorded, they would barely recognize a word.

Under an alphabetic system, symbols are used to represent the phonemes of a language. The symbols in themselves have no meaning, but they represent the sounds of speech. By ordering the phonetic symbols along a line, the sound of a word can be represented. In most alphabetic systems, groups of phonemes are separated by gaps to indicate the end of one word and the beginning of another.

We have already seen that spoken English has between 42 and 45 individual phonemes, while the written form uses a 26-letter alphabet. This mismatch of written and spoken forms is true of all European languages that use the 26-letter Roman alphabet. The roots of this apparent anomaly lie within the historical development of European languages in relation to the Roman empire. The Romans acquired and adapted the Greek alphabet so that 22 characters notated the phonemes of Latin. As the Roman Empire grew, the Roman alphabet was appropriated by conquered nations to record their native languages. Adaptations had to be made as the number of letters available in this alphabet did not reflect the variety of sounds within the different spoken languages. Symbols for four additional phonemes have since been created, but still the Roman alphabet is lamentably short. Many European languages have developed additional phoneme symbols – such as the cedilla, the circumflex, the umlaut and the grave and acute accents – to augment the alphabet. Bill Bryson, in his book *Mother tongue*, notes how crucial these marks can be to pronunciation: 'In Hungarian, for instance, toke means capital, but töke means testicles.' In English, extra phonemes are represented by a combination of letters.

The simple numeric mismatch of phonemes and letters is one of the reasons behind the linguistic nightmare that is spelling. Ideographic languages, by contrast, have virtually no confusing spelling – only mismatches of meaning. In languages where each phoneme is represented by an individual character, a more logical order to the arrangement of the letters exists. In Hebrew, for instance, vowel phonemes are not represented in the script and have to be guessed from the context ('N Hbrw, fr nstnc, vwl phnms r nt rprsntd n th wrttn frm nd hv t b gssd frm the cntxt'). In English, the 'rules' of spelling seem to be forever flouted by irregularities. However, David Crystal (in *The English language*) notes that, in fact, 84 per cent of English spellings conform to a consistent pattern – though how many schoolchildren or foreign students would agree with him is a matter of conjecture.

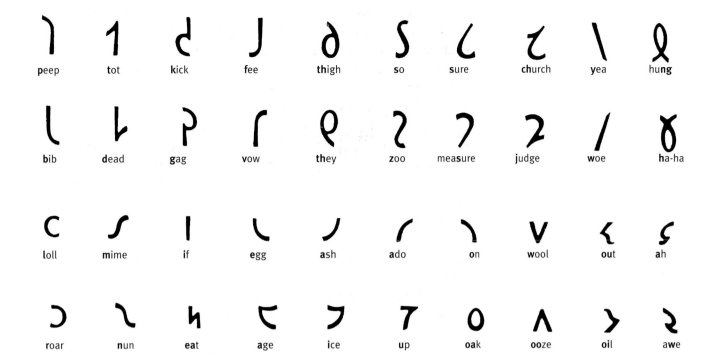

peep	tot	kick	fee	thigh	so	sure	church	yea	hung

bib	dead	gag	vow	they	zoo	measure	judge	woe	ha-ha

loll	mime	if	egg	ash	ado	on	wool	out	ah

roar	nun	eat	age	ice	up	oak	ooze	oil	awe

George Bernard Shaw, the Irish playwright, was so critical of English spelling that he wrote in Pitman's shorthand. In his will, Shaw left a legacy to anyone who could design a rational alphabet of at least 40 characters. Kingsley Read responded to the challenge and created the Read's Shaw Alphabet. This was a somewhat academic exercise, however: its usage was stymied from the start, as it would have required anyone writing in the world's second most popular language to learn a completely new script.

As we have seen, Ferdinand de Saussure separated ideographic systems from phonetic (alphabetic) systems. The French philosopher Jacques Derrida argued that they were not entirely separate. While the letters of the alphabet are indeed phonetic symbols, Derrida pointed out that their written and typographic arrangements demonstrate ideographic principals. There is not a phonetic relationship between punctuation marks, upper and lower case, italics, bold and extended forms, expressive flourishes and rules, or even the white space between words. These ideas, and the whole paraphernalia of the typographer's palette (see Chapter IV), are ideographic signs.

A phonetic code is contained within an ideographic system.

Kingsley Read's Shaw alphabet was devised to reflect the phonemes of English as a response to the playwright George Bernard Shaw's challenge to create a rational alphabet of at least 40 letters.

A B C D E F G H I J K L M

Graphics student Andreas Lauhoff attempted to construct letterforms which reflected individual's speech, terming them speech-recognizing letterforms. The letterforms **above** are based on an analysis of speech spectographs in which the relative volume of many individual phonemes within a sample recording have been plotted.

There are elements within our sound systems that the written systems of notation – being devised primarily for the preservation of meaning – fail to document. Often conversations are conducted without fully formed phrases and sentences as defined grammatically in the written code. A dialogue allows the listener to signal understanding by gesture or facial expression, and prevents the speaker rambling. If ideas are missed or misinterpreted by a listener a speaker may repeat, reinforce or substitute words, or offer up metaphor or allegory as a way of representing meaning. A kind of oral shorthand is engaged which allows ideas to be transmitted quickly. Telephone conversations may include hundreds of confirmations such as huuum, umm, eh, ehhhh; these sounds serve to reassure the talker that the listener remains attentive. Conversations may reveal to a listener a familiar voice, a personal and idiosyncratic pronunciation, a regional accent, a dialect or localized use of phrase and identities of class, gender or age. While it is possible to deduce some of these from written code, many are masked by typographic blandness.

The dramatist Ben Jonson wrote: 'Language most shows a man: Speak that I may see thee.' Speech has many forms and purposes: a conversation, a discussion, an order, a cross-examination, a sentence, a sermon, a prayer, an address. According to A S Byatt's *Possession*, 'the Ancient Druids believed that the spoken word was life and that writing was a form of death'. Plato, in ancient Greece, saw conversation as the birthplace of philosophy: writing merely encapsulated what had previously been discussed.

Typography has no formal mechanism within its signs or structural presentation for signifying pitch, accent, volume, rhythm or the geographic positions of one speaker to another; for this reason it is often responsible for ironing out the vibrancy of the spoken word. Some writers and designers have adapted the system or added an image or symbol in order to express the features of speech that are undocumented in conventional written form. Irvine Welsh, in his novel *Trainspotting*, for example, wrote dialogue in dialect. Using the phonemes of a working-class Edinburgh accent he amended the spelling to enable the reader to internalize the accent. You read in your head what you hear on the street.

Just as a map is the 'notation' of landscape, so typography is the notation of language. The conventions of typography are changing as new technology empowers innovative approaches to design both for the printed page and for the audiovisual screen. Traditionally, typography has not expressed the oral tradition of language. The 'map' of type has viewed language as a structure devised to reveal considered written ideas. By contrast, typography today needs

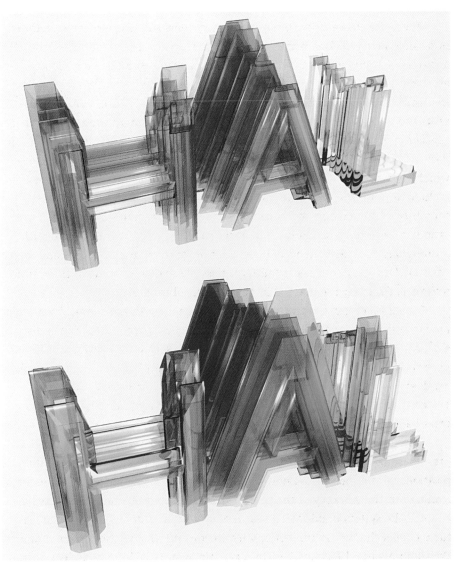

The two dimensional letterforms were redrawn in three dimensions (**left**) on the basis of a wave form. These two examples are based on David Bowman saying *HAL* in an increasingly demanding tone on the soundtrack of the Stanley Kubrick film *2001 – a space odyssey*, 1968.

to reflect the richness of the way we speak. Through its rigid structure, typography has sacrificed elements such as accent, gender, age, volume, speed, rhythm and geography in order to preserve meaning. By identifying the previously ignored features of the oral tradition and devising strategies for their notation and expression, typography will, we believe, improve its description of language.

Other voices

Here, and on five other spreads in the book, we present different people's views on type design, typography, graphic design and printing. Shown in no particular order, they act as background and represent other voices about the subject, some of which we agree with, and others not. They also act as a taster of some of the items listed in the further reading section on page 174.

New words start on the stre
newspapers or magazines an
tising Mark Lawson on *Front row*, BBC Radio 4, 3 January 2001 • To publis
presenting words to the publi
phy' means the process of mal
and effective; and a typograp
sionally trained to perform th
doing so Walter Tracy, *The typographic scene*, p.11 • The functio
cate a message so that it effe
tual meaning and its emotiona
both typographic, and in the s
strictly tautologous. The wor
print using standard element

or in nightclubs, stopover in
each their terminus in adver-
rs and others concerned with
n print or on screen, 'typogra-
g the words visually attractive
er is someone who is profes-
task, and earns a living from
of typography is to communi-
vely conveys both its intellec-
eeling Willie Kunz, *Macro and micro typography*, 1999, p.8 ● To mention
ne breath / sentence, grids, is
typography means to write /
to use standard elements im plies

Before moving on to examine the grammatical and lexical aspects of language, it is perhaps worth considering the effects of technology on both speech and writing. Scientific discovery and technological innovation have progressively extended the influence of language beyond the physiological limitations of speech. The craft of writing and the skill of reading have enabled meaning to be transported around the world in the absence of the author – resulting in 'speech' without sound, the unuttered word. The invention of type marked the 'industrialization' of language: typography and print turned language into a mass-produced commodity. Technology has built upon the principles of our own physiology: the transmitter–receiver–recorder model reflects our own voice, ear and memory. Through the development of mass media it has extended the written and spoken systems, enlarging the audience and magnifying the influence of language. Today, digital media combine the main features of earlier technologies within a single format. Through the continued development of technology we will no doubt continue to redefine the boundaries of language and to broaden its influence.

Language & technology

Oration
spoken
visual
animated subject
variable viewpoint
sequential
portable
interactive
ephemeral

Theatre
spoken
visual
animated subject
fixed viewpoint
sequential
fixed
limited interactivity
ephemeral

Inscription
writing
visual
static text
best read square to subject
sequential
fixed
no interactivity
permanent

Print: book/newspaper/magazine
written
visual
moving through space
best read square to subject
sequential
portable
no immediate interactivity
permanent

Postal service
written
visual
moving through space
best read square to page
sequential
portable
delayed interactivity
permanent

Telephone
spoken
oral
moving through time & space
non-visual
sequential
portable
interactive
ephemeral

Radio broadcast
spoken
oral
moving through time & space
non-visual
sequential
portable
non-interactive
ephemeral

Sound recording
spoken
oral
preserving language
non-visual
sequential
portable
non-interactive
permanent

Film/television/video
spoken & written
oral & visual
moving through time & space
viewpoint selected by director
sequential
portable
increasingly interactive
ephemeral

Digital technology & web
spoken & written
oral & visual
moving through time & space
viewpoint selected by reader
sequential/non-sequential
portable
interactive
permanent or ephemeral

Grammar

If writing were architecture, then books would be buildings, pages floors, paragraphs rooms, sentences walls, words furniture, letterforms bricks, phonemes clay and grammar mortar. In speaking our first language, most of us grasp the fundamentals of grammar. The way we acquire language as children instils in us the notion that language is not merely a collection of words, a vocabulary with definitions, but that it has an invisible architecture. We recognize that merely gathering up appropriate words into bundles doesn't enable us to communicate. Meaning is constructed through the ordering of words. The invisible structure of language is termed syntax. An illustration of how order can affect meaning is to shuffle the four words of a simple sentence into their 24 possible combinations. The potential complexity of word order is multiplied, of course, by the number of words in a sentence: five words give 120 combinations; six words, 720 combinations; and ten words, 3,628,800 combinations.

Faced with an apparently endless set of word order combinations to create meaning in a single sentence, it is astonishing that two-year olds can already grasp the structure that cements language. As children, we not only absorb language structures passively, we actively search them out. Having realized that cow becomes cows and that horse becomes horses when there are more than one, a child will declare a flock of sheep to be sheeps. The word 'sheeps' has not been absorbed but rather constructed on the basis of the child recognizing and applying a structural pattern to language; unfortunately, this particular pattern is irregular. Having learnt our first words we undertake this task subconsciously: the act of ordering speech is embedded within us.

The syntax structure that holds language together can be broken down into units. Sentences contain a hierarchy; large units are made up of smaller units. The smallest units are termed constituents. The constituent parts of a sentence can be visualized in the form of a tree diagram. The tree diagram shows how a sentence can be broken down into its 11 syntactic units, but does not describe the units themselves.

The constituent units can be described in two ways: syntactic class and syntactic function. The syntactic class of a unit is determined by its grammatical properties, *eg* noun, naming an object. The syntactic function describes how the unit operates within a sentence, *eg* a phrase containing the subject. The units can be described by 18 'function labels' and 38 'class labels'. The constituents of the tree diagram can now be identified by class and function. The function label is identified first, followed by the class label.

The simple illustrations used here to demonstrate the structure of language – syntax, constituents and class and function labels – use grammar as an analytical tool to describe the parts of speech. This approach, termed descriptive grammar, examines the way language actually works rather than determines the way we think language should work. By contrast, normative or prescriptive grammar, as traditionally taught in schools, involves the learning of numerous 'rules' and their appropriate applications to ensure a 'correctness' of speech and writing.

Order affects meaning:

Typography is visible language.
Typography is language visible.
Typography language visible is.
Typography language is visible.
Typography visible is language.
Typography visible language is.
Is visible language typography.
Is visible typography language.
Is typography language visible.
Is typography visible language.
Is language typography visible.
Is language visible typography.
Language typography is visible.
Language typography visible is.
Language visible typography is.
Language visible is typography.
Language typography visible is.
Language is typography visible.
Visible language is typography.
Visible language typography is.
Visible typography language is.
Visible typography is language.
Visible language typography is.
Visible is language typography.

Constituent structure

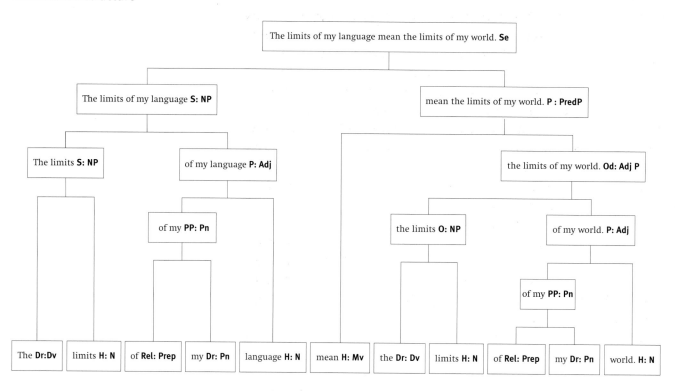

Function labels (abbreviated)

A	Adjunct
Ax	Axis
C	Complement
Cx	Non-central complement
Dr	Determiner
H	Head
M	Modifier
O	Object
Od	Direct object
Oi	Indirect object
P	Predictor
P C	Predicative complement
PCo	Objective predictive complement
PCs	Subjective predicative complement
PD	Peripheral dependent
Pred	Predicate
Rel	Relator
S	Subject

Class labels (abbreviated)

ACl	Adverbial
Adj	Adjective
AdjP	Adjective phrase
Adv	Adverb
AdvP	Adverb phrase
Aux	Auxiliary verb
CCl	Comparative clause
Cl	Clause
Clen	Past participle clause
Cli	Infinitival clause
Cling	Present participle clause
Coord	Coordinator
Dv	Determinative
DvP	Determinative phrase
GP	Genitive phrase
MCl	Main clause
Mv	Main verb
N	Noun

NCl	Noun clause
NP	Noun phrase
Pcle	Particle
Pn	Pronoun
PP	Prepositional phrase
PredP	Predicate phrase
Prep	Preposition
RCl	Relative clause
SCl	Subordinate clause
Se	Sentence
Subord	Subordinator
Ved	Past tense form of verb
Ven	Past participle form of verb
Vi	Infinitival (base)
Ving	Present participle form of verb
Vo	General 'other' present form of verb
VP	Verb phrase
Vs	Third person singular present tense form of verb

The lexicon

This term refers to the branch of linguistics that records a language's vocabulary. The term is itself derived from the Greek *lexis*, meaning 'word'. Lexicographers examine how words are formed: how they originate and how they change through time in terms of pronunciation, spelling and shifts of definition. Languages are in a continual state of change: words are appropriated from elsewhere; they go in and out of fashion; they are adapted to identify new developments in technology or ideas. Definitions are stretched to embrace new concepts; words gain prefixes or suffixes that adjust the way they can be used grammatically; or they become redundant, falling out of use completely: mere sounds without a living definition. Lexicographers record these patterns of change, continually collecting words, cataloguing them and preserving them in dictionaries, glossaries and thesauruses.

The way we use words makes the lexicographer's task even more complex – a difficulty which is compounded by the use of idioms. Native English speakers clearly understand phrases such as 'I have a bone to pick with you', 'like a red rag to a bull' and 'it's raining cats and dogs', but anyone learning English and searching for definitions word-for-word would find themselves in a semantic desert. These idioms communicate ideas poetically rather than through the literal translation of individual words. The lexicographer is, as it were, caught between a rock and a hard place – between alphabetical entries and clear definitions. As a consequence, dictionary definitions extend to include examples of common idiomatic phrases.

Lexicographers in search of definitions have also unearthed the origins of words, the etymology. This process involves digging deep into myth and folklore, translating languages and consulting technical glossaries. The hunt for the derivation of a word can often reveal interesting word groups, linked by meaning. For example, the origins of the phrase 'a square meal' are naval. Sailors in the 1800s, for some peculiar reason known only to the Admiralty, would eat off square plates; therefore a portion that filled the whole plate became known as 'a square meal'. The lip of the plate, which prevented the food from falling off, was called the fiddle, and a greedy sailor who took more than his fair share by balancing food on the lip of his plate was said to be 'on the fiddle'. Both phrases are still used today, although they have of course become detached from their naval origins.

A dictionary provides definitions of words, but it also reveals far more of the lexicographer's craft. A single entry in a concise dictionary gives spelling at the time of compilation, breaks the word into its constituent syllables, indicates inflection, provides a phonetic guide to pronunciation, identifies the grammatic class (*eg* noun or verb), makes a series of definitions, provides examples of idiom and reveals the etymology (*eg* Latin or Greek). For example, shown overleaf is the entry for the word 'language' in the *Concise Oxford dictionary* (1996).

The dictionary

A dictionary entry

1 Spelling
2 Pronunciation guide
3 Grammatical element
4 Idiom
5 Definition
6 Example
7 Etymology

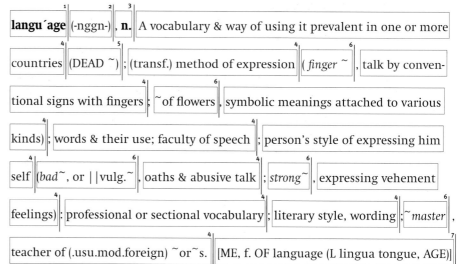

langu´age (-nggn-), **n.** A vocabulary & way of using it prevalent in one or more countries (DEAD ~); (transf.) method of expression (*finger* ~, talk by conventional signs with fingers; ~of flowers, symbolic meanings attached to various kinds); words & their use; faculty of speech; person's style of expressing himself (*bad*~, or ||vulg.~, oaths & abusive talk; *strong*~, expressing vehement feelings): professional or sectional vocabulary; literary style, wording; ~*master*, teacher of (.usu.mod.foreign) ~or~s. [ME, f. OF language (L lingua tongue, AGE)]

Above A definition of language from the *Concise Oxford dictionary* (1996) showing the components of each entry.
Right A page from Samuel Johnson's 1755 dictionary showing the definition of typography.

The development of the dictionary

The term dictionary is derived from the Latin *dictionarius*, 'a collection of words'. The first English use of the word dictionary entitled a compilation of Latin words put together by John Garland in *c*.1225. In the fifteenth century non-Latin dictionaries were being produced across Europe. These dictionaries served as an aid to the study of Latin. In 1440 a Dominican friar in Norfolk catalogued 1200 English words and their Latin equivalents in a manuscript entitled *Promptorium Parvulorum* 'store house for the little ones', clearly revealing the relative importance of Latin and English. This early dictionary was printed in 1499 by Richard Pysoon, an associate of the English printer William Caxton. Another of Caxton's assistants, Wynkyn de Worde (a name later adopted by an English society of printers and typographers), published *Ortus Vocabulorum*, the beautifully entitled 'garden of words'. This was the first English dictionary to record both word and definition in English. Peter Levin realized the potential of a new market and published a concise dictionary, *Manipulus Vocabulorum*, with another succinct title, 'a handful of words'. This book listed only 9,000 entries and was ordered not alphabetically but by the initial letter of the final syllable – the entries read in rhyme (words which share a common last phoneme), the first Rhyming Dictionary.

By the sixteenth century the value of dictionaries was recognized as both a publishing goldmine and an academic essential. The now humorous and quaint-sounding titles used by the early compilers of dictionaries is reflected in the idiosyncratic nature of the words they contained. Early dictionaries were aides-mémoires constructed in a somewhat haphazard manner, compilers made an individual assessment of difficult words and sprinkled their dictionaries with personal favourites. It was not until 1623 when Henry Cokeram published *The English dictionary* that a more rational and systematic approach to word selection was undertaken. John Kersey, who compiled the *New English dictionary* in 1702, made the first attempt to define words in everyday usage.

From the eighteenth century, dictionaries began to contain all the elements with which we are familiar today. Nathaniel Baily's *Dictionarium Britannicum* of 1730 contained methodical alphabetic listing of words in everyday usage, consistent spelling, entries and definitions in the same language, etymologies and punctuation guides.

The systematic collecting, ordering and formal definition of words in eighteenth-century dictionaries lead scholars all over Europe to create a new role for themselves as the arbiters of their nation's linguistic purity. Lexicographers became judges whose dictionaries made verdicts on correct usage. Samuel Johnson, a veritable titan in the world of dictionary compilation, realized the impossibility of freezing definitions. After eight years of compiling his *Dictionary of the English language* (1755) he wrote in the preface that no writer 'can embalm his language and secure it from corruption'. Johnson had a modern vision of language, not fixed but fluid, and of dictionaries reflecting rather than determining the way words are used.

The first American–English dictionary was published in 1798, though far more influential was Noah Webster's *American dictionary of the English language* of 1828 which contained 70,000 entries. Webster's dictionary reflected American usage of English, while Johnson's earlier publication reflected British usage. Though separated by only 73 years the contrast between the two was marked, American–English contained whole groups of words whose origins lay in the new world and the adaptation and new usage of terms derived from the old. The separate development of English across two continents illustrated Johnson's vision of language, 'no dictionary of a living tongue can ever be perfect, since while it is hastening to publication, some words are budding, and some falling away.'

The Johnson and Webster dictionaries are held in great esteem by modern lexicographers not merely for their accuracy and extensive vocabulary but also because they represented the last significant compilations by individuals. *The new English dictionary on historical principles* was published in 1928 and became the now-familiar *Oxford English dictionary*. This work took over seventy years to compile and was undertaken by teams of volunteer academics and students in Britain and America. It claimed to define every English word in usage since the seventh century.

A similar pattern of dictionary development can be traced through other European languages. Wilhelm and Jakob Grimm, well known for the creation of *Grimm's fairy tales*, were also responsible for the creation of *Deutsches Worterbuch* which systematically catalogued German vocabulary through the mid-nineteenth century. During the same period a French lexicographer, Émile Littré, compiled the *Dictionnaire de language française* (1863) a thirty-year task which attempted to define words in common usage.

The advent of computers has radically changed the way dictionaries are compiled. The Oxford English Dictionary Project of 1984 set out to update and convert the existing dictionary to one that could be read on screen. The OEDP would form a common basis for all future print and electronic editions. The 20-volume print edition with over 500,000 definitions is available as a CD-Rom or can be accessed through the web.

Despite lexicographers' exhaustive attempts to catalogue and define the extent of English vocabulary, the exact number of words in English remains unknown. *Websters third new international dictionary* of 1961 had over 450,000 entries while the *Oxford English dictionary* of 1992 had over 500,000 entries. When comparisons were made between these two books the overlap of common entries was less than half. Many lexicographers estimate the extent of the lexicon in English to be over 1·5 million words, though if the lexicon is extended to include all scientific and technical words the total may be tens of millions – there are, for example, over a million names for insects.

As well as identifying differences in definition, compilers of dictionaries recognize similarities. Words can be ordered not merely alphabetically, as in dictionaries, but grouped by common meaning. Groupings of words with shared meanings are termed semantic fields by lexicographers. The concept of grouping words into semantic fields was put forward in the early seventeenth century by the English philosopher and essayist Francis Bacon, who described a way of dividing ideas into a small number of areas which could be progressively sub-classified until all concepts were assigned to their appropriate place.

The notion of grouping lexical themes was not formally taken up until 1852 when Peter Mark Roget, an English doctor, first published *Roget's thesaurus*. Describing the function and rationale of his new publication, Roget wrote: 'a collection of words ... arranged, not in the alphabetical order as they are in a dictionary, but according to the ideas they express ... the principle by which I have been guided in framing my verbal classification is the same as that which is employed in the various departments of Natural History, thus the sectional divisions I have formed correspond to Natural Families in Botany and Zoology, and the filiation of words presents a network analogous to the natural filiation of plants and animals.' Roget divided the lexicon into six main areas: abstract relations, space, the material world, the intellect, volition and sentiment/moral powers. He termed these 'classes', and ordered them numerically. Each class was then subdivided into sections and numbered within its class; and each section was divided into heads, giving a total of one thousand semantic categories. Roget hoped that individuals would learn the classification system and by making informed choices at the level of class, section and head, would be able to locate a word. It is still possible to use a thesaurus in this way, but an alphabetical index of key words in modern editions speeds up the process enormously. The 'semantic field' approach of *Roget's Thesaurus* is demonstrated when contrasted with the dictionary definition of 'language' (see page 30).

Classifications

557. Language – N. *language,* tongue, speech, idiom; patter, lingo 560 n. *dialect;* mother tongue; vernacular, common speech; correct speech, Queen's English; lingua franca, Koine, pidgin, pidgin English, Chinook; sign language, semiology 547 n. *gesticulation;* artificial language, Esperanto, Ido, Volapuk; private language, idioglossia; officialese, translationese; confusion of tongues, polygot, medley, Babel 61 n. *confusion.linguistics,* language study, glottology, dialectology, philology; phonetics 577 n. *pronunciation;* derivation 599 n. *etymology;* morphology; semasiology, semantics 514 n. *meaning;* onomasiology 561 n. *nomenclature;* palaeography 125 n. *palaetiology; linguistic geography, word-g.; polyglottism, bilingualism; literature 589 n. reading matter.linguist,* philologist, glottologist; etymologist, lexicographer 559 n. *etymology;* semasiologist, onomasiologist; grammarian 564 n. *grammar;* phonetician 398 n. acoustics; man of letters, belletrist 492 n. *scholar;* humanist, Hellenist, Latinist; polyglot, bilinguist. **Adj.** *linguistic,* philological, etymological, grammatical, morphological; lexicographical, onomasiologyical, semaśiological; analytic; agglutinative; monosyllabic; tonal, inflected; holophrastic; written, literary, standard; spoken, living, idiomatic; vernacular, slangy 560 adj. *dialectical;* current, common, demotic; bilingual, diglot; multilingual, polyglot.

Communication theories

Theories of communication in relation to language only really began to be defined and formalized in the mid-twentieth century. However, it is clear that from early Greek times philosophers contemplated the nature of words and the relationship between speech, writing and reading. Literature holds many examples of the power of language and the nature of words, but they exist within the context of a narrative and do not stand alone as theories.

The first model of communication theory was put forward by the engineers Claude Elwood Shannon and Warren Weaver in 1948.

Information source>Transmitter signal>|Noise source|Received signal> Receiver> Destination.

The model reflected the technology of the day – telephone, radio and radar – and identified the conceptual structure that lay behind it. (Shannon and Weaver's original work was based on the telephone system, hence the inclusion of noise source or interference.) The technology-based model was amended slightly to reflect human communication. The adaptation of the model for human speech and writing was merely to envelop both transmitter and receiver within a common subculture. However, while there is commonality between the way machines and humans communicate, Shannon and Weaver's theory only examines the conduit: sound waves, created by speech, are encoded into electrical pulses within the mouthpiece of a telephone and decoded and amplified through a vibrating membrane in the earpiece, whence they reappear as speech.

The receiving of the signal that happens in our ear does closely resemble the telephone's vibrating membrane, but our decoding of the message involves our cognition or interpretation of meaning – something not accounted for by Shannon and Weaver. A telephone converts speech into code and code into speech, but has no understanding of what language means. George Gerbner proposed a model not adapted from machines but based on human analysis.

This model, together with others by David Berlo, placed far greater emphasis on perception, shared cultural context and the form of the signal – not merely in phonetic terms, as perceived by the ear, but also in terms of gesture and facial expression, as perceived by the eye.

Ferdinand de Saussure's course in general linguistics, semiotics and anthropology, devised in the early twentieth century, analysed both the spoken and written code. Saussure identified words as signs and became infuriated by what he saw as the meaningless nature of written forms, 'the tyranny of writing'. He spoke of 'The emptiness of forms. The husks of language, containing the essence, the body, but not the soul.' He recognized that there is no material relationship between the spoken word and the object it represented. The phonemes from which a word is composed have no intrinsic meaning; language only works on the basis of mutual agreement. It is not owned by an individual, but is the possession of a community. If a group collectively decide that a chair is called a 'table', then that is its name. We may hear speech, but we do not understand it if we are outside the fold of that language community. Learning a language is the making of shared semantic agreements with others. Saussure put forward the idea of the 'signifier', the phonetic sound or the arrangement of letters, and the 'signified', the concept or meaning. He extrapolated from this analysis that linguistic value resides not in the sign, but in its relation to other signs within the system. Meaning is generated from the collective grouping of signs: it is built from the parts. It is the structure of language that conveys meaning. These theories form the basis of what is known as structuralism. The belief that meaning could by constructed by the transmitter of language was a natural extension of Saussure's analysis. Through speech and writing, the architect of meaning was the author.

Saussure's ideas, and those of his structuralist followers, influenced the development of modernism and have been embraced by practitioners of architecture, industrial design, graphic design and type design. What appealed to modernist thinkers was the belief that authors or designers could transmit fixed meanings through constructed forms. They could construct a brave new world that would deliver radical messages through the authorship of form.

Structuralism has since been re-evaluated by many writers from a range of disciplines. Doubts were initially raised about the validity of constructing and transmitting 'fixed meaning'. The doubts cast on structuralism threw a shadow on modernism, with its belief in the designer's role as author. From the 1960s onwards, post-structural thinkers began to re-examine the way in which language is received and interpreted. Roland Barthes, Michel Foucault and Jean Baudrillard began to attack Saussure's assertion that the signs in language – the words – are neutral. By analysing and questioning the structuralist principal that meaning is built through a system, Barthes began to dismantle the structure. All three developed ideas that challenged the assumed precepts in a range of fields, including literature, language, advertising, architecture and politics.

The basis for their analysis lay in the questioning of absolutes. For these post-structuralist thinkers, most ideas contained a dualism: certainty contains within it uncertainty, while fixed meaning embraces interpretation. In many

JAN TSCHICHOLD: Poster 1926, Normformat A

The early work of Jan Tschichold exemplified modernist beliefs that it was the designer's responsibility to clarify and organize information along rational principles, without decoration, for its readership.

In contrast to the modernists' rational approach Ed Fella offers an expressive irreverence to both the form of letters and the delightful disorganization of structure. The envelope **top**, while not typography, reveals the origins of the typographic doodles which are extended into his commercial work. The results seem unplanned, amateurish scribbles developed from a starting point without sense of what the end might be. The reader has to interpret the information, enjoying or enduring the idiosyncrasies of the form.

respects this philosophic questioning of structuralist ideas revisited a far earlier debate. The early Greeks had contemplated the relationship between mind and body. They questioned how external things related to their internal meaning: how the outward appearance of an object related to its essential nature. Is the essence of a vase defined by its external clay form, they asked, or by its containment of the inner space or void?

In his influential book *Of Grammatology* (1967), the philosopher Jacques Derrida devised the term 'grammatology' to describe the study of writing. He saw writing as a copy of the spoken word and typography as something that mechanically formalizes the copy. For Derrida, the material forms of language – writing and speech – together represent meaning. The 'reading' of the representation, the interpretation by the viewer or listener, is not determined by the transmitter but by the receiver. The reader brings his or her own ideas and experiences to a message; language is defined by interpretation. In this way, structuralism was itself dismantled or 'deconstructed'. Roland Barthes extended the deconstructivist belief in interpretation still further, suggesting that the interior essence of self is actually defined by external readings. He proposed that the author's role of constructing meaning through form had been usurped by the reader's ownership of meaning through interpretation. The result: 'the death of the author'. Deconstructivist ideas were given physical forms in architecture, design and typography. Such physical artefacts made visible the radical nature of the ideas, but have often been belittled as a superficial style rather than the manifestations of a critical approach.

A bitter and somewhat childish debate, which is often reduced to 'my *ism* is bigger than your *ism*', has raged between those who maintain that modernism lives on as an unfinished project and those who claim to have witnessed its last rites. Accusations fly from both sides about the misrepresentation of each party's argument. It is clear that not all modernist typography is authoritarian, structured imperialism, delivering a specific fixed and indisputable message to the eye of its readers. It is equally clear that not all deconstructivist work is illegible style-based nonsense paying no attention to content, or is a mass of mixed messages based entirely on individual interpretations. Such crude polarization is perhaps a product of the protagonists spending too long in the rarefied air of academic debate.

Form III

Parts of a letter

Capital ('caps' or 'upper-case') **letters** are principally constructed between two parallel lines: the baseline and the cap-height.

Lower-case forms have three main vertical proportions. The 'x-height' is quite literally the height of the lower-case x and is not a fixed proportion of the cap height but is specific to each typeface. The x-height is the most important element in determining how large a typeface appears (see also page 108). The part of a lower-case letter that extends above the x-height is known as the ascender and may be higher than the cap-height. The part of a lower-case letter extending below the baseline is the descender.

Towards a 26-letter alphabet

If writing is the physical notation of language, then type is its mechanical notation. In Europe the invention of type is ascribed to the German Johann Gutenberg (c.1394–1468), although in Korea there is evidence that movable metal type was first used as early as 1241.

The advent of movable type and printing represented the mechanization of an alphabet system whose traceable origins went back some three thousand years. For the typographer, there are two key elements to the story of the Western alphabet leading up to Gutenberg's invention of type, both of which developed in parallel. The first is the establishment of the 26 symbols that represent the phonemes – both vowels and consonants – of the majority of European languages. The second is the continual refinement of those symbolic forms, leaving a legacy of 26 letters in both capital and lower-case varieties, the concept of a small space between words and a left-to-right reading direction.

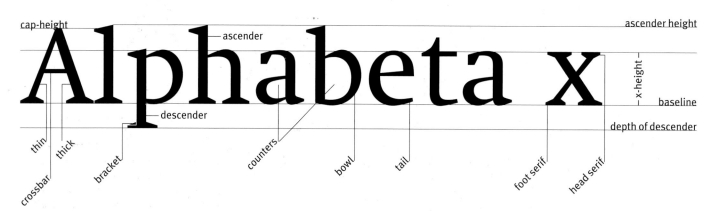

cap-height — ascender — ascender height — x-height — baseline — depth of descender
thin — thick — crossbar — bracket — descender — counters — bowl — tail — foot serif — head serif

Upper and lower-case small caps lining figures non-lining figures

Small capitals (small caps)
Some fonts contain small caps, capital letterforms that are designed to work optically with lower case. They are generally a little higher than the x-height. (See page 170 for usage).
Numerals
These can be of two kinds. Numerals of cap height are known as 'lining numerals'. In older typefaces and good contemporary ones, there exist 'non-lining' numerals, which visually balance the lower-case letters. These are a useful alternative, designed for setting running text (see also page 165).

Italics
Upright letters are often referred to as 'roman', sloped letters are known as italics. They may be 'cursive' *ie* with a flow like joined-up writing, or non-cursive which may appear like a sloped roman. The development of italics is outlined on page 54.

cursive sloped roman

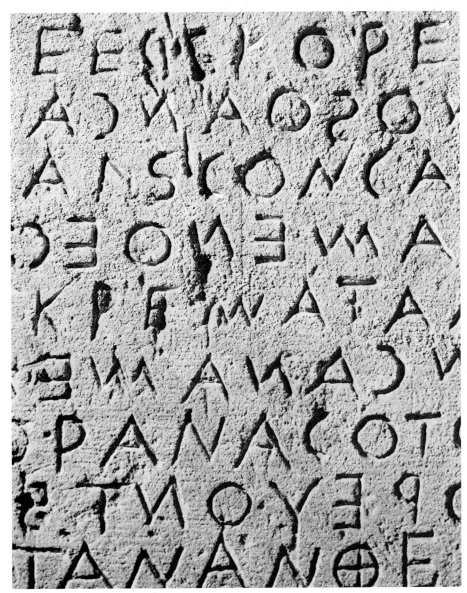

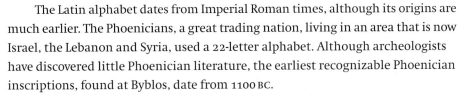

1

2

3

Greek letters

The letter A (**above**) appears to have developed from a pictogram of an ox's head, the horns protruding above the triangular face (**1**). The Phoenician letterform has been turned through 90 degrees and has lost the pictogram's representation of eyes (**2**). The Greeks adopted the Phoenician symbol for alpha but reorientated it along a vertical line of symmetry to reflect their vision of beauty (**3**). The symbolic horns of an ox became the embryonic Roman foot serifs.

Formal inscribed Greek letterforms (**left**) are more refined than earlier inscriptions. This example from the seventh century BC demonstrates boustrophedon reading, alternate lines reading from left to right, then right to left in the manner of an ox ploughing a field, which is the origin of the term. All the letters are monoline majuscules with a character height of approximately 15mm and sharing a common baseline. The letterforms are broad, and the stroke angles on the crossbar of the A and the E are now square. The letter O is circular, while the letters P, S and K retain the sharp triangular forms of the early Greek and Phoenician versions.

The Latin alphabet dates from Imperial Roman times, although its origins are much earlier. The Phoenicians, a great trading nation, living in an area that is now Israel, the Lebanon and Syria, used a 22-letter alphabet. Although archeologists have discovered little Phoenician literature, the earliest recognizable Phoenician inscriptions, found at Byblos, date from 1100 BC.

The classical Greek alphabet, also known as the Ionic or Eastern alphabet, was developed from the Phoenician alphabet, and in 403 BC it became the official alphabet in Athens. The Greeks adopted the Phoenicians' 22 consonants, used two as vowels and created three new vowel signs, making 25 letters in all. The Greeks used the Phoenician names for the letters but amended the spelling to reflect their own pronunciation. Thus, the Phoenician 'aleph' (meaning 'ox') became 'alpha'; 'beth' (meaning 'house') became 'beta', and so on.

Before the official adoption of the classical Greek alphabet, Greek colonists had taken a script to Italy. This 'Euboean' alphabet became the Etruscan alphabet,

AVALE VE

VS·VT·TR

CET·PROBI

SENES·A

N·FLERE·A

RDEOV

and developed slightly differently from the classical Greek version. The Etruscans adapted the alphabet to reflect their phonetics, a process that required the use of 26 letters.

In due course, the Romans developed an alphabet from that of the Etruscans, using 21 of the original 26 letters. Thirteen letters remained the same as the Greek: A, B, E, H, I, K, M, N, O, T, X, Y, Z; eight letters were amended: C, D, G, L, P, R, S, V; and two further letters, F and Q, were reinstated (they existed in early Greek but had been dropped in classical Greek). The alphabet now had 23 letters, representing both consonants and vowels, and with this the Romans were able to write a phonetic representation of their language, which we now call 'Latin'. The additional three letters – J, U and W – are more recent introductions to the alphabet needed to represent other sounds. The Romans used I to represent the sounds for both I and J, and V to represent both U and V; W was needed to represent a sound in Old English.

Although the Roman alphabet took many forms, *Capitalis quadrata* (square capitals), have exerted the most influence on lettering and typographic development. Many versions of these exist, principally on inscriptions; those from the reign of Trajan (as seen, for instance, on Trajan's Column in Rome from *c*.114 AD) are perhaps the most celebrated.

Roman letters

Edward Catich put forward the theory that the stone V-cut letters of Trajan's Column were not merely the product of a skilled stone carver using a chisel. He suggested that the letters were first painted onto the carving surface, allowing the spelling and length of the inscription to be checked before carving. A skilled calligrapher, Catich recreated the strokes he considered necessary to the structure of each letter.

A brush creates letters differently from a pen: it is turned as it makes strokes, and different amounts of pressure can be applied to create thick and thin marks.

The drawings above show the brushstrokes separately, then combined, and finally a tracing of the letter A from Trajan's Column.

Opposite Carved Roman square capitals from the Via Appia, south of Rome, show clearly how the square and the circle formed the underlying structure for Roman letterforms. Noticeable too is the variety of letter widths.

Towards upper- and lower-case letters

The square capitals used for monumental inscriptions are the most obvious of all Roman alphabets and could be described as 'formal'. For day-to-day written communication simpler 'informal' forms were used. Examples of cursive informal scripts (see 'Handwritten sources', page 53) have been found on ceramics and small wooden tablets covered in wax. (A bone or bronze stylus would have been used to scratch letterforms into the wax.)

For more important documents, scribes wrote on papyrus or vellum using a reed dip pen or a brush. Their writing style was developed primarily for reasons of speed, and is referred to as 'rustic'. Rustic letters are condensed capitals with pronounced thicks and thins, and with heavy horizontal strokes where serifs might be. These letterforms also existed as a carved form, and some inscriptions combine them with square capitals.

The period between the fourth and ninth centuries was one of immense artistic invention in terms of new letterforms. The forms of letters themselves changed, and new characters appeared which begin to suggest our lower case. After the rustics came Roman uncials, then the half-uncials and uncials of the insular tradition (from monasteries at the edge of the Roman empire, such as Kells in Ireland and Lindisfarne in Northumberland).

At the end of the ninth and the beginning of the tenth centuries, as part of a wide-ranging political reorganization, the Holy Roman Emperor Charlemagne instigated a new, clearer script to replace the many differing styles in use throughout the empire. Developed by Alcuin of York, working in the monastery at Tours in France, this so-called Carolingian minuscule was written with a pen held at an angle, and used open, rounded forms that moved away from the studied heaviness of uncial forms. It formalized the idea of a twin (but not paired) alphabet: what we now call upper and lower case.

Holding a pen at that same angle could also create letters of a quite different nature, and during the following five centuries several distinct styles evolved from the Carolingian model. In Northern Europe the transition points between the written strokes were emphasized, leading to condensed and often very angular letters. These forms would later be termed blackletter (after their colour) or gothic (after the period), but the term broken script describes their appearance far more clearly. Several variants of these existed, and when Johann Gutenberg invented printing from movable metal type at Mainz (in what is now Germany) around 1454, it was on these styles that he based his types. The first, used in the *Mainz indulgence* of 1454–5, is modelled on a more informal Bastarda while the type used for the *42-line Bible* of 1455 is a highly formal Textura. (Such types remained in use in Germany until well into the twentieth century, and were for a time a key part of Nazi propaganda.)

Rustic forms were drawn with a dip pen or brush and were faster to write than the formal square capitals. This example, from the late third to mid-fourth century, shows how the compressed majuscules with their bold terminations gave a dark, even texture to a page.

Roman uncials ('inch-high letters'), from around the fourth to fifth century. Drawn using a broad nib, the uncial letterform is wide in relation to height, and uses large rounded counters. Ascenders and descenders are short, and there is very little inter-word spacing, giving the visual impression of two parallel lines between baseline and x-height.

Insular uncials like these from the *Book of Kells* (seventh century) are derived from the older roman uncial but reflect individual monasteries developing their own calligraphic forms. It is interesting to note the use of small capitals, *eg* R, integrated with the uncials.

Carolingian minuscules from the *Gospels of Metz* (early ninth century) have smaller counters and larger ascenders and descenders. These forms are closer to our understanding of lower-case than any of the other forms described above.

The **humanist bookhand** which evolved in Italy in the fifteenth century was based on Carolingian models. With round, open proportions, large ascenders and descenders and generous inter-linear space it makes a dramatic contrast to the Textura (broken script) used in Northern Europe at that time which became the model for the first printing types (see overleaf).

Ad completorium de f.cruce.
DOmine Iefu Chrifte fili dei
biui, pone paffionem , crucē,
& mortem tuam inter iudiciū tuum
et animam meam nunc et in hora
mortis mee:& femper largiri digne-
ris biuis mifericordiam & gratiam
defunctis requiem & beniam ,eccle-
fie tue pacem & beram concordiam,
et nobis peccatoribus bitam & glo-
riam fempiternam . Qui cum Deo
patre et fpiritu fancto biuis et re-
gnas deus. Per omnia fecula fecu-
lorum.Amen.
Recommendatio.
HAs horas canonicas cumde-
uotione. Tibi chrifte recolo
pia ratiōe. Ut qui pro me paffus es
amoris ardore , Sis mihi folatium
in mortis agone.

C Sequūtur hore de fancto fpiritu
Ad Matutinas.

Early printing types

Gutenberg's types were based on the styles of
writing in use in Germany at that time. Even after
the advent of roman types in 1469 (see page 55)
broken scripts continued to be used for the Church.
This missal, printed by Higman in Paris in 1497,
shows a Textura with its characteristic condensed
and angular letterforms creating a dense heavy-
looking page quite different from the effect given
by the humanist bookhand.

As with many early printed books, space here
has been left for coloured initial letters to be added
later by hand.

Numbers

No one can be certain when the need for numbers
surfaced, though it seems likely that it emerged
in parallel with language. Agreements about mea-
surements of length and height enabled groups of
early builders, hunters and trappers to work col-
lectively. The physical properties of objects were
often described using units of length based on
human anatomy, eg feet have an obvious deriva-
tion and an inch is the distance from the top
knuckle of a man's thumb to its tip.

Keeping a record and calculating

The process of counting is of little use without
the creation of a lasting record. Relying solely on
memory or word of mouth can lead to confusion.
The earliest forms of record, where a single mark
is used to represent a single unit, are referred to
as figural numeration systems. Archeologists have
identified notches on bone, tally sticks, knots in
cord, shells, pebbles and wooden counters as
records of number sequences.

The simple figural recording of a count evolved
into calculation, a word derived from the Latin
word for stone or pebble, calculus. This apparently
ambiguous origin probably has its roots in fourth-
century BC Sumeria where clay stones called cal-
culi were made into cones and balls used to record
a count. An abacus fulfils the same function. It can
record a simple count, but in experienced hands it
can also complete complex calculations not easily
undertaken using mental arithmetic. However, the
abacus, like all early figural systems of calculation,
cannot record the process, merely the result. With
each new stage of the calculation the previous
stage is removed, preventing checking other than
by repetition.

Written numeration:
words and figures

In the West, written numeration takes two distinct
forms: as words phonetically spelt to represent
the sounds of a language and as figures using an
entirely separate symbolic code to represent the
same concept.

When expressed as words, there are only a few
individual names which are then combined to form
all others. In English, for example, there are sepa-
rate names for zero to twelve, adaptations of them
for thirteen to nineteen and individual names for
twenty and other multiples of ten, a hundred, a
thousand, a million and a billion.

Numbers expressed as words, eg two thousand
and two, have their meaning trapped by language
but when written in figures (eg 2002) they are
almost universally understood.

Figural systems gradually evolved into more
sophisticated digit systems, a name with obvious
links to traditions of finger counting. Digit systems
arrange symbols horizontally or vertically and work
as a code independent of a particular language or

script. Today only two sets of symbolic forms are used consistently with the Western alphabet, Roman figures and the more common Hindu–Arabic figures.

Each of these has a different mathematical basis: Roman figures use the more simplistic additive system while Hindu–Arabic figures use the more sophisticated hybrid system.

In an additive system such as the Romans used, two thousand and two is written MMII, *ie* a thousand + a thousand + one + one. This system relies on an ever-expanding set of symbols to accommodate larger numbers.

In a hybrid system, two thousand and two is written 2002, *ie* 2 × a thousand + 2. Theoretically, such a system is capable of notating infinite numbers by reordering a limited quantity of symbols in any sequence.

Roman numerals

The Roman symbols developed throughout the period of their influence are often assumed to be alphabetic, but the Roman alphabet did not originally include some of the letters used, nor are they organized in an alphabetic sequence. The initial unit symbols 1 to 5 are consistent with those used by the Etruscans and may relate to pictograms of finger counting where the figures I, II and III represent the hand's outer three digits and the figures IV and V represent the index finger and thumb. The figure X, for ten, and L, for fifty, were letters inherited by the Etruscans from the Greeks and, not being required to represent the phonetic spelling of Latin, were appropriated as figures. In early Roman inscriptions the Greek theta symbol was used to represent a hundred and phi for a thousand, but these were subsequently changed as they adopted the Greek principle of using an initial letter: *eg* C = centum (a hundred) and M = mille (a thousand).

Because the Romans' language, Latin, became the official language of the Roman Catholic Church, it has exerted a continual influence on the development of western European history and culture. This has helped ensure that Roman numerals are still used today.

Hindu–Arabic figures

The figures most commonly used with the Roman alphabet are often referred to as Arabic, though a more appropriate term is Hindu–Arabic.

Inscriptions using these figures have been found in India dating back to the third century BC. The figures 1, 4 and 6 appear in the Asoka inscription of 300 BC, a hundred years later the figures 2, 4, 6 and 7 occur in the Nana Ghat inscription and three or four hundred years later a more complete sequence is used in the Nasik caves. The figures used in the early Indian inscriptions resemble those we use today. Modern positional notation exploiting the concept of zero seems to have occurred in India around the fifth century AD. A document on cosmology written in Sanskrit dating from 458 uses eight digits in a positional notation system which reads from right to left to record the value 14,236,713.

In 773 an Indian ambassador visited Baghdad, an important city for Arabic scholars studying mathematics. His knowledge of the Indian digit and computation system was recognized by the city's Caliph al-Mansur, who encouraged the scholars of his court to study the new system. In the ninth century Muhammad ibn Musa al Khwarizmi wrote *The book of addition and subtraction by Indian methods*. It was the many translations of this book into Latin which largely established the Hindu–Arabic system in Europe. By the twelfth century its influence was so great that the Latin title for al Khwarizmi, 'Algorismus', gave its name to the mathematical process of algorithms. It seems likely that the popularization of the figures was not merely the influence of scholars, but of Arab merchants disseminating their knowledge along trade routes which linked the eastern Arabs of Baghdad with the western Arabs of Moorish Spain. A manuscript written in Spain in 976, where the Hindu–Arabic figures are referred to as Gobar numerals, supports this theory, and is often cited as the first use of the system in Europe.

Alphanumerics

Scholars of mathematics throughout medieval Europe made use of two principal calculating devices: the abacus and the computing table. The latter consisted of a table surface marked with ruled lines to form either columns or rows, upon which were placed loose counters ('apices') similar to those used in a game of draughts. In the thirteenth century Alexander de Villedieu wrote *Carmen de Algorismo* (*Poem of Algorism*) which formally recognized zero as a digit. Raoul de Laon took up the idea on his computing table by using a new counter ('sipos') and placing it in columns where it represented the value nothing. From here it was just a short step to representing the physical roundness of the counter as the symbolic figure 'o'. With the addition of a figure for zero, the ruled lines delineating the columns of the computing table were no longer required. Numbers could be added, subtracted, multiplied and divided in written form as the vertical alignment of the digits ensured the correct reading of the numbers' value.

The new practice of making calculations using written figures increasingly rendered the abacus and computation table obsolete. Scholars in Europe now had a common method of recording language and calculation which could be presented independently or easily combined in the form of books.

Above Detail from a treatise 'on arab geometry' published in Ulm by Leonarde Holle in 1482 (column width reduced from 91mm). Note how, at this early date, fractions existed as type, but that the figure 9 has not quite taken on its common form.

Classifying and describing typefaces

For anyone working with type, one of the first challenges is how to make sense of the thousands of different typefaces that are available. The simple way of organizing them is in an alphabetical list, which is how most typeface catalogues are arranged. This works well if a typeface is known by name, but is of little use when searching for something with specific visual characteristics.

Classifying typefaces according to visual similarities produces smaller groupings, which aids both recognition and selection. As well as forming the organizational basis for a library or reference work, this visual grouping can help increase awareness of the history and development of a typeface.

The categorical labelling of typefaces began during the nineteenth century, when there was a massive expansion in the range being produced. Printers and writers such as John Southward in Britain and Theodore Low de Vinne in the USA sought to rationalize this process in the early surveys of type design practice they were both to present. At the same time there was a growing interest in the study of historical typeforms, so that by the early twentieth century writers such as Daniel Berkeley Updike had broken down the evolution of Latin types into a series of categories. These early categorizations were to inform the underlying structures – if not the exact nomenclature – of most later classificatory systems.

The best known of these is that of Maximillien Vox and dates from 1954–5. His proposals gained the acceptance of the Association Typographique Internationale (ATypI), a body representing all the major manufacturers (a far smaller number then than now) and other interested parties. One aspect of the proposal was the introduction of new names for the (in some cases) familiar groupings, to facilitate international dialogue. Thus Garalde was derived from GARamond and ALDus (Manutius); Didone from DIDot and BodONI. A comparative table of names is shown below.

Vox's proposal was to become the basis for a number of classification systems, although the names he proposed were not always adopted. The British Standard (BS) version shown opposite reveals the shortcomings of such 'pigeon-holing' systems. Although many typefaces do fall into certain groupings, others are open to interpretation – for the type designer it is often the 'grey areas' that have the most appeal. Both Vox and the BS acknowledge that there are typefaces that cannot be neatly categorized, and suggest the use of compound terms to describe them; but in reality this adjectival, descriptive approach was rarely used. However, with the number of typefaces available at that time (1954–67) – perhaps ten per cent of today's number – the system was just about workable.

A more serious shortcoming of the Vox system, however, is its focus on typefaces designed for use in books. These were regarded as the highest expression of

Classification nomenclature

This table charts some of the terms used to describe the principal typeface groupings, and shows the variations that exist between countries – something that Vox sought to eliminate with his new names. Note the quite different uses of the term 'gothic'.

Vox	BS (GB)	French	German	US	Other
(Medieves)	Blackletter		Gebrochene Schriften	Text	Gothic
Garaldes	(Old face)	Elzevir	Antiqua	Old style	
Lineales	(Sans serif)	Antique	Grotesk	Gothic	Grotesque
Mécanes	Slab serif	Egyptienne	Egyptienne		

Category		Description	Examples
No.	Name		
I	Humanist	Typefaces in which the cross stroke of the lower case e is oblique; the axis of the curves is inclined to the left; there is no great contrast between thin and thick strokes; the serifs are bracketed; the serifs of the ascenders in the lower case are oblique. NOTE. This was formerly known as 'Venetian', having been derived from the 15th century minuscule written with a varying stroke thickness by means of an obliquely-held broad pen.	Verona, Centaur, Kennerley
II	Garalde	Typefaces in which the axis of the curves is inclined to the left; there is generally a greater contrast in the relative thickness of the strokes than in Humanist designs; the serifs are bracketed; the bar of the lower case e is horizontal; the serifs of the ascenders in the lower case are oblique. NOTE. These are types in the Aldine and Garamond tradition and were formerly called 'Old Face' and 'Old Style'.	Bembo, Garamond, Caslon, Vendôme
III	Transitional	Typefaces in which the axis of the curves is vertical or inclined slightly to the left; the serifs are bracketed, and those of the ascenders in the lower case are oblique. NOTE. This typeface is influenced by the letterforms of the copperplate engraver. It may be regarded as a transition from Garalde to Didone, and incorporates some characteristics of each.	Fournier, Baskerville, Bell, Caledonia, Columbia
IV	Didone	Typefaces having an abrupt contrast between thin and thick strokes; the axis of the curves is vertical; the serifs of the ascenders of the lower case are horizontal; there are often no brackets to the serifs. NOTE. These are typefaces as developed by Didot and Bodoni. Formerly called 'Modern'.	Bodoni, Corvinus, Modern Extended
V	Slab-serif	Typefaces with heavy, square-ended serifs, with or without brackets.	Rockwell, Clarendon, Playbill

Category		Description	Examples
No.	Name		
VI	Lineale	Typefaces without serifs. NOTE. Formerly called 'Sans-serif'.	
	a Grotesque	Lineale typefaces with 19th century origins. There is some contrast in thickness of strokes. They have squareness of curve, and curling close-set jaws. The R usually has a curled leg and the G is spurred. The ends of the curved strokes are usually horizontal.	SB Grot. No. 6, Cond. Sans No. 7, Monotype Headline Bold
	b Neo-grotesque	Lineale typefaces derived from the grotesque. They have less stroke contrast and are more regular in design. The jaws are more open than in the true grotesque and the g is often open-tailed. The ends of the curved strokes are usually oblique.	Edel/Wotan, Univers, Helvetica
	c Geometric	Lineale typefaces constructed on simple geometric shapes, circle or rectangle. Usually monoline, and often with single-storey a.	Futura, Erbar, Eurostyle
	d Humanist	Lineale typefaces based on the proportions of inscriptional Roman capitals and Humanist or Garalde lower-case, rather than on early grotesques. They have some stroke contrast, with two-storey a and g.	Optima, Gill Sans, Pascal
VII	Glyphic	Typefaces which are chiselled rather than calligraphic in form.	Latin, Albertus, Augustea
VIII	Script	Typefaces that imitate cursive writing.	Palace Script, Legend, Mistral
IX	Graphic	Typefaces whose characters suggest that they have been drawn rather than written.	Libra, Cartoon, Old English (Monotype)

the printer's art. Book typefaces were derived from the Roman inscriptional square capital letter, which was undergoing a revival at the start of the twentieth century (in part due to the teaching of Edward Johnston at the newly established Central School of Arts & Crafts in London). In addition, the manufacturers of the new mechanical composition machines were busy reviving 'historic' typefaces rather than commissioning new or novelty designs.

Today, new and novelty typefaces are in the majority, and the pace of manufacture is frenetic: the current catalogue issued by FontShop – one of the largest type retailers, representing more than 30 manufacturers – contains over nine thousand fonts. In terms of classification this presents both a practical and a philosophical nightmare. While some writers may question the right of many new typefaces even to exist, the purpose of any classification system is to record actual practice, and try to make sense of it. Vox-based systems no longer reflect what is happening in the 'big bad world' of type usage.

A new description system, devised by Catherine Dixon as part of her PhD work at Central Saint Martins College in London, first made its appearance in the book/CD-Rom *Typeform dialogues* published in 2001. Dixon's system is used on the following pages as the basis for explaining the principal varieties within type

British Standard 2961: 1967, Typeface classification and nomenclature.

This was one of several national standards to follow the ATypI-approved Vox scheme. Note the great attention given to the differences between types derived from a roman model (four categories) leaving only five for everything else. Of these, category IX, 'graphic', is so loosely defined as to become a dumping ground for misfits.

Catherine Dixon's type description system

Opposite A screenshot from *Typeform dialogues*. Although unnamed here, the vertical axis shows five main sources (bracketed): decorated/pictorial, handwritten, roman, nineteenth-century vernacular and additional, while the horizontal indicates formal attributes. The extract shown here indicates how the relationships between these two result in 'patterns'; these can be plotted against time, with indications along the bars to indicate popularity.

design. Dixon's approach focused on description rather than categorization; it therefore reflects more effectively the subtleties of type design practice. The framework hangs on three description components: sources, formal attributes and patterns.

Sources

Sources are the generic influences informing a typeform; their classification grew out of an analysis of the background to the existing categories. They comprise: decorated/pictorial, handwritten, roman, nineteenth-century vernacular and additional. In one sense they can be understood as four very broad categories, but their breadth enables them to make links – hidden by other systems – between a variety of typefaces. An overview of how these categories might look plotted against time is given in the diagram opposite. Each of these sources is described in detail on pages 53–70: taken together, these serve to give a pictorial overview of five centuries of type design.

Formal attributes

Formal attributes are the basic individual units of description that refer to a typeface's design and construction. There are eight of these – construction, shape, modelling, terminals, proportion, weight, key characters and decoration – each with a further sub-menu of its own. They are explained on pages 50–2.

Patterns

When a source (or sources) and a particular group of formal attributes become established in a fixed relationship, the result is known as a pattern. To give a sense of history and context, patterns can be plotted along a timeline to provide a link from the particular to the universal (see overview diagram opposite) – demonstrating that, although typefaces spring from specific times, they need not be bound by them. The diagram also shows how, while patterns are key to understanding the early centuries of type design, from a certain point the relationships between formal attributes and sources dissolve amid the diversity of practice. The principal patterns are explained and illustrated with their sources on pages 53–70.

What is distinctive about Dixon's work is its lack of bias. Most other systems are limited by their particular view of history: implicitly they state 'this is good' and 'this is bad' (or unimportant). Dixon's system simply says that a typeface exists, and can be described. Using a combination of the two key elements – sources and formal attributes – it presents a way of describing any typeface. The overview diagram helps to show how the history of type design represents a series of parallel developments rather than a cohesive story in gradual evolution.

additional

nineteenth-century

roman

handwritten

decorated/pictorial

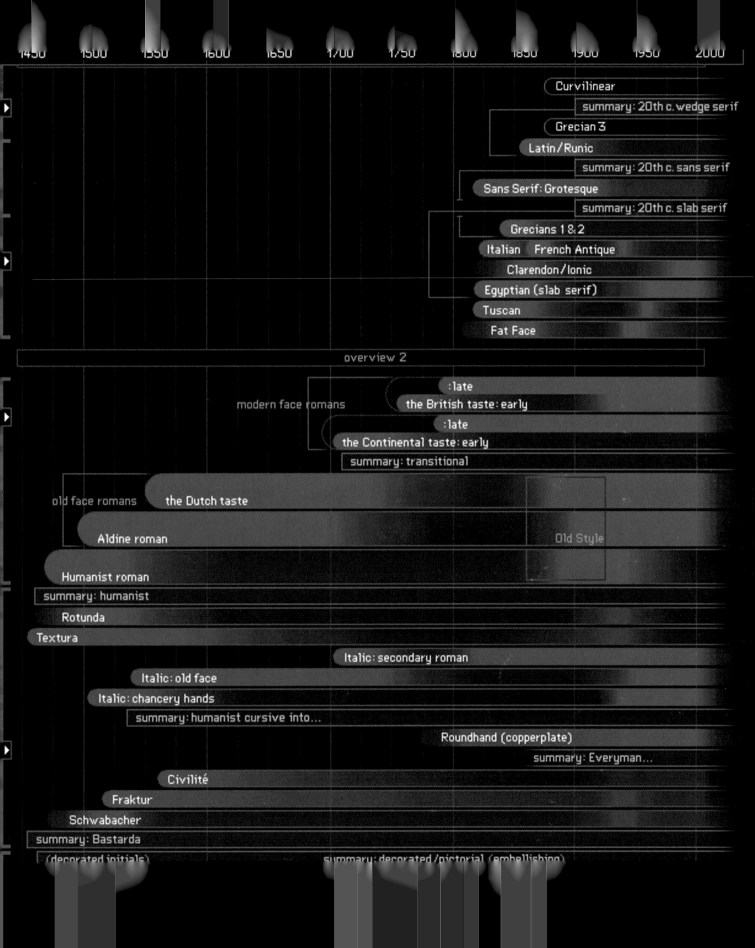

1450 1500 1550 1600 1650 1700 1750 1800 1850 1900 1950 2000

Curvilinear

summary: 20th c. wedge serif

Grecian 3

Latin/Runic

summary: 20th c. sans serif

Sans Serif: Grotesque

summary: 20th c. slab serif

Grecians 1 & 2

Italian French Antique

Clarendon/Ionic

Egyptian (slab serif)

Tuscan

Fat Face

overview 2

:late
the British taste: early

modern face romans

:late
the Continental taste: early

summary: transitional

old face romans the Dutch taste

Old Style

Aldine roman

Humanist roman

summary: humanist

Rotunda

Textura

Italic: secondary roman

Italic: old face

Italic: chancery hands

summary: humanist cursive into...

Roundhand (copperplate)

summary: Everyman...

Civilité

Fraktur

Schwabacher

summary: Bastarda

(decorated initials) summary: decorated/pictorial (embellishing)

Formal attributes

Specific terms are used to refer to the different elements of a typeface design. Before looking at typeface sources it is worth briefly examining these 'formal attributes'. They fall into eight categories.

- Construction
- Shape
- Proportions
- Modelling
- Weight
- Terminations
- Key characters
- Decoration

Construction

Each character in a typeface comprises a number of component parts. These are often referred to as 'strokes' – when the character shapes are derived from handwritten forms – or 'elements'. These component parts can be assembled or 'constructed' in a number of ways.

Continuous construction

O

Here there are no emphatic points of transition between strokes, or breaks between elements.

Broken or interrupted construction

Here there are emphatic points of transition between strokes or clear breaks between elements. Broken script (see page 53) is pen-derived while stencil letters are often adaptations of pre-existing designs (see also Decorated/pictorial sources, page 64).

b e DE

Letterforms can also be modular: made up from individual, separate elements or from a limited set of related elements.

Other approaches to construction

o e o

eg, sampled, random, amorphous

References to tools

eg, scissors, round pen (see also page 54), imitating industrial sources, *eg* typewriter

Reference to character sets

T ᏗᏝ

eg, capitals only, lower case only

Shape

The basic shapes embodied in the Latin alphabet, as it has evolved from the monumental inscriptions of the ancient Roman civilization, are curves and straight lines (see Roman sources, pages 55–60). The treatment of each of these components and possible variations in their shapes can be used as a starting point describing the component shapes of all type designs.

Variants to traditional forms

AMK

eg curving of normally straight lines, rounded corners, irregular character elements.

Treatment of curves

□ O O

eg angular (curves replaced by straight lines), broken or fractured curves, continuous

Aspect of curves

0 O O □

eg oval, round (circular), round/slightly square, square

Details of curves

P R C

eg exaggerated bowl treatments, bowls and stems not touching, jaws close-set

Upright stems

eg Edges parallel, convex, made with concave elements, irregular, flared

Other details

HHHH

eg Position of crossbars

Proportions

Proportion is used to describe basic letterform dimensions and use of space.

Width

While many typefaces are available in only one width, others have a family of wider and narrower variations. The most common variants are shown below.

HHH

condensed, medium (normal), expanded

Relative proportions: capitals

RDI

following the Roman square capital proportions

RDI

capital widths generally regular

RDI

capital widths regular *ie* monospaced

Relative internal proportions

Il Il

ascenders higher or equal to cap-height

large x-height

small x-height

Modelling

The visual character of a typeface is in part determined by the weight and variety of line used within the form.

Contrast

This describes the relative difference between the thickest and thinnest parts of a letterform

OOOO

none, medium, high, exaggerated

Axis of contrast (angle of stress)

This identifies where the thickest and thinnest parts of a letterform are positioned

OOOO

none, vertical, angled, horizontal

Transition

This describes the way the thick and thin parts of a letterform are related

OOOO

none, gradual, abrupt, instant

Weight

Attributes of weight describe the thickness of forms across an entire font of characters, governing its overall 'colour' or impact. The relative difference between thickness and thinness within individual characters is described under attributes of modelling.

Colour

Some typefaces are available in only a single weight and are described in terms of their 'colour'.

ELM

light in colour

Deo

medium in colour

DEO

black in colour

Weights within a family

Many types are available as families of heavier and lighter variations. For purpose of description, medium may be regarded as the 'normal' or 'regular' weight (although it can sometimes indicate an additional slightly heavier weight) with other weights being described in relationship to it. Because of this, such weights are not necessarily equivalent between different typefaces.

LMB
LMB

light, medium, bold

Terminations

This describes the variety of stroke terminals found within letterforms, where and how they have been applied.

Baseline terminals

Terminals derived from handwriting may take several forms: beak stroke, hooked stroke, oblique rectangular serif, slab serif.

Tapered serifs evolved from Roman inscriptional capitals and are known as 'roman' serifs. They may appear blunt and/or unrefined, sharp and refined, very sharp and refined, line serifs.

Other terminal variations include slab serifs, bracketed slab serifs, vestigial serifs, wedge serifs, flared terminals, tuscan (bifurcating) serifs or sans (meaning 'without') serif.

Ascender terminals

These may be handwriting-derived with a blunt top, handwriting-derived tapered serif, 'roman' with blunt serif, 'roman' with a sharp and refined serif. Other varieties match those of baseline serifs above. The style of these ascender terminals is generally repeated for x-height terminals.

Terminals: specific characters

Characters such as *c*, *e*, the ear of *r* and curve of *a* have distinctive terminals which are useful aids to describing and identifying typefaces.

Some basic varieties shown here are plain, tapered, blunt/sheared, softened teardrop lobe, fully-rounded

The upper terminals of *E*, *F*, and *T* and lower terminal of *E*, *F*, and *L* are also often distinctive. The main seriffed varieties are oblique, symmetrical and splayed, symmetrical and vertical.

Key characters

There are several characters whose treatment is significant in distinguishing one typeface from another. A basic selection is shown here.

single or double-storey

oblique or horizontal cross-bar

sitting on, or descending below the baseline

single or double-storey with open or closed tail

pointed, flat or concave apex

without spur, horizontal spur, vertical spur

sitting on, or descending below the baseline

short tail, tail dissecting bowl, long tail

straight leg, curved leg, curved leg with tail

Decoration

Decoration can be considered as a source (see pages 64–5) as well as an attribute for type design. Detailing as an attribute describes some of the common motifs and treatments used when detailing already existing letterforms.

inline

outline

shadow

cameo (reversed-out)

shaded

stencil

decorated or pictorial elements on surface of letter

Handwritten sources

'Scripts' or 'hands'?

The term 'script' is often used to describe different kinds of writing. It can be used more exclusively, however, to refer to very specific examples of written forms. To avoid confusion, within this book the term 'hand' denotes a handwritten form.

Type design can make reference to a handwritten source in one of two ways:

Explicit: where the activity of writing is directly translated into the construction and shape of the typeform. This can be indicated by a cursive construction, combined with attributes such as inclination, joining of strokes and distinctive pen-derived terminals.

Implicit: where there is evidence of the pen or another writing instrument in the final presentation of the letterform.

Speed and status, Latin and vernacular

Generally speaking, the more quickly written a hand, the lower its status. Hands ranged from sedate, largely non-cursive and formal varieties, through more simply constructed and semi-formal versions, to those that were very quickly written, usually cursive and informal.

Hands of different status became associated with different forms of language. Book production was initially confined to ecclesiastical scholarship and was always undertaken in Latin, the universal language of the Church. It was a highly prestigious activity, for which the most formal written hands were reserved. More informal hands were used for the documentation of everyday life and were written in the vernacular (national languages or regional dialects).

Early handwritten models for typefaces

Although quite different in appearance, early handwritten models for type share a common ancestor: the Carolingian minuscule. This first emerged in the 790s in the court scriptorium of the Emperor Charlemagne at Tours, in France, and became the official hand of the Holy Roman Empire. This hand evolved in various ways, two of which are particularly important here:

Broken script, a written hand particularly associated with northern Europe, whereby the broad-edged pen construction emphasizes the transition points between written strokes. This typically results in angular letterforms which appear broken or fractured. Strokes are densely packed, giving the page a heavy appearance. Chief among the many varieties of broken script are Textura, Rotunda and Bastarda (the latter including Schwabacher, Fraktur and Civilité).

The term 'broken script' – a direct translation of the German *gebrochene Schriften* – is used because it describes what is seen, and avoids the negative associations of terms such as blackletter or gothic.

Humanist hands, associated with the more southern areas of Europe, were intentional revivals of the earlier Carolingian models. Soon after printing reached Italy, they became in part the model for the earliest roman types (see pages 55 & 58).

Und er zeigt' mir dort eine feine Wiese im Garten zum Tanzen zugerichtet, da hingen eitel güldene Pfeifen, Pauken und feine silberne Armbrüste. Aber es war noch frühe, daß die Kinder noch nicht gegessen hatten. Darum konnte ich des Tanzes nicht erharren und sprach zu dem Mann: „Ach, lieber Herr, ich will flugs hingehen und das alles meinem lieben Söhnlein Hänschen schreiben, daß er ja fleißig bete und wohl lerne und fromm sei, auf daß er auch in diesen Garten komme; aber er hat eine Muhme Lene, die muß er mitbringen." Da sprach der Mann: „Es soll ja sein, gehe hin und schreibe ihm also."

Pattern: Broken script

Some of the varieties of broken script are shown **above**. From left to right, Textura, Rotunda, Schwabacher and Fraktur.

Because printing originated in Germany, the first typeforms were broken script (see also page 44). They continued to be used as an everyday type in Germany until well into the twentieth century. The calligrapher Rudolf Koch was Germany's dominant type designer during the early part of the century; this page (**left**) from his posthumously published 1936 New Year book shows broken script's dense rhythm.

Development of the italic

Italic is now a subdivision of roman type, but during the sixteenth century as many books were produced in italic as in roman.

The first italic type was produced for a series of small classic books from the press of Aldus Manutius in Venice in 1501. It was based upon a hand employed in the Papal Chancery for 'briefs' (letters), which was a quicker and more informal sloped humanistic script than that used for 'bulls' (edicts). The book shown **below** was printed by Manutius in 1502. Note how these first italics were lower-case only and used roman caps.

Throughout the seventeenth century, italic continued to be used independently, although after 1600 no roman typeface was cut without a companion italic.

With the Romains du Roi typeface of 1702, there was a deliberate attempt to make italic a secondary type which took on the formal characteristics of the roman. The type was cut for the Imprimerie Nationale (French royal printing office) by Philippe Grandjean following analysis of typeforms by the French Academy of Sciences and recommendations in the forms of engravings (**above left**).

In 1742, Pierre Simon Fournier was the first type founder to introduce serifs into the italic lower case where they replaced pen-derived terminal strokes (**above**). The process was continued by Firmin Didot, whose 1784 type is nearer to being an inclined roman than any previous cursive. Didot later reversed this style, giving up the serifs, and this became the model throughout the nineteenth century.

Twentieth-century italics vary considerably and there has been much debate about whether they should be sloped romans or cursive. With many there is an element of both.

Later handwritten sources: roundhand, informality, everyman ...

After the establishment of roman as the norm, the influence of handwriting on type design continued in other ways. Through the scribes it appears in the italic; while in the eighteenth century writing masters such as George Bickman and Thomas Cotterell developed the roundhand. In turn their work influenced type designers such as John Baskerville.

While established hands such as these continue to play a role today, the main tendency in recent years has been towards current and popular forms such as brush scripts and individual writing. In these type designs it can often be difficult to discern the exact tool – pen, brush or engraver; as with so many newer types, they are hybrids.

Pattern: Copperplate

Copperplate was popular with English engravers in the mid-eighteenth century and Charles Snell was one of its leading exponents. This detail is from his *Standard rules* of 1714. Snell Roundhand designed by Matthew Carter in 1973 is a revival of this style.

Errors in composition and distribution can easily be avoided, because each lowercase type shows on the shoulder the corresponding sign in clearly legible capitals.

Pattern: Informality and everyman

One of the most successful and popular examples of the informality of brush-drawn script being translated into the fixed, repetitive medium of type is Roger Excoffon's Mistral of 1953 (**above middle**). This has a true joining lower case and represented something of a technical achievement for metal type: it needed no kerns. This detail from a Fonderie Olive specimen shows how the type sat on its body.

Mistral's informality is still 'tutored', but some contemporary designs seek to imitate the untutored everyday hand. An example is Alessio Leonardi's Graffio of 1995 (**above**).

Roman sources

Types following this model combine inscriptional Roman square capitals with a lower case based upon the minuscules of the written humanist bookhand. The lower case also adopts attributes of the inscriptional capitals – notably the tapered serifs – to achieve harmony. Its line is refined and modelled, while its overall shape consists of continuous open curves with a round aspect.

Within type design, no other source has generated such a great quantity of typefaces. Apart from in some areas of northern Europe (which retained broken script), the bulk of typefaces produced between 1500 and 1800 followed this source. Stylistic progression was very gradual, and types fall into five main pattern groups: humanist roman; Aldine roman; Dutch taste roman; Continental taste modern and British taste modern. Text types still use this as a major source, albeit with some modifications.

Roman or roman?

In the context of typography, the word 'roman' is confusingly multifunctional: it has often been very loosely applied – used, for example, to indicate an upright letterform or one with serifs, as opposed to an italic or a sans serif. As used in this book, 'Roman' with an initial capital means 'of the Roman people', while 'roman' with a lower-case initial refers to a particular model followed within lettering and type design history.

Axis of contrast (angle of stress)

The main difference between the various roman patterns lies in the angle of stress which informs their underlying structure. Humanist and Aldine romans both show the angled axis of contrast derived from the humanist bookhand, while in the British and Continental taste romans the axis is vertical. See also Formal attributes: Modelling, page 51.

Pattern: Humanist roman
Humane (Vox); Humanist (BSI)

Typeforms influenced by the humanist hand, as practised in Padua, Italy, are considered the first 'roman' types. These types retain some slight references to their written origins – such as the sloping crossbar of the e – hence the term humanist roman.

The earliest example is the 1469 type of Johannes and Wendelin De Spira, but it was the Frenchman Nicholas Jenson who was to establish the permanent standard for this letterform. His 1470 type (**above top**) has a full system of serifs; there are no hook serifs; the h has a straightened leg; and the capitals, barring some modifications to the letters M and H, follow the typographic model of inscriptional capitals. It was still being directly copied as late as 1520, thereafter gradually losing ground to the roman of Aldus, for which it served as the direct precursor.

The style was virtually ignored until the late nineteenth century when William Morris, a key member of the Arts & Crafts movement in Britain, turned his attention to typography. Several notable revivals ensued, among them Morris's own Golden (1890), Thomas Cobden-Sanderson's Doves Press Roman (1891) and Bruce Rogers's Centaur (1915), shown **above** in drawings.

plies some sort of modular ments; since such relationshi the determination of dimens and vertical Anthony Froshaug, 'Typography is a grid' reprinted in Robin Kinross (ed.) A **type designer standing supre lar miracle to the envy of any watch him in the act of makir betical symbols do not disap vanish from notice as separat as whole printed words better**

Ward quoted in 'I am a communicator', 1970 ● **Typography result circulate in our common world is thus a completely social act**

ers, *notes on multiplied language*, 1994, p.19 ● **Sound as form** Tomato, lecture

tively as a means of engagin doubt sometimes infuriating t

ationship between such ele-
s two-dimensional, it implies
s which are both horizontal

haug, typography & texts, p.187 ● **If you want to see the**
performing his own particu-
her manual letterer, you must
his letters vanish. His alpha-
ear off the page, but they do
orms and present themselves
an any handmade letters do Beatrice
n material products. [...] They
nd must be so judged. Design
art of the social texture Robin Kinross, *Fellow read-*
The designs function decora-
amusing, persuading and no
reader, rather than as a vehicle

A setting in 'Monotype' Bembo where alphabetical
order has been sacrificed in favour of pattern

Pattern: Aldine roman
Garaldes (Vox, BSI); Old face

A generation after Jenson, in 1495, the great
Renaissance publisher and printer Aldus Manutius
published *De aetna* by the Italian scholar and
cardinal, Pietro Bembo, using a new set of types
cut by Francesco Griffo. The capitals from this work
were reused with an improved lower case four
years later for the printing of the *Hypnerotomachia
Poliphili*. Developed from the earlier humanist
romans, but with an improved balance of upper
and lower case and a straight-barred e, this face
became the model for type design for the next two
hundred years. The design was further refined in
France from 1540 onwards by Claude Garamond,
Jean Jannon and Robert Granjon. Garamond was
the first to market types rather than cutting them
purely for his own use.

The Aldine roman was interpreted according to
the Dutch taste and gradually lost ground to the
modern letterforms introduced in the eighteenth
century. It re-emerged during the nineteenth cen-
tury and became particularly popular at the start
of the twentieth century following the invention of
mechanical typesetting and the resultant interest
in 'reviving' historic typefaces. The typefaces
Bembo (shown **above** in a 1960s Monotype
specimen), Garamond, Granjon and Jannon, in
the forms we now use, all date from this period.
See also page 75 for revivals of Aldine types.

Pattern: Dutch taste
Garaldes (Vox, BSI); Old face

The typefaces that developed in France from the
1540s had an influence on Dutch printers. Towards
the end of the sixteenth century a more robust let-
ter – now seen as exemplifying the 'Dutch taste'
– started to appear in the work of the punchcutter
Hendrik van den Keere. This was followed by fonts
by others such as Cristoffel van Dijk, Nikolas Kis
and the brothers Bartholomaeus & Dirk Voskens,
who cut some of the finest typefaces of this kind.

These Dutch typefaces were in turn bought
by English printers, notably Dr Fell for Oxford
University Press. William Caslon I was the first
English printer and typefounder to satisfy the
home market, and his typefaces – the first of which
was issued in 1725 – followed these Dutch models.

Caslon's typefaces continued to be employed
for most of the eighteenth century (in 1776 they
were used by Benjamin Franklin to set the US
Declaration of Independence). The version shown
above is by Stephenson Blake, who became own-
ers of the Caslon Letter Foundry in 1937.

During the twentieth century the basic Dutch
model proved useful for several modified reinter-
pretations. Imprint (1911) and Plantin (1913) are
important early examples, but Times New Roman
(Stanley Morison, 1932) is by far the best known,
and arguably the most widely used typeface ever.

(Transitional and Modern)
Reales (Vox) and Didones (Vox, BSI)

The move away from an angled to a vertical axis of
contrast was started by the Romain du Roi at the
start of the eighteenth century (see next column).
The types of Pierre Simon Fournier, *c.*1750 (**above**),
are sometimes described as 'transitional' because
they combine features of both the old face (angled
axis) and the modern face (vertical axis) together.
In the detail above, the e has a distinctly angled
axis of contrast while the a shows far less evidence
of the pen, being more upright and 'designed'.

Pattern: Continental taste moderns

Above Philippe Grandjean's Romain du Roi of 1702 was the first roman typeface not to use the angled axis of contrast of previous romans (see Formal attributes: Modelling, page 51) and is an example of an early Continental taste modern. Based in part on analytical engravings (see italic story on page 54), its emphasis was firmly vertical although the transition from thick to thin is gradual. Note the l, i and d with two top serifs and the spur on the stem of the l.

The later Continental modern face has hairline strokes, vertical shading and abrupt stroke contrast. Its first appearance was in typefaces by Firmin Didot, c.1784; it was subsequently developed as a pattern by Didot himself, by Giambattista Bodoni in 1798 and by Justus Eric Walbaum, c.1800. Their types appear 'designed' rather than 'drawn' and their abrupt vertical stress makes them difficult to read in any quantity without the use of generous leading. They demanded exacting presswork and high quality paper to achieve the desired effect. The detail **above right** shows something of Bodoni's austere typography.

Of this pattern, revivals of Bodoni are by far the most common, but many ignore the subtleties of his originals. Among the best is Bauer Bodoni which dates from 1929 and is shown **right** in a detail from a poster designed in 1995.

Pattern: British taste moderns

In Britain, John Baskerville was the first printer to modify the old face roman. As a writing master, he brought new influences – such as the British roundhand – to the types he produced.

The modern face roman, as represented by British taste, shares the same influences of vertical shading and fine line as the Continental; but whereas the Continental forms favour a rational, sometimes mathematical approach, their British counterparts always follow a modelled and altogether more fluid written line. The serifs, while eventually flattening out, remain bracketed. Baskerville's generous use of space and lack of ornament was frowned upon in Britain during his lifetime, but was highly influential on the Continent. His model was followed by the typefaces of Richard Austin (for Dr Fry, of Fry's chocolate fame) in 1769, and William Martin (for William Bulmer) in 1790. Shown **above** is Monotype's hot metal Baskerville in a design by Catherine Dixon.

Nineteenth-century vernacular sources

Above The English vernacular in architectural form: examples cast in stucco in Louth (Lincolnshire) and London. The English vernacular proved popular across a wide variety of media, remaining remarkably coherent in form. As a typeface, however, it was not so widely used, and had all but disappeared from type books by 1815.

GHIJKLMNOPQ

ijklmnopqrstuvwx

GHIJKLMNOPQ

hijklmnopqrstuvwxy

890 .,:;!?''-(⌐—)

24 point. Display also available in 14, 18, 30 (

The later British pattern for the modern face was established by John Bell with his type of 1788. This shows the influence of Didot (see preceding page) and yet with its delicate cut, bracketing of serifs, not quite vertical shading and smoother transition, it stops short of the Continental taste. It is often referred to as the first British modern face, but Baskerville, too, clearly shows the same tendencies, albeit in a less fully realized form. Bell was the first design to have lining numerals, although they are considerably less than cap height (the norm today is to have them the same).

The story of roman typefaces is one of continuous development and refinement, from the time of their introduction in the late fifteenth century to the appearance of the modern letter. During the nineteenth century, industrialization had a profound effect on society and created new and diverse uses for type. To meet the needs of ephemeral commercial printing, new kinds of letterforms appeared. These were often in large sizes for display use, and were based on particular regional interpretations rather than those of the roman text faces.

Such variation has led to its identification as a separate source. As with the modern roman, there were two regional variations of the roman letter: English and Continental.

English vernacular

If the key to identifying a roman letter is its refinement of line and its classical proportions, the nineteenth-century English vernacular is remarkable, by contrast, for its vigorous character and the regularity and squareness of its proportions – as exemplified in a distinctive E with upper and lower arms of equal length. Stems and axes of contrast are uniformly vertical. The resultant letters are not harsh and mechanical, however; rather, they represent more robust versions of the British modern face, retaining a softness and roundness in their forms. The contrast in stroke widths remains subtle, and serifs are bracketed fully.

Continental vernacular

The Continental equivalent of this form shares the robust regularity of its English relative. However, the modelling is more restrained, resulting in strong, even lines. The proportions, although still regular, are not square, the letters being either slightly condensed or slightly expanded.

Success and legacy

The underlying sturdiness of these vernacular forms provided a firm foundation for type designers to play with. They explored the capacity for exaggeration of attributes such as modelling, weight, proportion and terminal construction. The results of these experiments form the patterns discussed on the following pages. These patterns are far less rigorously determined than those of the roman model, and encompass a far wider range.

During the first half of the nineteenth century the English vernacular was the basis upon which ornamental letters were constructed; but from the 1860s the Continental source increased in importance. There ensued a breakdown in the mutual exclusivity of sources, as influences from other areas became absorbed into type design and began to be combined with the vernacular source.

Ma

Above A 'fat face' can be seen as an exaggerated English vernacular letter with hairline thins, serifs without bracketing and whose terminal stroke endings have been cut abruptly. The first (shadowed) fat face was from the Bower & Bacon foundry, London, in 1809.

Opposite Nineteenth-century advertising typography, in stark contrast to book design, featured all the display types at a printer's disposal. Moderns, fat faces, Tuscans and Egyptians are all combined on this Hereford printer's work from 1831.

THEATRE, HEREFORD.

Second Assize Night,

BY DESIRE AND UNDER THE IMMEDIATE PATRONAGE OF

J. Arkwright, Esq

HIGH SHERIFF.

And Third Night of Mr.

MEADOWS,

Of the Theatre Royal, Covent Garden,

Who will appear in Two of his favourite Characters.

On Thursday, August 4th, 1831,

Will be presented Sheridan's Comedy of—The

SCHOOL
FOR
SCANDAL.x

The Part of Sir Peter Teazle, by Mr. MEADOWS,

Sir Oliver Surface	Mr. GRANBY.
Sir Benjamin Backbite	Mr. HANCE.
Joseph Surface	Mr. HASTINGS.
Charles Surface	Mr. SAUNDERS.
Mr. Crabtree	Mr. GILL
Rowley	Mr. CLIFFORD.
Careless	Mr. EDWARDS.
Trip	Mr. STANHOPE.
Moses	Mr. M·GIBBON.
Lady Teazle	Mrs. RIGNOLD,

To conclude with the laughable Farce of—The

SLEEP
WALKER

Pattern: Tuscan

The history of this letterform goes back far longer than that of type, appearing in inscriptional letters cut by Filocalus for Pope Damasus I in the fourth century (**this column, top**). Its main characteristic is that the points of the serif are extended and curled, usually bifurcating or even trifurcating the stem.

Tuscans were first cut as type by Vincent Figgins around 1817 (4-lines Pica Ornamented no. 2). Later in the century they tended to acquire a bulge in the middle of the stem. They were enormously popular with the Victorians, being produced in a wide variety of sizes in many decorative styles. A typical late nineteenth-century use is shown **above**: gilded and painted on the reverse of glass for advertising purposes.

Pattern: Egyptian (slab serif)
Mecanes (Vox); Slab serif (BSI); Antique/Mechanistic

The first slab serif types – a 5-line Pica Antique (u/c) by Figgins, *c.*1817, or the lower-case types from both Caslon and Figgins of 1821 – are comparatively monoline and light in weight, and in their general proportions resemble early architectural examples. Other varieties soon appeared, including italics, reversed faces (cameo) and open faces, as well as examples showing more pronounced differences between thick and thins. These were followed by condensed, expanded and elongated forms, lightweight Egyptians and many of the previous inventions used in combination.

The example **above** (part of the theatre bill also seen on the previous page) shows a bold weight Egyptian in both upper- and lower-case forms, as well as a cameo (white out of black) version.

Egizio
Bold
Redonda negra

Bias

308-20-72

Engl., A 3, a 3 - 1-3 - lb. 28 1/4
Esp., A 3, a 5 - Kg. 12,70

Mesa

308-20-60

Engl., A 3, a 4 - 1-3 - lb. 19 7/8
Esp., A 4, a 5 - Kg. 10.00

Drank

308-20-48

Engl., A 3, a 4 - 1-3 - lb. 13 1/4
Esp., A 4, a 6 - Kg. 7,40

Pattern: Clarendon/Ionic
Mecanes (Vox); Slab serif (BSI)

Clarendons can be defined as Egyptians with bracketed slab serifs and a clear differentiation between thicks and thins. Ionic is a name sometimes given to the lighter Clarendons, typically used for setting newspapers.

It is not clear whether Clarendons are derived from the poster-sized roman types with blunted serifs or – like Egyptians – from architectural usage, several examples of which apparently predate its emergence as a typeface. An inscription on the Waterloo Bridge at Betws-y-Coed in Wales, 1815 (**above**), is the most famous of these.

The first typeface to be registered as a Clarendon was Robert Besley's design of 1845 – a slightly compressed form – but this was not the first type in the Clarendon pattern. This distinction goes to Figgins's Shaded of 1815/17, followed by Blake & Stevens's outline type of 1832.

The significance of the Besley letter and its imitations lies in the relationship between them and roman types. Used in combination with ordinary (modern) roman booktypes, Clarendon provided a bold weight to give emphasis.

Egizio (**left**) is a 1955 revival by Aldo Novarese for Nebiolo. It was itself revived by David Berlow in 1987, as Belizio.

Pattern: Italian/French antique

Exhibiting playful perversity, these are slab serif types with a horizontal stress in modelling. In Britain they date from 1821. Because of usage, they are often associated with the 'circus' or the 'wild west'. Some of these nineteenth-century types were revived in the 1950s, with Robert Harling's Playbill (**above**) being the best known.

Pattern: Grecian 1 and 2

Among the varieties of semi-ornamental letters invented in the 1840s was Grecian. Based on the simple idea of removing the corner from a letter, there were two very distinct designs.

Grecian 1 was the larger of the two designs. Derived from the compressed Egyptian, it is a cramped and angular letter. Acropolis (*EN* **right, below**) is a recent reworking by Jonathan Hoefler, part of a larger series of nineteenth-century revivals known as the Proteus Project.

Grecian 2 is lighter and smaller, a sans-serif type with the curves broken into points and the connecting lines converted into curves. It is an outline face, sometimes decorated and always slightly shadowed.

Pattern: Latin & runic

In Britain, types with basically triangular serifs appeared from the 1840s onwards. On early versions the serifs have a concave aspect, sometimes distinguished as runic, with the clearly triangular seriffed types being latin. The underlying proportion is generally slightly condensed or slightly expanded and shows little contrast.

Jonathan Hoefler's Proteus Project includes a latin (*IE* **right**), called Saracen.

My imitation of you

CASLON

Pattern: Sans serif; grotesque

Lineales (Vox);
also: sans surryph/sans-serif/
sanserif/Egyptian/gothic (US)/Doric

Like the Tuscan, the sans serif has its origin in Greek and Roman times (see pages 38–41) and an interest in antiquity from architects and collectors in the late seventeenth century reawakened interest in the form.

The first sans-serif typeface was Caslon's so-called Egyptian of 1816 – a clumsy, unbalanced set of capitals probably intended for headings and emphasis only (**left, above**). Lower case arrived in 1835 with a face from William Thorowgood, as did the name 'grotesque' (usually shortened to 'grot').

The typical form is heavy with a contrast of thick and thin to accommodate the weight; the capitals are of even width. The curves are squarish and the jaws of letters such as C are often curled inwards.

At this time the idea of typeface families had yet to emerge: founders produced related designs of different weights, often identified by number only. Each was detailed individually but shared the same aesthetic. In Britain, Stephenson Blake's Grotesque series (no.9 shown **above** in a 1977 work by artist David Troostwyk) typifies the approach.

EN IE

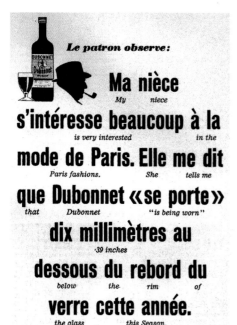

Decorated/pictorial sources

Between book & the vernacular

There is a long heritage of decorated letters... the carpet pages of the Gospels of Kells... tance, are all developed to the extent where... richness and detail of the overall design...

More recently, these late-nineteenth-century forms have been revived by David Berlow as the Bureau Grotesques series; nos 79 and 17 are shown **above, top** from the digital type magazine *Fuse* 4.

Despite the many twentieth-century variations and refinements of the form discussed in more detail on pages 66–7, designers keep returning to these original versions because of their blackness and vigour, and the contrast they can give to other faces. Shown **above** is a press advertisement from *Queen* magazine, 1962.

Medieval scribes established a tradition of using decorative initials within a manuscript to 'illuminate' the text. In the formative years of printing this tradition continued, with ornamental type being used for initials and display work. These decorative typefaces differed from main text type in two ways. Firstly, in terms of size: while text type was small, ornamental type was larger. Secondly, in terms of origins: while the 'plain letters' used for the text were based on handwritten and roman sources, 'ornamental letters' stood apart from these typographic traditions – either as a result of embellishing or, later, 'encompassing' (see **opposite**).

It should be noted that perceptions of ornamental typefaces have not remained constant. In the nineteenth and early twentieth centuries sans serif types were seen as modified variants of the 'plain' vernacular letter; used for display purposes, they were termed 'semi-ornamental'. Today, however, they are fully accepted by most users as everyday plain types (with many younger designers dismissing the practical virtues of serifs as ornament).

Embellishing

When an existing, identifiable letterform has been modified by applying a decorative treatment, it is usually referred to as 'embellished'.

At first such typefaces were only used singly; the first known example used in running text is Union Pearl, from the English Grover Foundry (*c*.1690). Embellished types came into vogue some 60 years later when Fournier cut his first decorated types: two Ms, designed as initial letters, are shown **above left**. The influence of Fournier's decorated types spread across Europe as they were copied by other foundries.

Nineteenth-century type design was characterized by the invention of new kinds of typeface (see pages 60–4) and an exploration of decorative ideas. Starting with simple effects such as inlines and shadows, patterns and pictures were introduced onto the face of the letter and three-dimensional effects explored. The most complicated of these letters – such as the R shown **above** (Wood & Sharwood's 14-line Ornamented no.1) – originated not as punches (see Chapter IV) but as wood engravings.

Complexity is not essential, however. Simple embellishment using pictorial elements is shown by two twentieth-century examples. **Right, above** is one of Eric Gill's engraved initials for *The four gospels*, published in 1931, and **below** is part of an alphabet drawn by the Spanish artist Joan Enric Garcia-Junceda (1881–1948).

New means of embellishing letterforms are continually being introduced. Trixie (1991), by Eric Van Blokland, is based on the manual typewriter face and is supplied with an optional sound facility for full effect.

Fleurons and dingbats

'Fleurons' is the generic name given to non-alphabetic decorative material. These predate printing: they originally derived from the flourishes of the bookbinder. Shown **above** are some examples available from H W Caslon & Co in 1924.

Today, such decorative material is usually derived from individual pictorial elements rather than units used in combinations to create a pattern; these individual elements are often called 'dingbats'.

Encompassing

When the letterform itself is decorative/pictorial, and is not derived from an existing letterform, it can be described as 'encompassing'.

Early examples include Figgins's Rustics of *c*.1845, whose letters appear to be constructed out of branches. Other nineteenth-century encompassing decorative treatments included the contortion of identifiable objects into character shapes – a trend that continues to the present day.

Miles Newlyn's Missionary, 1991, sketches for which are shown **above,** is constructed of fine lines with leaf-like terminals. The quality of line is reminiscent of copperplate engraving. A drawing by John Watson (**right**) used as an initial letter in the book *Bound image* (1988) is part of a rich tradition of figures contorted to create letterforms.

The theme of *Fuse 4* (1992) was 'exuberance'. Rick Valicenti's type started as 'automatic drawings' which were scanned into Fontographer and made into a font with the minimum of 'tidying up'. An alternative letter e is shown **right**.

Detailing today is as much about what can be taken away from a letterform as what can be added – and as such it has become increasingly impossible to distinguish the 'plain' from the 'ornamental'. Caustic Biomorph (**right**) by Barry Deck, also created for *Fuse 4*, was 'inspired by decay and garbage'.

Additional sources

The diversity of sources and ideas used today, and their wide range of potential combinations, can make it difficult to identify clear patterns. There is enormous diversity, too, in the uses to which types are put. When type was produced exclusively by publishers such as Manutius or printers such as Baskerville, and was 'controlled' by the producers, it spoke with one voice. Today, while a designer may have clear ideas about a type's intended use, once it is on the market anything can happen.

The following pages chart the development of the sans serif – a form that rose to prominence in the mid-twentieth century and has remained popular into the twenty-first – and indicate some of the new starting points used by today's type designers.

72 Point Ludlow 6-F Franklin Gothic

Length of lower-case alphabet: 1042 points

Development of the sans serif
1 Grotesques and Neo-grotesques

In 1898, Berthold's Akzidenz (meaning 'jobbing') Grotesk, shown **above** in a 1960s specimen, refined the sans-serif pattern and created what became the prevalent twentieth-century form. Sometimes referred to as neo-grotesque, the difference between this and the examples shown on page 63 is startling: gone are the regularity of capital width, the variation of stem width and the double-storey g. This is an apparently monoline letter with few quirks.

In the US at around the same time, refinement of the grotesque pattern was also taking place. 'Gothics' with a variety of prefixes appeared: Alternate (1903), Franklin (1903, by Morris Fuller Benton, **left**), News (1908) and Record (1927) are some examples. These American versions are not as monoline as Akzidenz, and almost all retain the double-storey g.

All these faces, with their many weights and width variations, mark the beginnings of the large, carefully rationalized type families of today.

Following World War II the grotesque pattern was again the focus of type designers' activities. The Haas foundry in Switzerland based a new typeface on Akzidenz. Neue Haas Grotesk (Max Miedinger, 1957) was renamed Helvetica when taken over by the German foundry Stempel in 1960. Following careful targetting of leading German multinational companies in the 1960s and its availability on American composing equipment at the same time, it has become the ubiquitous corporate typeface. Its clean lines and apparently 'neutral' feel have also endeared it to artists. Shown **right** is a text work, *Meeting #13* by Jonathan Monk.

ARE YOU AWARE OF THE N.U.R. PROVIDENT FUND BENEFITS?
FOR SO SMALL A CONTRIBUTION!

DEATH AND ORPHAN FUND

Benefits:—
At death of member £5.
Children (under 15 years of age):
9s. per week for first child and
5s. per week for each other child.

Contribution:—Id. per week.

DISABLEMENT FUND

Benefits:—
If permanently incapacitated by accident at work £20.
If retired by reason of age or ill-health after 60 years of age,
between £20 and £30.

Contribution:—
2d. per week under age 29.
2½d. per week age 29 and over.

ACCIDENT FUND

Benefits:—
If injured at work:—
After 6 months' membership 8s. per week for 10 weeks.
After 12 months' membership 16s. per week for 10 weeks
and 8s. per week for further 10 weeks.
If fatally injured at work:—
After 1 year's membership £7 10s. 0d.
After 5 years' membership £15.

Contribution:—Id. per week.

SICK FUND

Benefits:—
12s. per week for 20 weeks.
7s. 6d. per week for 20 weeks and 2s. 6d. per week for
remainder of illness.
£5 at Death, or on retirement at normal retiring age.

Contribution:—Between 4d. and 11d. per week according to age

ASK YOUR BRANCH SECRETARY OR COLLECTOR FOR ANY ADDITIONAL INFORMATION

Univers, by Adrian Frutiger for Deberny & Peignot, although designed two years before Helvetica, never attained the same popularity despite being designed as a comprehensive family of 21 fully related weights. The diagram **above** shows how optical, rather than mechanical, rules govern its construction.

2 Roman

Edward Johnston taught calligraphy at the Central School of Arts & Crafts in London. His knowledge of handwritten letterforms shaped his famous design for the London Underground typeface of 1916. Its fusion of sans-serif and roman patterns was a complete break with contemporary practice. Shown **above** in its 1930s form, it was modified by Banks & Miles in 1980 and is still in use today.

Eric Gill, Johnston's pupil, had worked with him on the London Underground type. His own Gill Sans of 1927–30 uses the same sources but is different in its details because it was designed for mechanized typesetting, not signage. **Above** is a 1949 edition of one of his books.

Gill Sans became in Britain what Akzidenz was to Germany and Franklin Gothic to the US, the ubiquitous national everyday typeface. The union book (**top**) dates from 1961.

3 Geometry

Designers and artists have long been fascinated by geometry. In the fifteenth century Albrecht Dürer and Gian Francesco Cresci tried to rationalize letterforms in accordance with geometric principles, and this detail (**left**), from a lettering copybook, dates from the sixteenth century. It was not until the twentieth century, however, that geometry began to influence type in a direct way.

Above Geometry was used by Edward Wright for his architectural lettering for the Metropolitan Police headquarters building in London in 1967. This detail is from the constructional drawing provided to the architects.

Left Related in part to Bauhaus ideas, geometry was the basis for Paul Renner's Futura of 1927–9 (shown in a specimen from *c*.1960). A close inspection reveals that it is not constructed mechanically but with careful adjustments to make it appear both monoline and geometric.

Above Geometry also provides an easy entry point when first tackling type design. The basic elements of line, diagonal and circle can be combined somewhat irrationally, as seen here in Mr Keedy's Sans (**top**) of 1991 or Zuzana Licko's Variex (**above**) of 1988.

Continuing the roman form

Aside from the sans serif, the twentieth century's other major preoccupation was the revival of historical faces. This has tended to obscure the fact that many fine contemporary roman types continue to be designed. One example is Gerard Unger's Swift from 1985, used to set the main text of this book. Others include Charter (Matthew Carter, 1987); Scala (Martin Majoor, 1991); Quadraat (Fred Smeijers, 1992) and Eureka (Peter Bilak, 1997).

Other sources

The vernacular continues to exert considerable influence, but in a different way from the nineteenth century when it was very much concerned with local traditions. Type design has now become global and its use is not restricted to 'professional designers'.

'Non-design' elements, outside print, and those generated by specific tools or machines, are nowadays readily taken into type. Dynamoe (**top right**) copies the punched self-adhesive strips of the Dymo labelling machine. Signage and environmental lettering do much the same. Platelet, 1993 (**second from top**), by Connor Mangat, is a decorative response to the restrictions of American licence-plate lettering.

While revivals have been an accepted part of type design for more than a century, recent trends have been towards combining several different sources – rather like sampling in music. Prototype, 1989 (**second from bottom**), by Jonathan Barnbrook, combines upper- and lower-case elements from up to six typefaces.

Theories and strategies from other disciplines also influence character construction. Neville Brody's *Fuse* project, begun in 1990, takes a different theme for each issue and asks four designers to respond. Gerard Unger's 'd'coder' (**bottom**) is from *Fuse 2*, 'Runes'.

CHOREOGRAPHY: WAYNE McGREGOR

The impact of technology

Technological constraints have been a key feature of many typefaces produced in the twentieth century and into the twenty-first, due not least to the many differing technologies involved in their manufacture. The three types used in the exhibition title shown **below** demonstrate differing responses to specific problems.

'**fur**' is set in Bitstream Charter, designed by Matthew Carter in 1986 when computer memory was a critical issue. In order to make a smaller font file there are no extraneous curves. Serifs and trailing edges of curves are all straight lines.

'**flex**' is set in Praxis by Gerard Unger, designed in 1977 for use on CRT typesetting equipment (see Chapter IV). Rather than trying to counter the equipment's tendency to round off sharp corners, Unger exaggerated this rounded quality.

'**NI**' is set in Bell Centennial Bold Listing, designed by Matthew Carter in 1978 for the Bell Telephone Company's directories. Types used for printing onto newsprint on very high-speed web presses need to have carefully opened-out counters and ink traps at junctions.

When used at the sizes for which these types were originally designed, these features would remain unnoticed. Seen large as here, however, their individual visual qualities are celebrated.

God is with us: hear ye people, even to the uttermost end of the earth.
Hear ye people, even to the uttermost end of the earth.
Hear ye people, even to the uttermost end of the earth. The people that walked in darkness have seen a great light.
The people that dwell in the shadow of death, upon them the light has shined.
For unto us a child is born! [God is with us]
For unto us a son is given!
And the government shall be upon his shoulder; and his name shall be called

WONDERFUL COUNSELLOR! *[God is with us]*
THE MIGHTY GOD, THE EVERLASTING
FATHER, THE PRINCE OF PEACE. Hear ye people, even to the uttermost end of the earth. CHRIST IS BORN!
Hear ye people, even to the uttermost end of the earth.
Hear ye people, even to the uttermost end of the earth. God is with us:
CHRIST IS BORN! CHRIST IS BORN!

Best wishes for Christmas 1996 from Phil, Jackie, Beth & Felicity Baines, Lowfield, 498 King's Road, Willesden Green, London NW10 2BP. Arrangement of text a [second] response to *God is with us* (a Christmas proclamation) by John Tavener (VC 5 45035 2). Set in Argo by Gerard Unger and SOPHIA by Matthew Carter. Printed by Collins & Walterstow Ltd.

Lettering before type

Today, there is a typeface to represent virtually every style of lettering or writing that has ever existed. In terms of description, forms referencing such sources can always be qualified by another term – rustic, half-uncial, etc. – as appropriate.

Two examples, and approaches, are shown here. The card **above** features emphasized text set in Sophia. Designed in 1993 by Matthew Carter, Sophia is based on a hybrid alphabet of capitals, uncials and Greek characters from sixth-century Constantinople. It is used here to reflect the Christian subject matter. Lithos (1990), by Carol Twombly, is also based on Greek lettering. It has been used on this ice-cream wrapper, **right**, for its visual qualities alone rather than any historical references it may have.

Manufacture & design IV

Type is not lettering

Lettering implies the use of the hand and a tool such as a chisel, pen or brush. More recently it might also involve the use of computer software. What distinguishes it from type is that it is the creation of letters that – regardless of whether they are designed for reproduction – are essentially 'special' and made for a specific purpose only. Type, however, was from the outset designed for duplication. Its units (individual letters) could be assembled to set a message, disassembled and reused to set other messages. These requirements – ease of assembly and disassembly – are what made printing from movable metal type so important an invention, and have to a degree influenced the appearance and manufacture of typefaces ever since.

In terms of their fundamental principle of modularity, there is no difference between the latest digital fonts and the metal typefaces cut by Gutenberg around 1450. Digital type shares two of the three dimensions of its metal predecessor. Because many of the typefaces we encounter in our daily lives were not originally designed for current typesetting systems, a knowledge of certain aspects of their design and manufacture can help us appreciate the skills of their designers, and can provide lessons about the disciplines that are still pertinent today.

Metal type

Below In metal type, two of the three dimensions were fixed – the body or point size, and the height to paper (type height). The third dimension, character width, varied from letter to letter and while it was possible to allow part of a character to overhang the sides of the body (a kern, see the letter f in the type **opposite below**) all ascenders, descenders, accents etc. had to fall within the point size.

The em square and digital type

Right The em continues to be used as a basis for the construction of digital type. In PostScript the em square measures 1,000 × 1,000 units (in TrueType it is 2,048 × 2,048 units). When the typeface is made and used, the 1,000-unit height becomes the point size, while the character width (or 'advance width') is defined by the type designer. The rectangular area occupied by the character is sometimes referred to as the 'body' – a hangover from the days of metal type – and the space between the character and edge of the body is known as the 'sidebearing'.

 Below In digital type it is possible to allow ascenders, descenders, accents etc. to exceed the point size and there are many typefaces which take advantage of this fact.

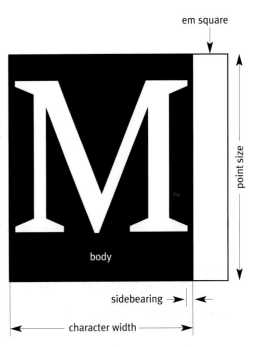

As with metal type, the 'kern' is the part of a character that overhangs its body:

and certain character combinations overlap unpleasantly:

for these, 'ligatures' (combined characters) exist:

Bottom A square the same size as the point size was known as an 'em' (or 'mutton' in slang) and was used for spacing. Other spaces were derived from this; the 'en' (or 'nut') being half as wide; a 'thick' one-third; a 'mid' one-quarter; and a 'thin' one-fifth. Other larger spaces – known as quads – were used to space out lines. Because quads were multiples of an em, and because metal type was only produced in set sizes – 9, 12, 18, 24pt etc. – there was a relationship between spaces of different point sizes. These pages from *Typographic norms* by Anthony Froshaug demonstrate that relationship visually.

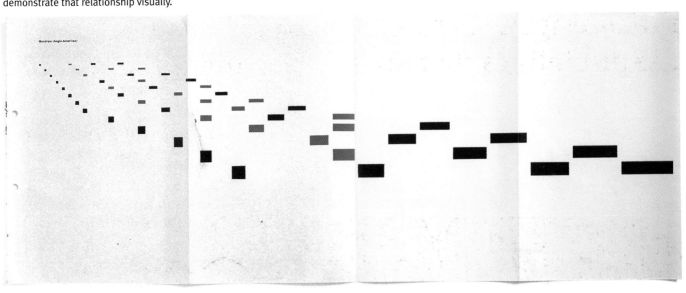

A punch, strike and a matrix used in metal type manufacture. The process involves an alternation of right- and wrong-reading of the letter: Punch, wrong-reading; matrix, right-reading; metal type, wrong-reading, printed page, right-reading.

One of the surviving punches cut by John Handy for John Baskerville in the eighteenth century.

Originally two cases were used for storing metal type: the top one for the capital letters and the one below for the small letters. The terms upper case and lower case are derived from this.

Hand punchcutting and movable metal type

While it is known that the methods of producing movable metal type invented by Gutenberg around 1450 drew on those of the metalworking trades, his precise methods are the subject of much current research. By 1470, however, punchcutting, as described below, was certainly established and remained the basis for all type production for more than 300 years.

The process began with the cutting of the design (in reverse) on the end of a steel bar called a punch. One punch was needed for every character of a typeface, at every required size. Several different tools were used: the outsides of characters were usually shaped with files or gravers, while counters were formed by using a counterpunch or were dug out. As the cutting of the shape progressed, it could be tested by blackening the image with soot from a candle flame and making a print, known as a 'smoke proof'. It was possible for skilled punchcutters to cut as many as four punches a day – though some letters are easier to cut than others. Despite having to work at the actual size of the punch, punchcutters could create typefaces as small as $3\frac{1}{2}$pt thanks to the precision afforded by working in steel.

Once complete the punch was hardened, driven into a copper blank (known as a strike) and filed on all sides (a process known as 'justification') to define its character width and alignment. The result was known as a matrix. This was placed into a mould, and the character cast. The mould was fixed in two dimensions – body depth (known as 'point size') and height to paper (type height) – but adjustable in the third: that of character width. Type was cast from an alloy of lead, tin and antimony: it had a relatively low melting point but allowed rapid and undistorted solidification. Once cast, the characters were distributed to cases ready for use.

In the early years of printing history, known as the 'incunabula' period (1450–1500), the trades of punchcutting, printing and publishing all operated under the same roof. As time went on, however, they began to separate. The man who cut the punches was known as a punchcutter, and was often the designer as well. Claude Garamond, William Caslon I, Pierre Simon Fournier and Giambattista Bodoni were all of this kind. Other punchcutters worked as directed, sometimes for one man or a company, sometimes as freelancers. Examples include Francesco Griffo working for Aldus Manutius; John Handy for John Baskerville; and in the twentieth century, Charles Malin worked for Hans Mardersteig among others.

Claude Garamond was the first to turn punchcutting into a commercial enterprise in its own right and to sell punches and strikes to other printers. Once type became a commodity in this way, the limitations of printers each using their own type sizes became apparent, and the complicated story of the development of the various point systems began to unfold (see opposite).

From the incredible variety of types produced by this method over a period of nearly five hundred years, it is clear that the manufacturing process did not restrict creativity and invention on the part of the punchcutter. The only real constraint was that of the printing process. Metal type was printed by impression (literally 'letterpress'), originally onto dampened paper; the resultant 'ink squash' from the type became part of the printed image. A skilled punchcutter would take this into account and cut slightly lighter types to compensate. One of

Reviving historic types

Because of vastly different type making as well as printing needs, revivals of historic typefaces can only ever be interpretations.

On the **right, below** is an enlargement of type cut by Francesco Griffo for *De aetna* by Cardinal Pietro Bembo, published by Aldus Manutius in Venice in 1495. Manutius was a printer and publisher, his pressmark is shown on the **right**.

Below are three currently available interpretations of Aldine type. On the **left** is Poliphilus, based on the type used in the 1495 edition of Francesco Colonna's *Hypnerotomachia Poliphili*. Produced by Monotype in 1923 it could be described as a facsimile in that it includes the imperfections of the printed original in its design. Bembo (**centre**), is a revival of the *De aetna* type which smoothes out such irregularities, it was produced by Monotype in 1929. On the **right** is Dante, a revival by Hans Mardersteig and hand punchcut for him by Charles Malin in 1954. It was later adapted by Monotype for hot-metal composition and now exists in a digital version by them and another from Officina Bodoni.

dadada

the reasons for the apparent inconsistencies between different typefaces bearing the same name is that they are based on different pages or copies of the same book showing a variation in inking. The contemporary designer seeking to revive a historic type cannot therefore slavishly copy; he or she has to make a number of judgements based on the historical evidence and the intended usage or market.

Another aspect that needed to be addressed by the type-cutting process was an optical one: design characteristics can look very different when the type is rendered at different sizes. It remains a problem to this day, but with hand-cut types, it was possible to make such optical corrections since every size needed its own set of punches. Generally large sizes might have a greater contrast of thicks and thins and be slightly narrower; smaller sizes would have less contrast, be wider and perhaps have a larger x-height.

What are points and how do we measure type?

Because metal type consists of physical elements which must be assembled rather like bricks, it made sense to measure the body on which the character was cast rather than the character itself. The idea that the different body sizes should relate in a logical way to one another was first noted by the printer Joseph Moxon in his *Mechanick exercises* of 1683.

The first real attempt to systematize body sizes was by Jean Truchet of the French Royal Academy of Sciences in 1695. A duodecimal system, it was based on the terminology and divisions (but not the dimensions) of the French 'foot' (*pied du roi*), and although used by the Imprimerie Nationale (Royal Printing Office) was not published as a national standard. It was copied by Pierre Simon Fournier in 1737 and popularized as his own. Although Fournier's system was quickly adopted throughout France and the Netherlands, it was replaced in 1783 by François-Ambroise Didot's revised version, which related sizes more directly to contemporary (French imperial) measures.

Like Fournier, Didot called his smallest units 'points', and used them to describe type sizes. Twelve points was known as a 'cicero': being more manageable for the measurement of larger dimensions, these were used to measure line lengths. The Didot system was adopted throughout mainland Europe despite the legal status given to the (decimal) metric system in France in 1801 and the 'Didot millimétrique' system devised by Firmin Didot (François-Ambroise's son) in 1812–15.

Britain and North America were slow to recognize the need for standardization and the range of type sizes offered were known only by names until well into the nineteenth century. The Anglo-American point system is, like Fournier's and Didot's, duodecimal. One point measures slightly more than $1/72$ inch with twelve points being known as a pica (or pica em). The system was first introduced by Marder, Luse & Co. of Chicago in 1872 after a fire at their factory forced them to restock. It did not meet with widespread acceptance until a meeting of the United States Typefounders' Association in 1886, when the exact size of the pica was agreed to be that used by McKellar, Smiths & Jordan of Philadelphia (the country's oldest foundry). Nominally, this system is based on the inch, but it is not exact. One pica measures 0·166044 inch rather than 0·166666 so as to avoid the recurring fraction. British type manufacturers began to adopt the system before the end of the century, and by the start of World War I it had become almost universal throughout Britain's colonies and dependencies.

With the development of photosetting and its successors in the latter half of the twentieth century, the idea of measuring a non-existent body

has seemed increasingly illogical. Various proposals for reform have been put forward: some have sought international standardization through the adoption of a metric point, while others have proposed the abandonment of the point system altogether in favour of metric units. Both these ideas met with antipathy from type manufacturers, not least because many were based in Britain (a nation reluctantly undergoing metrication) or the US (a nation seemingly oblivious to its existence).

More logical and practical were proposals contained in an ISO (International Standards Organization) draft proposal of 1978 that sought to measure the visible size of a character using the capital letter H as a guide. Despite the obvious advantages of being able to measure what appears on the page, as well as the benefits of using non-specialist terminology, this failed to be adopted, and no significant rational solutions to type measurement have since been suggested.

Today, we still use points to specify type size and refer to type's non-existent body. This was reinforced when Apple Computers used the Adobe page description language PostScript to drive their LaserWriter printer in 1985, and rounded the size of the point down to exactly $\frac{1}{72}$ inch. The current international standards (ISO/IEC 9541–1 & 2, 1991) concerning type construction reinforce the idea of a point body size within which characters are expressed in terms of x and y coordinates. See page 73 & 100.

Above Comparison of the difference between the main point systems of measurement.
From top to bottom:
72 & 144 Adobe/Apple points
72 & 144 Anglo-American points
72 & 144 Didot points

Mechanical punchcutting and composition of metal type

The Industrial Revolution introduced steam power and mechanization to most industries, and the printing trade was no exception. A machine for casting types was developed early in the nineteenth century, but the long-term success of the idea was dependant on the supply of vast quantities of matrices from which to cast type. For that, more punches than could possibly be cut by hand were needed. This requirement was met in 1885 with the arrival of the Benton Automatic Punchcutter, invented by Linn Boyd Benton and R V Waldo of Milwaukee. The newly mechanized process meant that type design changed from a physical craft into a two-stage process of design and production with many more people involved.

The basic process at Monotype in England (it varied from company to company) was as follows. Once a designer's ideas had been approved and translated into what amounted to engineer's templates, they were carefully traced with a stylus and transferred (using a pantograph) onto a wax-coated glass plate. A copper pattern (or 'former') was grown electrolytically on the wax, and from this the punches were reproduced – again with the aid of a pantograph – using the punchcutting machine. Mechanical composition of type quickly followed Benton and Waldo's invention. There were two main varieties, whose features gave the founding companies their names.

In 1886 the first Linotype hot-metal line-casting machine, invented by Ottmar Mergenthaler, was introduced; this combined keyboard unit, matrix magazine and caster in one unit. Matrices were assembled in line as a result of the operation of the keyboard, and when each line was complete it was cast as a single piece of metal (usually called a slug). The matrices were then automatically redistributed for reuse and the next line could be set (see pages 80–1). In 1912, following the expiry of the Mergenthaler patents, the near identical Intertype was demonstrated, and the first machine installed the following year.

For both machines the manufacturing process necessitated certain modifications in the details of a typeface design. Because the matrices were lined up next to each other prior to casting, there could be no kerned characters such as f. In addition, when different weights – such as roman and italic, or light and bold – were 'duplexed' (two characters on one matrix) together they obviously had to have matching character widths. It is a tribute to the skill of men such as Chauncey H Griffiths in the US, George W Jones and Walter Tracy in England, and the staff in the drawing offices, that these restrictions were sensitively handled and seldom noticeable.

In 1887 Tolbert Lanston took out a patent for the Monotype composing machine, which cast each character as an individual piece of metal. Unlike the Linotype, the Monotype keyboard and caster were separate units. The operation of the keyboard resulted in two holes being punched in a paper ribbon: these were the coordinates of the character in the matrix case waiting in the casting unit. Once the keyboarding was completed the ribbon was taken to the caster. As the ribbon was fed through, the matrix moved into position and type was cast letter by letter (see pages 82–3).

Mechanical punchcutting at Monotype, *c.*1956

After a type design had been approved, the drawing office translated the designer's ideas into working drawings using a set square and french curves (**top left**). While the designer's intentions were paramount, the requirements of the matrix case (see page 83) and the eventual point size also had to be considered.

When complete, the working drawing was placed onto the table of a pantograph while a wax-coated glass plate was placed at the reducing end (**top right**). Using appropriate rules and curves, the outline of the drawing was traced and a reduced design cut into the wax.

When the cutting of the outline was complete, the wax was removed from between the lines and the accuracy of the wax pattern was checked (**above left**).

By a process of electrolysis, a copper pattern was made from the wax and when approved this was placed onto the punchcutting machine. As the pattern was carefully traced (**above right**) tiny cutters replicated its shape onto the end of a steel blank to create a punch. When checked for accuracy, this punch was hardened and could then be used to create matrices.

The typewriter, the keyboard and 'cold composition' setting

Cold composition (or strike-on) is a term used to describe ways of setting type via a keyboard directly to paper. The typewriter is the simplest and most common example.

The first patent for such a machine – 'an artificial machine or method for the impressing or transcribing of letters singly or progressively one after another, as in writing, whereby all writing whatever may be engrossed in paper or parchment so neat and exact so as not to be distinguished from print' – was granted in London to Henry Mill in 1714. The first practical typewriter, however, was that of Christopher Latham Sholes in 1867.

Further development work and a contract with E Remington & Sons of Illinois followed and the first completed typewriters reached the market in 1874. Apart from the fact that it typed only capital letters, this machine had all the features of twentieth-century manual models: a cylinder with line spacing and return mechanism, and type bars (with characters all of a standard width or pitch) operated by a keyboard via connecting rods that struck the carriage at a common centre and printed through an inked ribbon. The keyboard itself was in the familiar qwerty pattern, now known as universal. The refinement of a shift carriage arrangement, to allow both upper- and lower-case characters to be on the same type bar and to be controlled from a single key, came a year later.

Eighty years later, despite sleek styling and chic advertising such as Olivetti's (**below left** by Giovanni Pintori), the mechanical details of typewriters had changed little.

After World War II attempts were made to combine the simplicity of the typewriter with the proportional character widths of 'real' typefaces. The first successful machine was the IBM Selectric Typewriter (**right**), introduced in 1961, which contained fonts of 88 characters on an interchangeable golf ball. These golf balls were available for the most commonly used typefaces of the day and in sizes from 6 to 12pt.

Despite appearances, the qwerty keyboard is not designed for fast typing; the most commonly used letters are placed under the weakest fingers in order to prevent the mechanism jamming. Different languages have slightly varying versions of the universal layout to reflect their different character frequencies, and these give rise to alternate names such as azerty and qzerty.

Keyboards for proprietary typesetting equipment did not always follow the universal pattern: the Linotype version, for instance, used keys arranged by frequency – a layout from one of the company's training manuals is shown **below right**. Typesetting equipment was further complicated by the need to include keys for typographic instructions and additional keyboards for italic and bold typefaces, subtleties which the typewriter omits.

The keyboard used today on PCs or Macs to perform typesetting tasks has the benefit of a century-old practice, but none of the advantages of extended keyboard arrangements found on earlier dedicated typesetting machinery; neither does it exploit the more ergonomic key arrangements that have been devised (such as the Maltron of 1977). The standard keyboard has only 80 keys, and the extended keyboard 105, whereas the typefaces they have to control have at least 256 characters. Many of these have to be accessed via complex key combinations (see also the discussion of digital typesetting on page 93 and in Appendices 1 and 2).

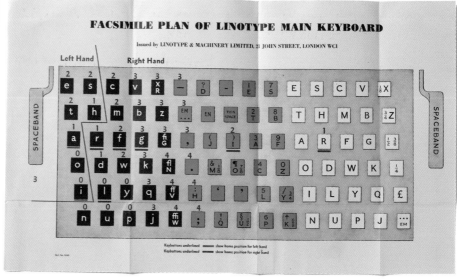

As with the Linotype matrices, the Monotype matrix case imposed restrictions on the designer because all characters in a row had to occupy the same width. Unlike the Linotype system, however, kerning was possible with the Monotype. Adjusting designs to accord with these requirements was generally dealt with by the drawing office rather than the designer. While in the vast majority of cases there was no problem, the Dutch designer Jan van Krimpen was one who took great exception to what he called 'arbitrary encroachments from the side of the drawing office on the designer's work and intentions'.[*]

Other companies produced variants on these or hand-setting principles. The Ludlow, developed by Washington I Ludlow and William Reade in Chicago, was introduced in 1911 and cast slugs from hand-assembled matrices. The company had a progressive type design policy which was geared towards the advertising and newspaper markets, and in Robert Hunter Middleton they had a designer who could respond to their needs.

Alongside these new companies others continued to issue type for hand-composition. For longevity, this was generally cast from a harder alloy than previously, often known as foundry type. The type was produced using the new mechanical methods but the designers had no unit systems or lack of kerning to worry about. Companies such as Stephenson Blake in Sheffield were concerned with preserving a rich historical heritage; others, like American Type Founders (ATF) or Fonderie Olive in France, concentrated on issuing contemporary designs.

Metal typesetting and letterpress printing started to decline with the advent of photosetting systems and offset litho printing from the 1950s onwards. As mass commercial media they were replaced by the mid-1970s, although due to restrictive union practices, national newspapers continued to use letterpress until the mid-1980s.

Monotype's last typeface for hot metal, Barbou, was released in 1968. A year later Intertype ceased production of their line-casting machines in the US, followed by Linotype (also in the US) the following year. Monotype casters continued to be made in Britain until 1987. There are still examples of these machines at work today, but their use is mainly restricted to shorter-run books for specialized markets rather than mainstream printing and publishing.

* Jan van Krimpen, 'Memorandum' quoted in *Monotype Recorder*, 'The Dutch connection', new series, vol.9 (undated), p.3

Ludlow

Top Matrices for 48pt Tempo Bold designed by Robert Hunter Middleton between 1942 and 1948, showing the casting surface (see also on the front and back covers of this book) and the side which faces the compositor when setting.

Above The Ludlow Typograph Company made much of their machine's ease of use. The matrices, being larger than type, were faster to set and the matrix stick could add space to fill out a line automatically. The matrix stick was then inserted into the machine and molten metal injected to cast the slug.

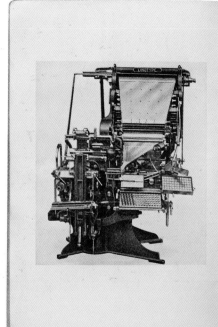

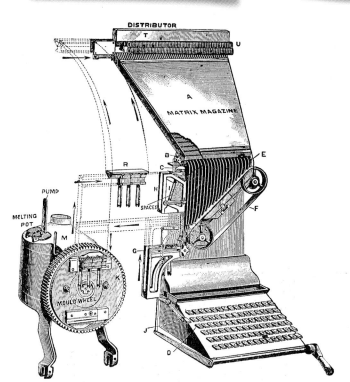

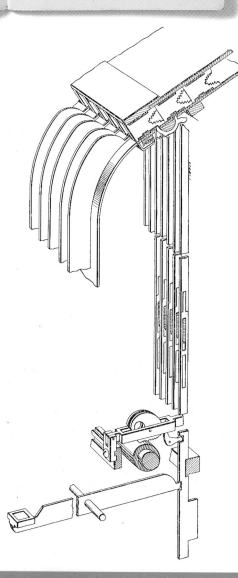

Taken from *Hints to Linotype learners*, the diagram **above** shows the path of matrices through the machine.

Matrices are stored in the magazine [A] and drop down guides [E] onto the assembler belt [F] in response to the action of the keyboard [D]. They form a line and have expanding spacebands inserted in the assembler [G]. Moving via a series of elevators they arrive at the mould wheel [K] where molten metal is injected from the pot [M] casting a 'line-o-type'. After casting, the matrices are transferred upwards on the first elevator. Spacebands are separated and returned immediately to the spaceband box [I] before the second elevator [R] takes the matrices to the distributor [T]. From here they are guided back to their correct channel in the magazine.

Line casting: Linotype & Intertype

Opposite Typesetting equipment manufacturers produced copious amounts of literature to promote their machines and to explain their use. This example from the British arm of the company dates from 1931.

Right, above Duplex display matrices for 24pt Minerva roman and italic showing both the casting surface and the teeth used when the matrices are redistributed to the matrix magazine after casting. Duplexed matrices meant that the italics for Linotype faces had always to match the width of the roman rather than be narrower, as is usually the case. Other combinations of weight or style could also be duplexed together, *ie* roman with bold or with small caps, but the same restriction of matching widths applied.

Right, below The finished product: Linotype slugs. These examples are cast on recessed bodies to save weight and type metal.

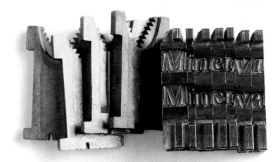

Diagrams from *The Intertype: its function, care, operation and adjustment*, published by the Intertype Corporation in 1929, to explain some of the matrix movements in more detail.

Left The keyboard and magazine, showing matrices lined up in their channel, the exit guides and the matrix release mechanism operated by levers from the keyboard.

Above The assembler unit showing matrices in line with a spaceband inserted.

Right Cutaway diagram of the reverse of the mould wheel showing how the duplexed matrices are raised when italics are needed and the slot through which the molten metal is injected to cast the slug.

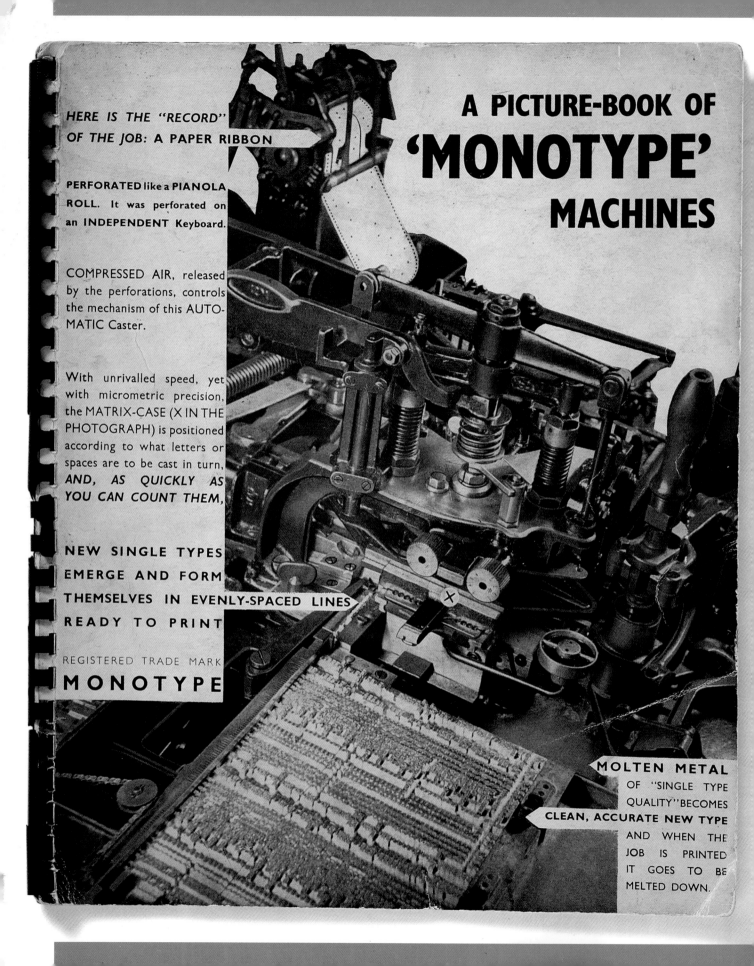

HERE IS THE "RECORD" OF THE JOB: A PAPER RIBBON

PERFORATED like a PIANOLA ROLL. It was perforated on an INDEPENDENT Keyboard.

COMPRESSED AIR, released by the perforations, controls the mechanism of this AUTOMATIC Caster.

With unrivalled speed, yet with micrometric precision, the MATRIX-CASE (X IN THE PHOTOGRAPH) is positioned according to what letters or spaces are to be cast in turn, *AND, AS QUICKLY AS YOU CAN COUNT THEM,*

NEW SINGLE TYPES EMERGE AND FORM THEMSELVES IN EVENLY-SPACED LINES READY TO PRINT

REGISTERED TRADE MARK

MONOTYPE

A PICTURE-BOOK OF
'MONOTYPE'
MACHINES

MOLTEN METAL OF "SINGLE TYPE QUALITY" BECOMES CLEAN, ACCURATE NEW TYPE AND WHEN THE JOB IS PRINTED IT GOES TO BE MELTED DOWN.

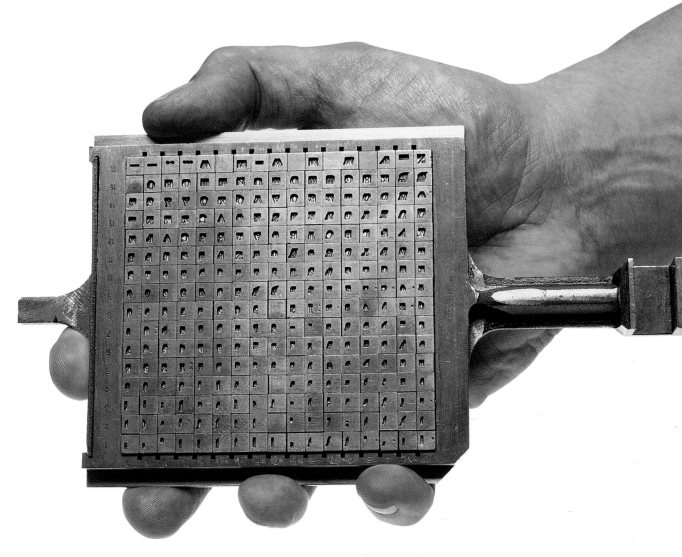

Single type composition: Monotype

Above Matrix case for Times New Roman (actual size). This example is 15 × 17 giving 255 possibilities and thus allowing several weights to be grouped together (in this case roman, italic and bold). The typefaces themselves were designed on an 18-unit to the em system, the narrowest (*eg* , . i) being 5 units wide and the widest (*eg* W) being 18. (In Monotype, the width of the em – known as set-width – varied from typeface to typeface and from size to size.) All the characters in any horizontal row had to be the same unit width.

 Left The publicity department at the Monotype Corporation vigorously marketed the company, its types and the virtues of its machinery. The cover of this brochure clearly explains the principles of the casting machine and its relationship to the keyboard unit (**right**).

The Intertype Fotosetter

Left and above The Intertype Fotosetter was the first photosetting machine to prove its worth in a commercial environment. Outwardly it resembled their linecasting machines, having an identical keyboard arrangement and recirculating matrices. Publicity such as this brochure from 1950 was a mixture of conservatism and 'brave new world'.

Below Matching publicity material was used to promote the typefaces that Intertype had newly adapted for the system. Each of those shown makes some visual reference to an aspect of type manufacture. Cairo, a lens; Century, the Fotosetter itself; and Garamond, a graver used in hand punchcutting.

Phototypesetting

In this process, the type exists as a set of photographic images (typically on a glass grid, disk or film strip) which are exposed to paper or film via a system of lenses. Printing might be either by letterpress (using etched metal plates) or, increasingly, offset litho.

The first experiments in using photographic means to generate type began over a century ago – early patents had been taken out by E Porzsolt in 1894 and William Freise-Greene a year later – and the principles of exposing images onto continuously moving paper via a short-duration electric spark were patented by two Germans, Siemens and Halske, in 1915. However, it was not until 1946 that the technology started to prove itself when the US Government Printing Office installed the Intertype Fotosetter. Early machines such as this, alongside the Rotofoto (1948) and the Monophoto (1952), represent a hybrid mechanical technology. Existing keyboard units were retained, but the metal-casting units were replaced by a photographic device.

Another, more original, approach to using photography was invented by René Higonnet and Louis Moyoud in Lyon, France: this established the practicality of imaging characters stroboscopically from a continuously-spinning photo-matrix disc. Having proved the idea, they emigrated to the US in 1946 where they continued their work, and the production model Photon 200 (marketed in Europe as Lumitype) appeared in 1956. Variations of their principles appeared in machines from Compugraphic, Varityper and Itek.

In the 1960s, the use of light as the means to generate the type image began to be challenged by the cathode ray tube (CRT). The Linotron 505 of 1967, by Ronald McIntosh and Peter Purdy, was the first such device to have a major impact, although CRT had been used in the Digiset of two years earlier (see Beyond the physical: digital typesetting, page 93).

The stumbling block to market acceptance of all these machines was not only scepticism about quality, but also the prohibitively high costs of the equipment. Quality concerns – often quite misplaced – centred on the three major side effects of the process. Firstly, with photo-matrices, certain adjustments needed to be made to character detailing in order to compensate for the particular properties of light (see diagram on page 90). However, this was a minor problem since the adjustments were understood by the manufacturers, straightforward to undertake, and at the sizes the typefaces were intended to be used at, their effects were unnoticeable.

The second side effect concerned the 'colour' of the type itself. In letterpress the final printed appearance of the type can vary according to the choice of paper, the amount of impression and the quantity of ink. Good book printing was in part judged by the uniformity of the black text throughout the book. With photosetting, the image could be used to create both the etched metal plates used in letterpress printing and the quite different plates employed in offset litho (with little impression and only minimal ink squash). As the latter means of printing became more commonplace, once familiar typefaces began to look too thin and 'clean'. The thinness was a particular problem at small sizes where parts of characters could disappear.

Naming a type company or product

With the arrival of mechanical composition at the end of the nineteenth century, type companies became complex commercial concerns with considerable financial backing and large numbers of shareholders. While a few of these names retained reference to their originating inventor, the trend – which continues today – was to invent ones that reflected the technology of the day and/or their product. The list below is not exhaustive but gives a flavour. (Company dates given here may differ from dates in the main text which often refer to a particular machine of the same name.)

Linotype (1886)
Monotype (1887)
Typograph (1890)
Unitype (1898)
Stringertype/Supertype (1902/36)
Ludlow Typograph (1906)
Thompson Typecaster (1908)
Amalgatype/Monoline/Intertype (1911)
Linograph (1912)
Typary (1925)
Varityper (1933)
Flickertype (1935)
Rotofoto (1936)
Uhertype (1938)
Intertype Fotosetter (1946)
Justowriter, Monophoto (1950)
Photon/Lumitype (1952/6)
Linofilm (1955)
Diatype (1958)
Letraset (1959)
Compugraphic Corporation, Phototypositor (1960)
IBM Selectric (1961)
Fototronic (1964)
Hell Digiset/Videocomp, Matrotype, Thompson Computerset (1965)
Linotron (1967)
Compuwriter (1972)
AM Comp/Set, Econosetter, Execuwriter (1974)
Monotype Lasercomp (1976)
CRTronic (1979)
Bitstream (1981)
Adobe PageMaker, Apple LaserWriter (1985)
Unicode (1988)
FontShop International (1989)
Letraset Fontstudio, Altsys Fontographer (early 1990s)
OpenType (1997)

The photographic image

Below A stencil (or 'frisket') from Linotype shown 55% of its actual size. While a designer's original artwork might be submitted as pencil or ink drawings, the production drawings for typefaces in the photosetting era often took the form of stencils cut freehand with a knife out of an acetate-backed red film (known variously as 'rubylith' or 'ulano').

Note the punched holes at the top of the sheet to ensure accurate alignment of the character during the matrix-making process.

Opposite Various methods were used to store the photographic image. A variety is shown opposite: Glass grid, Linofilm (*c*.1959); Film strip, Linoterm 1976; Individual matrix slides, Linofilm Europa, 1970. (All shown actual size). Brochure showing the five glass discs used in the Fototronic 1200 of 1968.

vehi

cle for extending meaning o
certain things bother me. Som
big, too fancy. All those differ
Gimme some photos. Mike Ty.
a grapefruit on the sidewalk
with just a caption in normal t
Halvetica stuff. Or FRANKling
by me. Just make it readable.
[...] My nephew's a graphic de
called Cranbrook. Jesus, the s
a bad dream. All those layer
who's in the dream or what co
ian or what's saying what,
office ‖ Crossroads of civiliza
against the ravages of time ‖ a
whispering rumour ‖ incessar

xploring the text Rick Poynor, *Typography now*, p.15. ● Ya,

imes the type is too small, too

sizes fighting with the page.

's head getting slammed like

ullbleed centerspread shots

e style design font. I like that

nic. Any of those gothics is OK

me in the fuckin head with it.

gner [...]. He goes to that place

ff I see from that place is like

going on and you don't know

ntry you're in or who's a Mart-

quoted in *Emigré* 15, 1990, p.33 ● This is ‖ a printing

on ‖ refuge of all the arts ‖

oury of fearless truth ‖ against

trumpet of trade ‖ From this

120 ⟶

The K S Paul PM 1001 of 1967 later became the Linotype 505 and was the first CRT device to achieve commercial impact. The complete system, shown **above**, comprised a control unit; a reproducer which contained 4 photo matrix grids each of 238 characters and the CRT; a tape merger correction unit and keyboard unit. In the standard version, the range of type sizes which could be set was 4–28pt and the output resolution was either 650 or 1,300 lines per inch.

To counteract the effects of photography (light spreads at junctions but softens corners) detailed adjustments needed to be made to typeface drawings to allow the designer's wishes to be realized correctly.

The third side effect related to the mechanics of photosetting. With its array of lenses to create different type sizes, there was no physical necessity to create a number of different designs, as had been the practice with metal. For their Monophoto range of machines, Monotype offered A (for 6 & 7 pt), B (for 8–12pt) and C (for 14–24pt) matrices. In practice, most printers, realizing that one matrix would create all sizes, bought accordingly. Monotype recognized this too, and began to design new typefaces for this medium with one carefully detailed master designed to work at all sizes. Adrian Frutiger's Apollo was the first of these in 1964, followed by Chris Brand's Albertina (1966) and José Mendoza y Almeida's Photina (1971).

The issue of cost took longer to resolve, but in 1968 Compugraphic introduced a range of simple, reliable machines which avoided the technical complexities of CRT and applied value engineering to the established photo-matrix and stroboscopic flash. The base model, CG2961, sold for £4,950, less than one-half the cost of competitors' equipment; Compugraphic's market share dramatically increased as a result. Other manufacturers soon brought their prices down, and henceforth hot-metal typesetting and letterpress printing rapidly declined.

Like the mechanical composition machines described earlier in this chapter, most of the machines mentioned above were originally designed to set text sizes of type. To supply the need for larger type, there appeared small desktop machines, whose purpose was purely the setting of what became known as headline type. These machines used photographic negatives of varying kinds to create the image. It was possible for skilled artworkers in a typesetting studio to create special characters – or even complete typefaces – to complement those supplied by the machine manufacturer. Another product designed to supply quick, cheap but original typefaces for the graphic design and advertising markets was the dry-transfer lettering pioneered by Letraset in 1961 (described opposite).

Dry transfer (or rub-down) lettering

The Letraset company was founded by 'Dai' Davies (the inventor of the dry-transfer process) and Fred McKenzie in 1959 with the idea of producing easy-to-use, affordable, display-size lettering. The original product required water to separate the letters from the backing sheet which, despite the time and effort involved, still proved faster than hand lettering. The idea was refined, and their dry-transfer lettering was launched in 1961. The letters were printed on the reverse of a polythene carrier sheet, overprinted with adhesive and protected by a backing sheet. To use, letters were selected and simply rubbed down onto the artwork in their required positions (**above**).

Letraset's master artwork was produced at a cap height of 15 cm and cut as a stencil out of rubylith film, but unlike the negative shown on page 86, the artwork for Letraset letters was cut in positive.

Because of their intended use for headline and display, Letraset faces were designed to be eye-catching and of the moment, and many of their names reflect this fact (**right**). Despite the popularity of the typefaces and their widespread use, Letraset's biggest selling rub-down sheet was no.557: *Line rules*.

Letraset produced more than 1,200 typefaces in dry-transfer form across several different ranges (some of which were available on subscription only). Of these, 474 were original designs and many were taken up by photosetting manufacturers. The dry-transfer product is no longer made and Letraset now markets digital fonts under the Fontek name.

<table>
<tr><td>6</td><td></td><td></td></tr>
<tr><td>64 Grotesque 215</td><td>82 News Gothic</td><td>95 SAPPHII</td></tr>
<tr><td>64 Grotesque 216</td><td>82 News Gothic Bold</td><td>95 Serifa</td></tr>
<tr><td>65 Hawthorn</td><td>82 News Gothic Condensed</td><td>95 Souvenir</td></tr>
<tr><td>65 Helvetica Bold</td><td>83 Old English</td><td>96 Souvenir D</td></tr>
<tr><td>66 Helvetica Bold Condensed</td><td>83 Optima</td><td>96 Souvenir Ligh</td></tr>
<tr><td>66 <i>Helvetica Bold It.</i></td><td>83 Optima Bold</td><td>96 Souvenir M</td></tr>
<tr><td>67 Helvetica Compact</td><td>84 Optima Medium</td><td>97 <i>Souvenir Me</i></td></tr>
<tr><td>67 Helvetica Extra Bold</td><td>84 <i>Palace Script</i></td><td>97 Standard</td></tr>
<tr><td>68 Helvetica Extra Light</td><td>84 Palatino</td><td>97 STENCIL</td></tr>
<tr><td>68 Helvetica Light Condensed</td><td>85 <i>Palatino Italic</i></td><td>98 Tabasco Bo</td></tr>
<tr><td>69 <i>Helvetica Light Italic</i></td><td>85 Palatino Semi Bold</td><td>98 Tabasco M</td></tr>
<tr><td>69 Helvetica Medium Condensed</td><td>85 Palatino Ultra Heavy</td><td>98 Times Bold</td></tr>
<tr><td>70 Helvetica Light</td><td>86 <i>Park Avenue</i></td><td>99 <i>Times Bold</i></td></tr>
<tr><td>71 Helvetica Medium</td><td>86 Peignot Bold</td><td>99 Times Ext</td></tr>
<tr><td>72 Helvetica Medium Extended</td><td>86 Peignot Light</td><td>99 Times New</td></tr>
<tr><td>72 <i>Helvetica Med. Italic</i></td><td>87 Peignot Medium</td><td>100 Tintopetto</td></tr>
<tr><td>72 Helvetica Med. Outline</td><td>87 Perpetua Bold 461</td><td>100 Tip Top</td></tr>
<tr><td>73 Horatio Bold</td><td>87 Plantin 110</td><td>100 Transport</td></tr>
<tr><td>73 Horatio Light</td><td>88 Plantin Bold</td><td>101 Transport</td></tr>
<tr><td>73 Horatio Medium</td><td>88 Plantin Bold Condensed</td><td>101 Trooper Ro</td></tr>
<tr><td>74 Isonorm 3098 Typ B m</td><td>88 Plantin Extra Bold</td><td>101 Univers 45</td></tr>
<tr><td>74 <i>Isonorm Italic 3098 Typ B m</i></td><td></td><td>102 <i>Univers 46</i></td></tr>
</table>

<table>
<tr><td>7</td><td></td><td></td></tr>
<tr><td>74 ita</td><td>89 Playbill</td><td>102 Univers</td></tr>
<tr><td>75 Jenson Extra Bold</td><td>89 Pretorian ← Clowns - Fun</td><td>102 Univers 5</td></tr>
<tr><td>75 Jenson Medium</td><td>89 PRISMA</td><td>103 <i>Univers 5</i></td></tr>
<tr><td>75 <i>Juliet</i></td><td>90 PROFIL</td><td>103 Univers 57</td></tr>
<tr><td>76 <i>Kalligraphia</i></td><td>90 Pump</td><td>103 Univers 59</td></tr>
<tr><td>76 Lazybones</td><td>90 Pump Light</td><td>104 Univers</td></tr>
<tr><td>76 Lectura</td><td>91 Pump Medium</td><td>104 <i>Univers (</i></td></tr>
<tr><td>77 Lectura Bold</td><td>91 Pump Triline</td><td>104 Univers 6</td></tr>
<tr><td>77 <i>Le Griffe</i></td><td>91 QUENTIN</td><td>105 Univers</td></tr>
<tr><td>77 LETTRES ORNÉES</td><td>92 Revue</td><td>105 Univer</td></tr>
<tr><td>78 linear</td><td>92 Ringlet</td><td>105 University</td></tr>
<tr><td>78 Loose New Roman</td><td>92 Rockwell 371</td><td>106 University R</td></tr>
<tr><td>78 Manuscript Caps</td><td>93 Rockwell Bold 391</td><td>106 Venus</td></tr>
<tr><td>79 Melior</td><td>93 Rockwell Extra Bold</td><td>106 Extend</td></tr>
<tr><td>79 <i>Murray Hill Bold</i></td><td>93 Rockwell Light 390</td><td>106 <i>Vivaldi</i></td></tr>
<tr><td>80 MICROGRAMMA BOLD EXTENDED</td><td>94 ROMANTIQUES</td><td>107 Windsor</td></tr>
<tr><td>80 MICROGRAMMA MEDIUM EXTENDED</td><td>94 Salisbury Bold</td><td>107 Windso</td></tr>
<tr><td>81 Modern No. 20</td><td>94 SANS SERIF SHADED</td><td>108 Windsor Elong</td></tr>
<tr><td></td><td></td><td>108 Zipper</td></tr>
</table>

International Typeface Corporation

ITC was founded in New York in 1970 by Aaron Burns, Herb Lubalin and Ed Rondthaler. The company was unusual at that time in that it was not a manufacturer of typesetting equipment but merely licensed typeface designs to others to adapt for their machinery.

The company's main method of advertising itself was through its magazine, *U&lc*, which ran until 1999. This was aimed primarily at users of its typefaces and featured informed articles and innovative design as well as a catalogue to promote its typefaces.

An aspect of typographic fashion in the photosetting era was tight letterspacing, and this – along with large x-heights – characterized many ITC faces of the 1970s. In addition, because the company's roots were firmly in the advertising industry, several of the early releases such as Avant Garde Gothic came complete with comprehensive sets of ligatures to enable logos and mastheads to be created easily.

In the late 1980s ITC went digital and since 1994 has marketed its fonts directly at end users as well as other manufacturers. In 2000, ITC was acquired by Agfa Monotype.

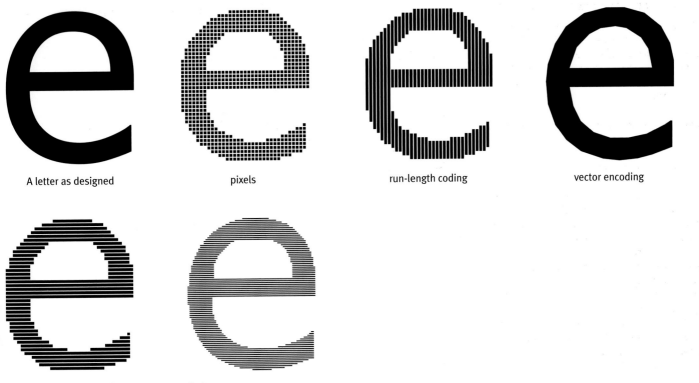

A letter as designed pixels run-length coding vector encoding

differing output resolutions

Beyond the physical: digital typesetting

In digital type there is no physical type, only data stored in a computer's memory. This data is viewed on screen, output onto paper, film or direct to plate or digital press cylinder for offset litho or xerographic printing.

The first machine to use digitized fonts was Dr-Ing Rudolf Hell's Digiset (known as the Videocomp in the US) in 1965; this used 'run-length coded' fonts (see **above**) and a CRT as the means of image generation. This method gave way to laser following the introduction of the Monotype Lasercomp in 1976, which also incorporated a raster image processor (RIP) for integrating text and image. As with photosetting, the cost of the equipment was a key to market acceptance, and the advent of the Linotron 100 and 300 some years later made the technology affordable.

During the 1980s the boundaries between the activities of design studios, offices and the printing/typesetting trades began to blur as a result of simultaneous developments in several different areas. Personal computers came down in price, WYSIWYG displays appeared, and type companies licensed typeface libraries to office printer manufacturers who had now tamed lasers for use in this unglamorous setting. The final event in this process was the combining, in 1984, of the PostScript page-description language of Adobe Systems Inc. with the Aldus (now Adobe) PageMaker software program on the Apple Macintosh computer.

PostScript is a device-independent computer language. It enables the user to combine typefaces from different manufacturers together on any PostScript-compatible computer, alongside other graphic elements and images, and print out to any PostScript-compatible printer. All typesetting systems for the preceding

Resolution

This concerns the appearance of the image, either as digitized and stored in the computer memory or as printed out or viewed on screen.

Top line above There are several ways to digitize a character. On the left is the letter as drawn by the designer.

Pixels (short for 'picture elements') are the basic method of rendering a character's shape. Here the quality of image is dependant on how many pixels there are to the inch. (In reality the pixels, like the scan lines in the other diagrams here, touch each other.)

In terms of computer memory, a more efficient way of storing this information is as run-length coding. Here, only the stop and start points of a character's outline need to be plotted and stored.

More economical still is to describe the character's shape as a series of straight lines which are 'painted in' by the output device. This is known as vector encoding, and at small sizes the irregular contours are not noticeable.

Second line above The appearance of type when printed is affected by the resolution of the output device. This can vary from 300 dpi (dots per inch) for the first generation of LaserWriters to the 2,500 or more lpi (lines per inch) of an imagesetter exposing onto paper or film. The effects of two different resolutions on a character's shape can be seen clearly above.

Emigré

Founded in San Francisco by Zuzana Licko and Rudy VanderLans, Emigré were early pioneers of the Macintosh. They founded the magazine of the same name in 1984 with VanderLans as editor and Licko providing the type designs which they started to market a year later. The magazine was part editorial, part promotion and part experiment, and it quickly established a loyal following. Its pages have acted as a showcase for many young designers and their typefaces, including Barry Deck (Template Gothic) and Jeff Keedy (Keedy Sans).

Using the newly released type design program Fontographer, Licko's early typefaces can be seen as a celebration of the limitations of the software of the time. Emperor, Oakland, Universal and Emigré, for example, are all bitmap faces designed for low resolution printers, while Citizen and Matrix reflect other restrictions. In more recent typefaces Licko has shown an interest in history, resulting in reinterpretations of both Baskerville (Mrs Eaves) and Bodoni (Filosophia).

hundred years had the limitation that a particular company's typefaces could only work on that same company's equipment or another company's to whom they had licensed the designs.

Linotype adapted the output device (these would in future be known as imagesetters) of their Series 100 and 300 typesetters so that it could interpret PostScript data and form a network with Apple Macintosh computers and LaserWriter printers. This move was followed by other manufacturers and eventually led to dramatic changes in the type industry as well as the way the graphic arts industries operated.

These changes centred on the role and location of typesetting within the work flow. Hitherto, graphic designers had produced pencil roughs for client approval and sent instruction sheets to a typesetting house; now the whole process – trial and error layouts, flowing in text, typographic formatting and detailing – could take place on an Apple Mac using one of several page make-up or design-orientated programs. Older graphics professionals, used to a clear division of roles and responsibilities, found the change difficult, but most others took full advantage of this more holistic way of working (while complaining bitterly, of course, about the ending of any notion of a copy deadline). Typesetting houses had to adapt by becoming service bureaux, outputting fully formatted files from designers, and by diversifying into colour reproduction and other aspects of pre-press work. Graphic designers, too, found that they had to expand their skills and learn at least a little about scanning and colour correction.

Profound changes occurred, too, in the field of type design and manufacture, where digitization eventually led to an increased 'democratization' of type production. In 1974 Dr Peter Karow invented the Ikarus type design program. This enabled drawings to be converted to digital outlines, and also allowed different weights to be interpolated from one design. In 1981 Matthew Carter and Mike Parker (both previously of Linotype) founded the first digital 'foundry', Bitstream Inc., in Cambridge, Massachusetts. This sold type to equipment manufacturers, following a similar model to the International Typeface Corporation (ITC) set up in 1970 by Aaron Burns, Herb Lubalin and Ed Rondthaler.

The Ikarus program remained the industry standard for font manufacturers until the appearance in the late 1980s of type design programs for the Macintosh platform such as Letraset FontStudio and Altsys (later Macromedia) Fontographer. Put simply, these enabled anyone to produce type that was 'technically' as good as that from a major manufacturer. This affordable software led to a new generation of type designers from outside the 'system'. The first of these was Emigré, the magazine/type foundry/record label set up by the husband-and-wife team of Rudy VanderLans and Zuzana Licko in 1984. They were followed by companies who sold type, such as FontShop International (FSI), based in Berlin, and the American FontHaus (now DsgnHaus) – both of which later diversified into type manufacture themselves. Many individual graphic designers have also become type designers – to a far greater extent than was ever possible before. Some sell through established networks but many market themselves via new technologies, including the internet.

Typefaces are no longer products bought by typesetting houses (numbering, at most, several thousand) but software for personal computers (numbering countless millions); as a result the unit price has come down dramatically. For the user, they represent a good investment: in 1985 the minimum typesetting charge in London – for a one-off piece of typesetting – was £15 plus VAT; five years later one weight of a PostScript typeface from a major manufacturer cost around £30, but it would still be working today, having survived four Mac operating system upgrades. PostScript, which describes the outlines of a typeface in what are known as 'Bezier curves', was followed in 1991 by Apple's own TrueType format, which describes outlines as 'quadratic curves'. Differences between the two formats are discussed on page 96.

Attempts to provide experienced type users with more sophistication and control led to the development of Multiple Master fonts by Adobe in 1991 and GX fonts from Apple in 1992. Multiple Masters allowed the 'morphing' of designs along axes between pre-set master poles, and GX worked along similar lines – but neither made significant inroads into the marketplace due to the lack of application support and a perceived over-complication of the product.

Incompatabilities of the PostScript and TrueType formats across the Windows and Macintosh operating platforms, as well as commercial expediency, forced Adobe and Microsoft to work together, and in 1997 OpenType was announced. OpenType is an 'envelope' technology that can contain fonts created in both formats. Its initial goal of cross-platform compatibility was soon extended to work with the larger international standard character set of Unicode, which is 'designed to support the interchange, processing and display of written texts of all world languages'. Unicode v.3·1 accommodates 94,140 characters – enough for all the world's languages. In 2000, Adobe announced support for OpenType with the next releases of InDesign and Photoshop, coinciding with the company's release of Palatino and Tekton – each containing 1,800 characters.

FontShop International (FSI) and FontFonts

FSI was set up in 1989 by Erik Spiekermann to market PostScript typefaces directly to end users. With a range of stock which included all the major manufacturers and fast delivery together with well-designed and targeted marketing, FontShop quickly became the obvious place to buy fonts in the countries where it operated.

A year later it launched its own 'label' of exclusive faces under the name of FontFont. This now numbers over 1,600 with new releases every six months promoted by postcard sets (see **above**). FontFonts include serious everyday faces such as Meta (Erik Spiekermann, 1991–8), Quadraat (Fred Smeijers, 1992–8) and Scala (Martin Majoor, 1992–9) as well as faces suitable for every kind of display imaginable.

In addition to FontFonts, FSI published the first 17 issues of Neville Brody and Jon Wozencroft's *Fuse* project, each issue of which contains four specially commissioned experimental typefaces.

Designing type today

As discussed above, with the new software programs type design has ceased to be a 'black art' known to only a few practitioners working for established companies. While not quite the 'press a few buttons' activity suggested by some internet tutorial pages, at a basic level it can be a relatively quick and easy process, and there is an increasing amount of useful information and opinion published in both book and web form.

There are very few designers who believe that one single typeface family – however extensive and versatile – can be used for every job. This would deny two of type's most distinctive uses: to give 'voice' to the content and add variety to life. Indeed, despite the bewildering variety of typefaces available, there is not always one to suit a particular need. In addition, many fonts do not have the extensive set of characters needed for detailed book work. Licence agreements from type vendors vary in their details, but many allow a font to be imported into a type design program and edited to create the necessary extras for the licencee's benefit. The boxed version of Gerard Unger's Swift used throughout this book is an example of this.

Software such as Macromedia's Fontographer enables designers to draw their own letterforms, blurring the distinction between lettering (a one-off) and type (a multiple) in a way not possible before. A typeface may start life as a few letters drawn for a specific project; these might later be added to in order to create a complete typeface which can then be made commercially available.

The final part of this chapter outlines the principal stages involved in modifying or creating typefaces. It is not a tutorial for any specific type design program and, although Fontographer is the most commonly used of these, the screenshots have also been made in FontStudio (an older Letraset product) and FontLab.

Postcript and TrueType

Left PostScript typefaces consist of three files. The printer font (sometimes known as the PFM), which is the design itself – its icon will vary with each manufacturer; the bitmaps, which are pixelated representations of the printer font for screen use; and AFM (Adobe Font Metrics) files, which contain purely numerical data about every aspect of the font's design.

Right With TrueType, by contrast, all the designs and data are contained in one single file within one same suitcase file.

Both these screen-shots show the icons as they appear on the Mac OS.

Creating logos or special characters

An interest in type design can sometimes start from dissatisfaction with a particular character in a font. If the job is a simple headline or logo it may be far easier to use ordinary graphics software to convert the character to its constructional outline, which can then be altered at will: it will not, however, be repeatable like type any more. Freehand, Illustrator and QuarkXPress are all capable of this.

If that character needs to be positioned alongside type it is necessary to use a type design program, as in these examples.

⊖ Holborn

🚌 8, 98

☎ 8155

With a bit of ingenuity, complex characters can be created using several key positions. Very accurate drawings are possible and variously tinted or coloured elements can be combined.

How large is a font?

If you are thinking of designing your own type, the first thing to think about is its intended use. If it will be just for personal use on a specific job, you might only need to design a few characters. If you hope to use it for any quantity of text you will need at least a full alphabet and punctuation. If you intend to release and distribute it you will need to follow a standard, *eg* ISO Set 1 which has 256 characters (see Appendices 1 and 2). The characters generally accessible on the Mac OS are:

Capitals (upper case)
ABCDEFGHIJKLMNOPQRSTUVWXYZ

Lower case and ampersand
abcdefghijklmnopqrstuvwxyz &

Accented characters
åâäàá ç êëèé ïíîì ñ òóôö ÿ
ÅÂÄÀÁ Ç ÊËÈÉ ÏÍÎÌ Ñ ÒÓÔÖ Ÿ

Figures
1234567890

Punctuation
, . ; : ... ' ' " " „ ◊ ¡! ¿? () [] { } / | \ * † ‡ ¶ §

Maths and monetary symbols, dipthongs etc.
+±=≠≤≥¬√ #¤∞∫£$¢¥ƒ% ÆæŒœ fifl ß
Δ∂∏∑Ω • @©®™

In addition to the above, there may be the need for an additional set of figures and small capitals (see Chapter V for guidelines to their usage).

Non-lining figures
1234567890

Small capitals
ABCDEFGHIJKLMNOPQRSTUVWXYZ

Generally, typefaces have more than one style. How many are developed depends on the design itself, its intended use and market. Typefaces for book work generally need at least the variants indicated below.

Italics are important for most text typography:
ABCDEFGHIJKLMNOPQRSTUVWXYZabcdef ghijklmnopqrstuvwxyz & 1234567890 , . etc.

A bold may be less necessary, but is usually expected: **ABCDEFGHIJKLMNOPQRSTUV WXYZ abcdefghijklmnopqrstuvwxyz & 1234567890 , . etc.**

Bold italics likewise: ***ABCDEFGHIJKLMNO PQRSTUVWXYZ abcdefghijklmnopqrst uvwxyz & 1234567890 , . etc.***

aaaa

It is interesting to look carefully at existing typefaces to see how an extensive typeface is planned and how well all the weights and variants relate to one another. Some typefaces, such as Univers (Adrian Frutiger, 1955) and Thesis (Lucas de Groot, 1995), were planned and designed as complete families at the outset and all weights and styles match seamlessly. Others, such as Helvetica and Gill (**above**), were added to over a period of years by different designers – and it shows.

Drawings help establish ideas

Overleaf Typefaces are usually designed so that all characters share a common set of visual elements. Working on paper is one of the quickest ways to establish the basic features of a design.

Overleaf left For beginners, squared paper can be helpful as it reflects the modular nature of the em-square, with its 1,000 units. The designer here (Phil Baines, *c.*1992) has begun to explore the slope of an italic and the details and consistency of the curve treatments. Basic proportions of the typeface: cap height, x-height, ascender height, descender depth and stem weights are all derived from the roman. Not all of these ideas were taken as far as digitization (see page 100) let alone the (not quite) finished typeface.

Overleaf right More experienced designers use drawings to sketch out ideas rapidly before using the computer. These are preparatory drawings by Jeremy Tankard for his Shires family of types (released 1998). There are six faces, each of the same basic blackness and underlying proportions and derived from vernacular nineteenth-century English lettering. Because these drawings are looser, the computer will be used more actively in the creation of the letter shapes.

In both these cases, drawings are only the start of the process. Basic digitization of shapes is followed by printouts which will be scrutinized carefully and marked with comments and corrections: type design is a back-and-forth process of enquiry just like any other aspect of design.

Drawings can also be very highly finished, as though they were templates to be plotted on a graphics tablet. An example by Miles Newlyn for his 1991 typeface Missionary, is shown on page 65.

IV: Manufacture & design **97**

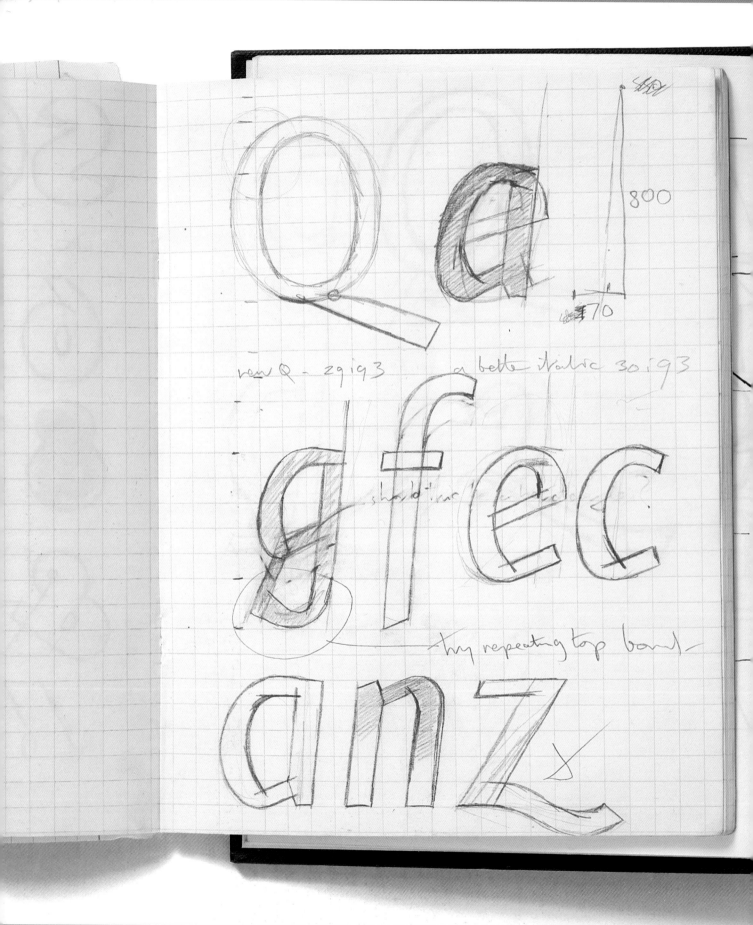

800

770

rew Q - 29i93 a better italic 30.i93

should'ise 'fec'

try repeating top band

...exture to surface of paintings — Johns, Rauschenberg.
Cy Twombly. Pollock

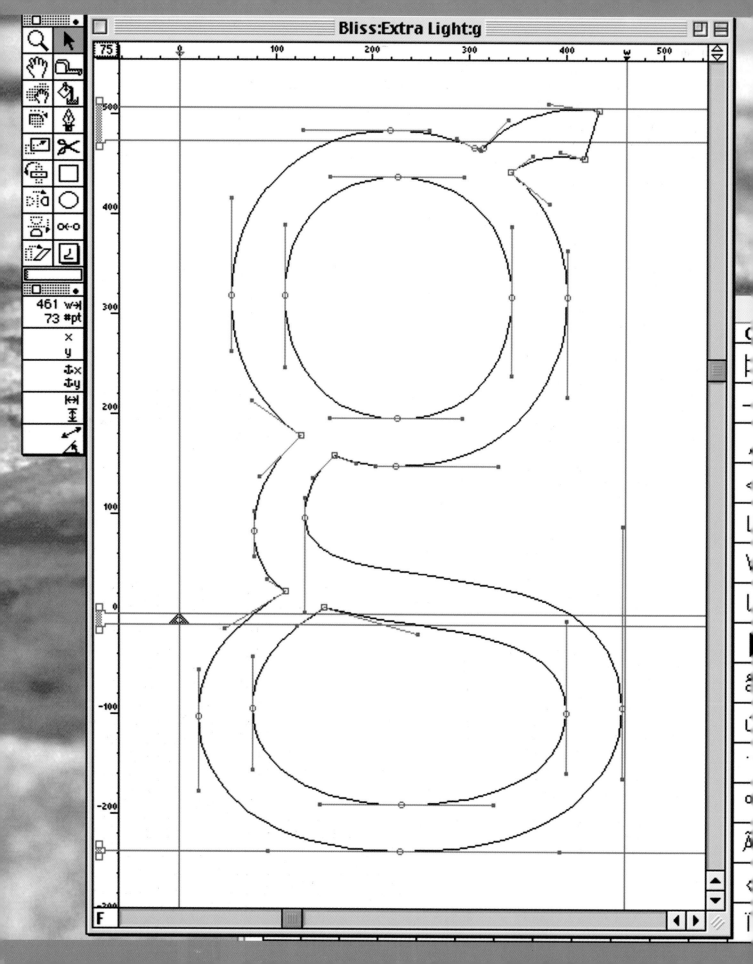

Digitization

Letters in PostScript format are drawn on a grid (the em-square), typically 1,000 × 1,000 units. Outlines *are* the type design and from them, type can be reproduced at a wide variety of resolutions from the coarse bitmaps necessary for screen representation to the 2,400 lines-per-inch of a high-resolution imagesetter.

The development of the typeface design takes place in the outline drawing window (**opposite**) where curves and straight lines link points and are manipulated by control handles. There are three main ways of working here.

1 Large-scale drawings can be scanned and imported into the background layer, traced automatically and then cleaned up. The degree of cleaning up required depends upon the quality of the drawing.

2 Drawings created in programs that utilize Bezier curves (such as Illustrator or Freehand) can be imported and then worked on.

3 Using rough drawings (such as those on pages 98–9) as reference only, the drawing tools of the type design software can be employed to digitize the design from scratch as here.

Interpolation of other weights

Right, top The process of generating large type families has been considerably simplified by the ability of software to interpolate weights. In this case, the software takes the outlines of the two selected extremes (light and extra bold) and creates new weights between as specified.

Bitmaps

Bitmaps are the basic way of displaying a typeface on screen. Each square (pixel) represents $\frac{1}{72}$ inch and at small sizes the character of the typeface is severely compromised. In PostScript one size must be created with the typeface (**right, middle**). In use, other sizes are created from the outlines as and when needed, by software such as Adobe Type Manager (ATM).

Hinting

'Hinting' is a set of instructions which can be built into the font to improve the image quality at low resolutions such as on screen. This PostScript example (**right**) shows green instruction lines controlling the consistency of horizontal stems and purple lines controlling the vertical. The display of the character at various point sizes above shows the effects of the instructions. Typefaces designed primarily for screen use are generally manufactured in TrueType format as this allows more complex hinting instructions to be given than PostScript.

The grid to the right of the hinting window shows the 256 characters available in ISO set 1; those in grey have yet to be designed.

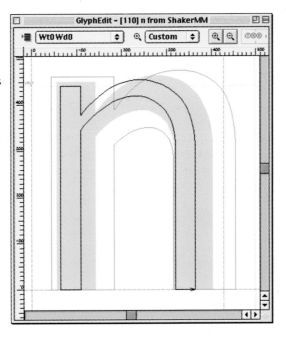

The typefaces on this spread were all designed by Jeremy Tankard. Outlines: Bliss 1996–2000. Interpolation: Shaker, 2000. Bitmaps & hinting: Enigma, 1999.

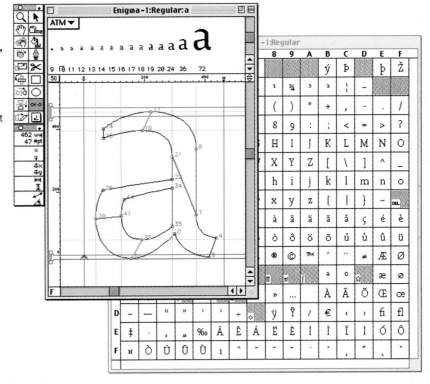

Character Metrics			Kern As	Kerning		Parameters
	Width	Left	Right	1st 2nd	Amount	Value
m	781	70	63	⇧ Fu	70 ⇧	0 ⇧
n	533	70	65	Ta	100	
o	550	40	40	Te	100	
p	557	75	40	To	100	
q	552	40	70	⇩ Tr	100 ⇩	
100	Width:	n	▶ 533			■ Enabled □ Disabled

Toulon

Spacing typefaces

Designing the character shapes themselves, however time consuming, is only part of the work of typeface design: type which is poorly spaced is as good as useless. The basic aim of spacing is to create an even colour for the type overall. Perhaps the best explanation of spacing is that given by Walter Tracy in *Letters of credit*, on which the following summary is based.

Some basic optical principles govern spacing: straight-sided letters have larger sidebearings than curved ones, while triangular letters have less still. An idiosyncratic typeface should follow these visual principles rather than the system described below, which is for more regular designs.

With the lower case, everything starts with n and o. Values for the left and right sidebearings of n are tested using five letters together. Visually each n should look like an n, the adjacent verticals should appear stronger.

nnnnn

The left side, being upright, will need a slightly larger sidebearing than the partly curved right-hand side.

The same process is applied to the letter o.

ooooo

Here the sidebearings will be equal and less than either of the values already established for n. These values are checked against each other by typing

nonon onono

You now have three sidebearing values from which you can deduce three more as the basis for spacing the rest of the alphabet as follows:

a = left side of n
b = right side of n
c = slightly more than left side of n
d = minimum
e = same as o
f = slightly less than o

These sidebearing values can then be applied to the lower-case as follows:

$_a b_e$ $_e c_f$ $_e d_a$ $_e e_f$ $_c h_b$
$_c i_a$ $_a j_a$ $_c k_d$ $_c l_a$ $_a m_b$
$_c p_e$ $_e q_a$ $_a r_d$ $_b u_b$ $_d v_d$
$_d w_d$ $_d y_d$

a (if double-storey, as here), f, g, s, t and z must be spaced visually and tested against the others.

Each letter is then tested against n and o:

anbncn ... etc.

oaoboco ... etc.

and modified as necessary. A further check then needs to be made using real text. Traditionally type companies used phrases containing all the letters of the alphabet, such as 'the quick brown fox jumps over the lazy dog'.

The system described by Tracy is for serif type, and needs some modifications for capital letters. Although these are checked against each other, bear in mind that they are more usually used with lower-case letters.

For capitals, H and O are used as the starting point, just as n and o are used for lower case. Having spaced these, other values can be deduced as follows:

a = H
b = slightly less than a
c = about half of a
d = minimum
e = O

These sidebearing values can then be applied as follows

$_d A_d$ $_a B_c$ $_e C_c$ $_a D_e$ $_a E_c$
$_a F_c$ $_e G_b$ $_a I_a$ $_d J_a$ $_a K_d$
$_a L_d$ $_b M_a$ $_b N_b$ $_a P_e$ $_e Q_e$
$_a R_d$ $_d T_d$ $_A U_B$ $_d V_d$ $_d W_d$
$_d X_d$ $_d Y_d$ $_c Z_c$

S must be spaced visually and checked against the others. As before, this is only the starting point, each letter is tested against H and O and then by setting real text. If a typeface is destined for commercial release texts in a variety of languages will need to be checked as character combinations and frequency of use vary widely and can dramatically alter the 'colour' of a face (see page 51). If this spacing is thoroughly done then the need for kerned pairs is much reduced.

Kerned pairs

These are instructions built into the font itself to tighten (or occasionally open) the character spacing of particular character combinations, and thus make them look better – it should not be used to correct a badly spaced typeface. In the example below, the *Va* and *y.* are kerned pairs.

Valley.

(Kerning and tracking are adjustments applied to a typeface by the end user. These are discussed in more detail in Chapter V.)

Kerned pairs should only be needed for awkward combinations such as

Ta Te To Tu Tr

and overhanging letters followed by punctuation,

eg F. T.

The exact amount will depend on your typeface.

The use of kerned pairs for triangular sided capital letters, although commonplace, is more problematic. Capitals should properly be tracked by the end user, which alters the appearance of the word from the way the type designer can specify.

In addition, while tightening A and V may help a word like

AVAIL

it ruins the word AVILA. A better practice would be to space all the straight-sided capitals apart and leave the sidebearings of the triangular characters unaltered.

For special typefaces or uses, kerned pairs can be used much more extensively to create overlapping and nesting letters, as seen in the example at the **top** of this column.

Structure V

Approaches to design

The preceding chapters on function, form and manufacture have examined different elements of typography: language, the development of the alphabet, ways of describing typefaces and how type is made. This chapter will explain how the components can be assembled or composed; the mechanics and poetry of structure. There are four broad approaches to typographic design: one concerned with documentation, an analytical approach, a conceptual approach and an expressive approach. These categories are not mutually exclusive and any job is likely to include more than one of them. The approach taken can reflect an individual designer's character and prejudices, or it can be intrinsic to the nature of the job.

Documentation concerns data – the message – and generally provides the starting point. Documentation records and preserves, and takes many forms: a letter, a brief, a listing, a ticket, etc. In its crudest form it can seem almost 'undesigned', pure information with no concern for audience or aesthetic nicety.

An analytical approach is well suited to the presentation of complex information and usually forms the basis for charts, diagrams, signage, timetables, maps, symbols, codes, indexing and so on. These activities share common roots in rationalism, in the examination and dissection of data, and in the understanding of the whole through an analysis of the parts.

A conceptual approach searches for the big idea that encapsulates the message. For some designers this is their prime method of communication. Conceptual design is particularly associated with cartoons, advertising, promotion and branding, though it is used across the whole spectrum of graphic design. It makes use of pun, paradox, cliché and pastiche; develops visual similes, metaphors and allegories; and combines two previously unrelated ideas to throw light on a third. Using a reductive and often simplistic approach, conceptual graphics appeal to the intellect and rely on designer and audience sharing the subtlety of wordplay.

An expressive approach appeals to the viewer's emotions. Like music, it appeals primarily to our heart: it strives through colour, mark-making and symbolism to emotionally 'reposition' the viewer. Absolute clarity is not always the intention here: this design approach is impressionistic, poetic and lyrical, inviting the viewer to reflect on the content.

Set against this background design approach, the designer is then faced with specific decisions. This 'palette' of options might be restricted – in the case of a simple book – or wide-ranging, as with the time and motion possibilities of film or new media.

Designing with type in two dimensions

The key elements of the typographic palette are based on the practice of print – despite everything that has happened since the invention of printing around 1450, the way we read has not fundamentally changed. Typography is a discipline that has historically presented language within a set of physical and intellectual borders. Its habitat is generally planar; sentences are arranged within a two-dimensional space that type sits on but does not penetrate. The structure of typography, like the design and manufacture of type, fundamentally deals with issues of vertical and horizontal space, constantly exploring the minutiae of proportional relationships within letterform and layout.

In print, the reader is presented with information that is fixed in time and in appearance, as dictated by publishers and designers. While the assumption is often that print is, by definition, linear and sequential, the reality is often very different. Once a book is produced, for instance, there is no control over how it is read or accessed: this becomes a private relationship between reader and author. In any case, not all books are intended to be sequential and linear: reference works, for instance, are designed to be accessed in a variety of ways, while many modern-day artists and writers have striven to subvert accepted notions of the linear book.

With time and experience, every designer develops an individual working method. While the order and timing of decisions within the design process may vary, the decisions that need to be made do not. To help explain the basic elements of the typographic palette the model of a simple text page will be used, with comments about other kinds of work included with each explanation and in the pictorial section on pages 126–47.

When designing such a page, a designer needs to make ten decisions: 1, typeface; 2, type size; 3, colour; 4, line length and horizontal space; 5, vertical space (leading); 6, alignment of text; 7, paragraph articulation; 8, column depth; 9, the position of text on the page; and 10, format. These are presented below from the detail outwards, although in practice designers develop different strategies for different kinds of job and the order of decision making varies widely.

1 Typeface

Typeface choices might be influenced by what is legible, what is available on a computer and by the nature of the text. Typefaces can also be chosen for historical reasons. While a novel set in Renaissance Italy or eighteenth-century Britain may benefit from the use of Bembo or Baskerville respectively, it is not a necessity. What matters is that the text is readable and attractive to its intended audience today. A broad knowledge of history – architectural and social as well as typographic – is a useful aid in the design process, but it should not become a straitjacket. Text types (often regarded as being less than 14pt) should generally be rather 'self-effacing': the idea is to read the words rather than notice the typeface. For display use, however – whether for flyers, posters, logos or websites – designers might choose something more attention-grabbing, and might give added meaning by employing a typeface with strong associative powers. Appearance, size (see pages 108–9) and colour (see pages 109–10) are not the

Legibility and readability

These two terms are often confused, and although related they are possible to separate. Legibility refers to the typeform, how easy an individual character or alphabet is to recognize when presented in a particular font. Readability encompasses both typeform and arrangement – how easily a text can be read. A wide range of factors affect this. Some are pertinent to the typographer's palette: characteristics of the font, size, use of space, colour, contrast, arrangement and structure of text, for example. Others relate to the medium of presentation, such as the screen, page or exhibition space and the ambient levels of light in the reading environment. An example is the contrast between the easily read intense luminosity of a cash dispenser screen at night, and its frustrating opacity on a sunny day: neither the font nor the structure accounts for the poor readability, merely the relative levels of illumination. It is possible to set a legible face in an unreadable way. While certain rules of thumb can serve as an aid to grasping concepts – Do you recognize the letter? If so, it's legible. Can you read a page? If so, it's readable – these tend to oversimplify the complexity of this area.

Many typographers have stated that there is no such thing as illegibility, arguing that a typeface that is not legible is not a typeface. This implies, however, that all readers, all of the time, share a common and consistent vision of letterform. Such a declaration of certainty denies the subtle change that takes place with each generation of readers, who through progressive exposure become accustomed to new letterforms. Our collective perception of what is legible is not a constant value: with every new reading the unfamiliar becomes the familiar. 𝔍f a fifteenth-century scholar living in what is now Germany, and used to reading the kinds of broken script then in use, were confronted with a screen of sans serif today, would he be able to read it? The language and the alphabet remain the same, but the letterforms, if not their arrangement, would be completely alien.

This argument does not justify the designer who arrogantly creates illegible letterforms in unreadable arrangements on the assumption that the reader will 'catch up and appreciate my genius'. Nor does it seek to deny the designer's responsibility for legibility and readability on the basis that this is a perception trapped in the minds of a generation of readers. It simply seeks to embrace an overall awareness, and strike a balance between an understanding of the historical development of the act of reading and an appreciation of what is needed to facilitate the task of today's consumers of text.

Typeface modification

Because type is digital, its outlines can be modi-
fied. Unfortunately, this facility is often misused.

Below, from left to right: Meta as designed,
with 75% and with 125% horizontal scaling ap-
plied: notice how all the vertical elements of the
typeface are distorted. Of these two examples
however, the condensed is the most noticeably
wrong. If you want condensed or expanded type,
use a condensed or expanded typeface.

BBB

Subtle use of scaling to extend or condense
characters' designed widths can be beneficial at
certain sizes and with certain types. The example
below left shows Gill Sans bold as designed and
below right with 94% horizontal scaling.

OaOa

When using italics, make sure you use the type-
face's correct italic. Most typefaces have italics
derived in part from cursive forms *eg* Swift, **below
left**, which are styled quite differently from a com-
puter generated version, **below right**. See also
Chapter III.

Qa Qa

Some italics appear to be simply sloped romans
eg Vendôme, **below left**, but even in these cases
they look different from a simple computer gener-
ated version, **below right**.

Qa Qa

Typeface customization

Some designers take a dim view of type manipula-
tion or customization – particularly those familiar
with setting text faces and versed in the tradition-
al values of book design. There are, however, both
functional and expressive reasons for manipulat-
ing a typeface.

For example, Gerard Unger's typeface Swift
has been modified for this book for functional
reasons: to visually demonstrate the body of a
typeface and what happens to a font in use.

On other occasions the needs of a particular
job may demand a specific font designed exclu-
sively for one client or commercial situation.
Newspapers are a case in point. Because they
are printed at high speed onto poor quality paper
(newsprint) the delicacy of most book typefaces
would reproduce poorly: counters would fill-in,
serifs and thins would appear too light, for exam-
ple. Most newspaper faces are considerably
more straightforward in both general design and
detailing. Shown **right**, are three generations of
newspaper typefaces superimposed on each
other to show the simplification of their forms
from the comparative delicacy of Modern no.1,
(1886), through Ionic no.5 (1926), to Excelsior
(1931). Both Ionic and Excelsior were designed by
Chauncey H Griffiths as part of Linotype's legibility
series of types, the others being Opticon, Paragon
(both 1935) and Corona (1941).

Typefaces can also be manipulated in more
expressive or painterly ways in order to convey
an emotion or evoke feeling. Such manipulation
– through blurring, bending, fracturing and slicing
– can add a range of new visual rhythms. The
example **below** was created by Jeff Keedy for the
publication which accompanied the exhibition of
the same name. His typefaces Skelter and Hard
Times are reworkings of Franklin Gothic and Times
New Roman respectively.

HELTER SKELTER
L.A. ART IN THE 1990s

only reasons for choosing a typeface; the designer should carefully consider the specific needs of each job. It is impossible to overemphasize the importance of the designer reading the actual copy, so as to gain a sense of what is involved in terms of complexity or hierarchy. From such a reading a list of questions will emerge, which in due course will lead to the making of certain design decisions. The questions to be asked might include:

— is it one text (*eg* a novel), or are there several different authors and opinions?
— is there much quoted matter?
— does the text contain many figures in the form of dates, etc.?
— are there footnotes?
— are there headings and subheads, and if so, how many levels?
— are there images? If so, how will they work (separate or integrated), and what about captions?

Other questions concerning the physical aspects of the job (see also Format on page 119) will also need answering. (For instance, what paper is being used? Is it bright or dull, matt or gloss, and does it have much show-through?)

This list is purely indicative: in reality, careful initial analysis prompts many of the specific questions. Because of this it is impossible to design effectively without a comprehensive brief and sample of material. It is the very constraints of a job that force thoughtful responses and create meaningful solutions.

Certain decisions can now be made. *Any lengthy text will almost certainly need an italic*; if there are many dates (1982–5) it may need a face with non-lining figures. **A bold may be necessary for headings or emphasis** BUT ANOTHER TYPEFACE OR STYLE MIGHT SERVE THE SAME PURPOSE JUST AS WELL. Captions and footnotes can be set in the same typeface as the main text or be given a different feel entirely. The most important factor is whether the function of each of those parts is clear. In this book, main text and footnotes are set in Swift (by Gerard Unger), a serif with generous x-height. To add visual difference, captions and side stories are set in Meta (by Erik Spiekermann), a slightly narrower sans serif typeface. Choosing complementary faces (for example when a work needs both main text and captions), particularly sans and serif, can be tricky. Choosing types by the same designer is sometimes recommended as this may ensure some commonality to each typeface's underlying structure, but this can negate the whole reason for choosing a different typeface in the first place.

Nothing beats testing choices early in the process, and computers today allow the earliest layouts to simulate the finished design. There is a relationship between type designs and the papers they were originally printed on. The types of the fifteenth to seventeenth centuries (*eg* Bembo, Caslon, Ehrhardt, Garamond, Janson), which were printed on fairly coarse papers, are quite different in their detailing to those of the late eighteenth and early nineteenth centuries (*eg* Baskerville, Bodoni, Didot, Walbaum), which were printed on much smoother stock. Those earlier types, at least as they were originally used, had a certain robustness which can look quite wrong on the smooth papers of today. Similarly, the delicacy of many modern faces will not reproduce well across a heavily textured ground. While office printers of 600 dpi are useful in producing roughs of a design on a variety of paper stocks, their resolution may mean that, at text

Type as texture: identical point size

Typefaces for use in continuous text are often chosen for their colour or texture on the page and how it relates to other elements in the design such as illustrations or photographs. This texture is created mainly, but not entirely, by the choice of typeface. These examples are set to the same point size (8·25) with 3·75mm leading. Meta.

Typefaces for use in continuous text are often chosen for their colour or texture on the page and how it relates to other elements in the design. This texture is created mainly, but not entirely, by the choice of typeface. These examples are set to the same point size (8·25) with 3·75mm leading. E&F Swift.

Typefaces for use in continuous text are often chosen for their colour or texture on the page and how it relates to other elements in the design. This texture is created mainly, but not entirely, by the choice of typeface. These examples are set to the same point size (8Æ25) with 3Æ75mm leading. Monotype Plantin.

Typefaces for use in continuous text are often chosen for their colour or texture on the page and how it relates to other elements in the design. This texture is created mainly, but not entirely, by the choice of typeface. These examples are set to the same point size (8·25) with 3·75mm leading. Monotype Times New Roman.

Typefaces for use in continuous text are often chosen for their colour or texture on the page and how it relates to other elements in the design. This texture is created mainly, but not entirely, by the choice of typeface. These examples are set to the same point size (8·25) with 3·75mm leading. Helvetica. (Apple Mac System 7·5 version).

Typefaces for use in continuous text are often chosen for their colour or texture on the page and how it relates to other elements in the design. This texture is created mainly, but not entirely, by the choice of typeface. These examples are set to the same point size (8·25) with 3·75mm leading. Monotype Gill Sans.

Typefaces for use in continuous text are often chosen for their colour or texture on the page and how it relates to other elements in the design. This texture is created mainly, but not entirely, by the choice of typeface. These examples are set to the same point size (8·25) with 3·75mm leading. Monotype Ionic.

Typefaces for use in continuous text are often chosen for their colour or texture on the page and how it relates to other elements in the design. This texture is created mainly, but

not entirely, by the choice of typeface. These examples are set to the same point size (8·25) with 3·75mm leading. Palatino (Apple Mac System 7·5 version).

Typefaces for use in continuous text are often chosen for their colour or texture on the page and how it relates to other elements in the design. This texture is created mainly, but not entirely, by the choice of typeface. These examples are set to the same point size (8·25) with 3·75mm leading. Monotype Perpetua.

Typefaces for use in continuous text are often chosen for their colour or texture on the page and how it relates to other elements in the design. This texture is created mainly, but not entirely, by the choice of typeface. These examples are set to the same point size (8·25) with 3·75mm leading. Adobe Futura.

Type as texture: constant x-height

Typefaces for use in continuous text are often chosen for their colour or texture on the page and how it relates to other elements in the design such as illustrations or photographs. This texture is created mainly, but not entirely, by the choice of typeface. In these examples the types have been resized to an approximately equal x-height with 3·75mm leading. 8pt Meta.

Typefaces for use in continuous text are often chosen for their colour or texture on the page and how it relates to other elements in the design. This texture is created mainly, but not entirely, by the choice of typeface. In these examples the types have been resized to an approximately equal x-height with 3·75mm leading. 8·25pt E&F Swift.

Typefaces for use in continuous text are often chosen for their colour or texture on the page and how it relates to other elements in the design. This texture is created mainly, but not entirely, by the choice of typeface. In these examples the types have been resized to an approximately equal x-height with 3Æ75mm leading. 8Æ75pt Monotype Plantin.

Typefaces for use in continuous text are often chosen for their colour or texture on the page and how it relates to other elements in the design. This texture is created mainly, but not entirely, by the choice of typeface. In these

examples the types have been resized to an approximately equal x-height with 3·75mm leading. 8·5pt Monotype Times New Roman.

Typefaces for use in continuous text are often chosen for their colour or texture on the page and how it relates to other elements in the design. This texture is created mainly, but not entirely, by the choice of typeface. In these examples the types have been resized to an approximately equal x-height with 3·75mm leading. 7·75pt Helvetica. (Apple System 7·5 version).

Typefaces for use in continuous text are often chosen for their colour or texture on the page and how it relates to other elements in the design. This texture is created mainly, but not entirely, by the choice of typeface. In these examples the types have been resized to an approximately equal x-height with 3·75mm leading. 8·6pt Monotype Gill Sans.

Typefaces for use in continuous text are often chosen for their colour or texture on the page and how it relates to other elements in the design. This texture is created mainly, but not entirely, by the choice of typeface. In these examples the types have been resized to an approximately equal x-height with 3·75mm leading. 7·25pt Monotype Ionic.

Typefaces for use in continuous text are often chosen for their colour or texture on the

page and how it relates to other elements in the design. This texture is created mainly, but not entirely, by the choice of typeface. In these examples the types have been resized to an approximately equal x-height with 3·75mm leading. 8·25pt Palatino (Apple Mac System 7·5 version).

Typefaces for use in continuous text are often chosen for their colour or texture on the page and how it relates to other elements in the design. This texture is created mainly, but not entirely, by the choice of typeface. In these examples the types have been resized to an approximately equal x-height with 3·75mm leading. 10·7pt Monotype Perpetua.

Typefaces for use in continuous text are often chosen for their colour or texture on the page and how it relates to other elements in the design. This texture is created mainly, but not entirely, by the choice of typeface. In these examples the types have been resized to an approximately equal x-height with 3·75mm leading. 8·65pt Adobe Futura.

sizes, some of the subtleties of the typeface design are rendered mute or, perhaps worse, mimicked cruelly.

If the job is for screen, different factors apply. For television and on computers the resolution of the monitor is a major problem. The 625 lines of a television and the 72 or 96 dpi of a computer screen are both very crude when compared to the 1,500 dpi (and higher) resolution used for print, and this can render many typefaces unreadable at certain sizes, particularly when they are reversed out. Some of the special needs of web typography are discussed in the side story.

Away from the rigours of text typography, the reasons for choosing typefaces differ. As indicated above, a principal reason is often novelty, or at least what will be noticed. The subject matter of a particular job can sometimes suggest a particular typeface, and its connotations – real or imagined – can be used as primary communicative elements. Choice of typeface is only one ingredient in the equation, however: many designers restrict themselves to a limited range of typefaces but use size and colour to make an impact.

It is a good idea to collect examples of typefaces and keep them for reference. These can come from obvious sources such as manufacturers' or retailers' catalogues or advertisements, but they might also include press cuttings of type in use. These samples do not have to be exemplary: in fact, specimens of type or treatments which do not work can be equally instructive.

2 Type size

As discussed in Chapter IV, it is important to bear in mind that the apparent size of a typeface, as viewed, is not the same as its point size. It is the visual x-height of the typeface that should be the guiding factor, not its nominal size.

Different kinds of work have their own requirements, and the context in which the work will be seen should be carefully considered. Books and magazines for adults are normally set in type of around 8·5 to 10 pt, but children and the elderly may need larger type. Type for signage needs to take account of the intended viewing distance (and speed) of the audience (see also page 147): an advertising poster for use on a rail network will need to be designed differently depending on whether the display sites are to be on the platform or to be seen across the tracks. Against these general observations should be set the fact that type can also be set at an unexpected size for effect. Large type in a book can suggest children's text, small type on a poster can draw the viewer in.

One problem with type size is related to the way type is measured. As discussed in Chapter IV, point size refers not to the appearing size of the type but to the 'body' on which it is made. There is no substitute for testing your typeface choice. The examples opposite show how different several typefaces can look when set at the same point sizes.

3 Colour

Colour in typography can mean one of three things. The first concerns the relative shade or tonal value of a particular typeface or style. Old printers referred to text as 'grey matter' and type is often chosen for its colour on the page. This can be affected by the general proportions of the face, the relative disposition

clickme gif (1541 bytes)

Type and the web

There are three main ways of using typefaces for web publishing. Using standard TrueType fonts (such as those specially commissioned by Microsoft and supplied with their web browsers) in the HTML code ensures that your design will display well on screen for the majority of users. An added benefit is that text remains 'live' and the reader is able to cut and paste as though it were on their own computer.

If standard fonts do not give the right feel to a page or site, the most widely used alternative is to turn areas of text into graphic objects (basically pictures) which are usually saved as GIFs or JPEGs. The advantage is one of typeface choice, the disadvantage is uneditable text and increased download time.

A third alternative (not fully functioning at the time of writing) is to embed fonts in the web page information. Bitstream and Microsoft are the two major companies involved, but at present there are many unresolved issues concerning browser, font format and platform compatability.

RGB and CMYK colour

Colour for use on screen is made from light and is sometimes described as 'additive colour'. The light colours are made from the three primaries – red, green and blue, abbreviated to RGB – which can be mixed in any combination and percentage value. If all three primaries are combined at 100% the result is white, and if all three are combined at 0% the result is black.

Colours for print are pigment-based and are specified in two basic ways. Specific colours for single, two-colour or three-colour printing are known as spot colours and are usually chosen from a colour matching system such as Pantone. Spot colours can also include specials such as metallic or luminous colours and varnishes.

When printing full-colour however, the usual method is to create colours from the pigment primaries cyan (blue), magenta (red) and yellow. When all three are mixed together at 100% the resulting colour will be black, and if mixed at 0% it will be white or the colour of the paper (hence the name 'subtractive colour'). Because of the impurities in pigments, however, black is added to the primaries to build up the depth of tone. This is known as CMYK (black = K for key). It is usually printed on a four-colour press, which allows all four to be printed 'wet-on-wet' in a single pass of the sheet through the machine.

Type and contrast

100% contrastcontrast
90% contrastcontrast
80% contrastcontrast contrastcontrast
70% contrastcontrast contrastcontrast
60% contrastcontrast contrastcontrast
50% contrastcontrast contrastcontrast
40% contrastcontrast contrastcontrast
30% contrastcontrast contrastcontrast
20% contrastcontrast contrastcontrast
10% contrastcontrast contrastcontrast
contrastcontrast

Legibility is affected by the degree of contrast between type and its background. For clarity, the difference between them should be no less than 30%. When using tinted backgrounds as above, notice how the almost monoline construction of sans serif type is clearer.

of thick and thin around the character shapes, the presence or absence of serifs and the shape of any serifs. A seriffed typeface, because of the serifs themselves and the thick and thin stems of the characters, will give a block of text a more interesting visual texture than the same text when set in sans serif.

It can also refer to the actual colour of ink used in printing. Traditionally, text in books has always been printed black, with red usually the second colour either for featured initials or for instructions. This suited both printing and reading. Today, the cost and ease of four-, five- and six-colour printing mean that colour can be widely exploited to reinforce a message, and in many kinds of work black is notable by its absence. With books, however, the practical needs of the reader come first and black still remains the usual colour for continuous text.

Colour can also describe the background on which the type sits, and as such has a large part to play in terms of readability. This background colour could be printed, as on this page which has a 5% yellow tint added, or could be the colour of the paper itself. The whole relationship of type to ground, and the tonal and colour differences between them, should be carefully considered, as demonstrated by the diagrams below left. While the 100% contrast between black type and a white ground is theoretically best for legibility, it can be uncomfortable to read. In novels or other books containing only text, paper is usually off-white. Those suffering from dyslexia also find a reduced contrast between type and background helpful, and pastel shades of paper are often recommended for their needs.* Illustrated books, however, can be a problem as images (particularly photographic) reproduce better on smooth, coated white papers. While we are arguably more used to reading type on these papers than previous generations, some types fare better than others. Typefaces with abrupt contrast between thicks and thins can give a somewhat dazzling effect which can prove tiring to the eye.

The problem of contrast is potentially more acute in on-screen environments because of screen glare. For this reason information is often presented against a coloured ground, or is designed primarily to be downloaded and printed out (often at the viewer's specification). Designers have less control over the final appearance of their work when producing for on-screen viewing compared to designing for print.

4 Horizontal space: line length, kerning & tracking and word space

When reading we do not read individual letters, or even individual words: the eye travels along each line, reading groups of words. In running text, the three factors which have most bearing on readability are type size, line length (or 'measure') and leading. For continuous reading, around 65 characters per line is considered optimum, but anything between 45 and 75 can be made to work with careful choice of leading (see 5 on page 113) and use of the hyphenation and justification (H&Js; see Chapter VI).

* Useful information about the needs of dyslexic readers can be found at *www.interdsy.org* and *www.bda-dyslexia.org.uk*

Lines of twelve words are considered optimum for easy reading. These lines contain only ten at best but because of the nature and brevity of the text, readability is not compromised.

Very short lines are tiresome to read, especially if justified (see 6 on page 114).

Longer lines can be made more readable by using more generous leading (but see 5 overleaf).

While the line length, which in today's software is often specified as the width of the text box, is the most obvious use of horizontal space within a page, the subtle relationships between letters and between words should also be considered here. At a basic level these are part of each typeface's design (see Chapter IV) but there are often good reasons for wanting to adjust either or both of these and software programs allow this. Altering the space between pairs of characters is known as kerning while an adjustment to whole words or paragraphs is tracking; often the terms are used interchangeably.

The inter-character spacing can be tightened, o r opened out. This should only be used subtly to improve the readability and look of text rather than to make it fill a pre-determined space. Small type (*eg* below 9pt) can sometimes be improved by positive tracking; headings or large type are sometimes better with negative tracking.

Kerning and figures

In addition to a general kerning of text, kerning can be applied between specific pairs.The numerals in the majority of typefaces all occupy the same character width to enable the tabular setting of figures:

£101·10
3·51
14·61

When setting dates containing the figure 1, however, this presents something of a problem as it can appear separate from the rest. Kerning will remedy this.

before 1958 after 1958

Tracking and halation

Halation is the effect of white (or light) spreading against a dark background. This effect can impair the legibility of text set white-out-of-black (reversed out) because individual letters can appear to merge into each other. This effect is more pronounced with back-lit type and careful adjustments need to be made to such type to ensure its legibility.

Tracked -2, word space 85% (as black type in all side stories)
The usual way to improve the legibility of reversed out text is by tracking. The effects of various amounts of tracking are demonstrated here. At small sizes the choice of typeface is also important, the thins and serifs of some serif types have a tendency to 'fill-in' with ink and may even disappear entirely.

Tracked 0, word space 100%
The usual way to improve the legibility of reversed out text is by tracking. The effects of various amounts of tracking are demonstrated

here. At small sizes the choice of typeface is also important, the thins and serifs of some serif types have a tendency to 'fill-in' with ink and may even disappear entirely.

Tracked +4, word space 100%
The usual way to improve the legibility of reversed out text is by tracking. The effects of various amounts of tracking are demonstrated here. At small sizes the choice of typeface is also important, the thins and serifs of some serif types have a tendency to 'fill-in' with ink and may even disappear entirely.

Perpetua tracked 3, word space 100%
The usual way to improve the legibility of reversed out text is by tracking. The effects of various amounts of tracking are demonstrated here. At small sizes the choice of typeface is also important, the thins and serifs of some serif types have a tendency to 'fill-in' with ink and may even disappear entirely.

The size of the word space is determined by the type designer and is usually about a quarter of the point size in width (*ie* 250 PostScript units), similar to the width of the letter i.

This 'designed' width is often too wide when text is set in upper and lower case and can be overidden by use of the H&J settings available in most programs. In this paragraph, and throughout the main text of this book, it has been reduced to 85% of its designed width.

When setting justified text, as described in 6 overleaf, the word space – of necessity – is allowed to vary in width from one line to the next.

5 Vertical space: leading

Leading is the invisible framework running vertically down a page, and together with type size and line length it has the greatest effect on the readability of a piece of printed text. Its exact definition changes according to technology:

In the days of metal type the term 'leading' was used to refer to the strips of lead which could be inserted between each line of type as an aid to readability and, to a degree, aesthetic effect. This example would have been described as 24pt type with 12pt leading. Type without leading was described as 'set solid'.

Leading is now used to describe the distance from one baseline to the next. This example is now described as 24pt type with 36pt leading. (When the leading is the same value as the type size it can be described as 'set solid').

Because type is now computer data and not a material object, it is possible to specify negative leading and to create a visual texture. There is a time and a place for effects like this, which draw attention to themselves and arguably engage the reader more – although they make reading very difficult. In this example the 24pt type is leaded 5mm (14·173 pt).

The opposite effect is shown here with 25mm leading (70·866 pt): far too much for these few lines: it destroys the unity of the text.

Incremental leading

When pages contain different columns of text with type set at differing amounts of leading, designers often use related values for the leading to help unify the design.

In this book the main text is set with 5 mm leading and caption and side stories set with 3·75 mm. Every fifth line of this story therefore aligns with every fourth of the main text.

Although it is more usual to specify leading in points, we have chosen to use millimetres rather than points in order to use one unit of measure for both horizontal and vertical dimensions and to make image placement easier.

Leading is as responsible for the texture of type on a page as typeface and type size. For continuous text, setting text 'solid' is seldom recommended unless the typeface has a small x-height (eg Perpetua) or is small on its body (eg Matrix). For this reason, in some programs leading has a default value which is usually a percentage (eg 120%) of the largest type size in a line. While this can prevent bad setting in some circumstances, in more demanding kinds of work where accurate placement of type and other elements is essential, it makes it virtually impossible to know exactly where a particular line or piece of type is. By specifying the leading as definite values instead, everything is measurable and accurate.

To provide unity throughout long or complex documents containing different kinds of text, leading can be used to create an invisible underpinning for the whole design. A leading value will be decided for the main text and values for captions, notes and endmatter will be established, not arbitrarily but in a related fashion. Although usually expressed in points, leading can be specified in whatever units the designer chooses. The particular specifications for this book are outlined in the side story, Incremental leading.

6 Alignment of text

There are four principal ways in which type is aligned: ranged left, ranged right, centred and justified. Each derives from slightly different practice and has particular advantages. There is no good reason – other than fashion – why several of these shouldn't coexist in the same document.

This style of alignment is known as RANGED LEFT (ragged right or flush left in the US). Although this is the way we write, until the twentieth century it was rare to find a printed book set like this. Eric Gill was an early advocate

of this style, arguing its efficacy by word and example in *An essay on typography* (1931). There are differing opinions about whether ranged left text should be hyphenated or not. If it is not, the right-hand margin can look extremely messy.

This is RANGED RIGHT setting (ragged left or flush right in the US). Because the start of each line is movable, and therefore potentially difficult for the eye to find, this style of alignment hinders the reading process. It is generally reserved for captions or short passages of text where its deficiencies are less noticeable.

This is CENTRED alignment
– LIKE A TITLE PAGE –
MADE POSSIBLE BY TYPE*
and is mainly used for display.
Although shunned by modernists
in their haste to appear 'different'
it was used masterly by
BRUCE ROGERS, (the post-war) JAN TSCHICHOLD
& HANS SCHMOLLER

* '[…] to write around a central axis is laborious, and can only be done following a completed first draft. There is, however, no great difficulty in centring lines of type, and the compositors of the first title pages that can really be described as such – from around 1500 – made immediate use of this possibility'. Jost Hochuli & Robin Kinross, *Designing books: practice and theory*, London, Hyphen Press 1996, p.18

Spacing variations in ranged-left text

Meta, tracked -2, word space 85%

The width of the word space is defined as part of type design but can be overridden in H&Js, usually by specifying a percentage. Its preferred width should rarely be more than 100%, and in many cases a smaller word space looks far better.

Meta, tracked 0, word space 85%

The width of the word space is defined as part of type design but can be overridden in H&Js, usually by specifying a percentage. Its preferred width should rarely be more than 100%, and in many cases a smaller word space looks far better.

Meta, tracked -2, word space 110%

The width of the word space is defined as part of type design but can be overridden in H&Js, usually by specifying a percentage. Its preferred width should rarely be more than 100%, and in many cases a smaller word space looks far better.

Meta, tracked 0, word space 110%

The width of the word space is defined as part of type design but can be overridden in H&Js, usually by specifying a percentage. Its preferred width should rarely be more than 100%, and in many cases a smaller word space looks far better.

Plantin, tracked 0, word space 85%
The width of the word space is defined as part of type design but can be overridden in H&Js, usually by specifying a percentage. Its preferred width should rarely be more than 100%, and in many cases a smaller word space looks far better.

Plantin, tracked 0, word space 110%
The width of the word space is defined as part of type design but can be overridden in H&Js, usually by specifying a percentage. Its preferred width should rarely be more than 100%, and in many cases a smaller word space looks far better.

```
Typefaces based on those used
by mechanical typewriters are modu-
lar, that is, they have characters
of uniform width. To set them any-
thing other than ranged left would
be to deny their essential design
characteristics. Courier.

Modular typefaces, that is,
typefaces with characters of
uniform width should always be
set ranged left in keeping
with their essential design
characteristics. OCR-B tracked
-5.
```

Spacing variations in justified text

Meta tracked -2, word space 60/75/125%

For justified setting, values can be specified for minimum, optimum and maximum word space widths; for the number of permitted consecutive hyphens at line endings and whether or not to break capitalized words. Different line lengths and typefaces will affect what is desirable here, a wider column will need far less variation than a narrow one. The programs also allow for variation in letterspace, but there are rarely good reasons to resort to using it: letters should seldom be spaced out to compensate for a poorly chosen relationship of type size and leading to line length.

Meta tracked -2, word space 85/110/250%, inter-character space -10/0/10%, unlimited hyphens

For justified setting, values can be specified for minimum, optimum and maximum word space widths; for the number of permitted consecutive hyphens at line endings and whether or not to break capitalized words. Different line lengths and typefaces will affect what is desirable here, a wider column will need far less variation than a narrow one. The programs also allow for variation in letterspace, but there are rarely good reasons to resort to using it: letters should seldom be spaced out to compensate for a poorly chosen relationship of type size and leading to line length.

Plantin tracked 0, word space 60/75/125%

For justified setting, values can be specified for minimum, optimum and maximum word space widths; for the number of permitted consecutive hyphens at line endings and whether or not to break capitalized words. Different line lengths and typefaces will affect what is desirable here, a wider column will need far less variation than a narrow one. The programs also allow for variation in letterspace, but there are rarely good reasons to resort to using it: letters should seldom be spaced out to compensate for a poorly chosen relationship of type size and leading to line length.

Plantin tracked 0, word space 85/110/250%, inter-character space 0/0/4%, unlimited hyphens

For justified setting, values can be specified for minimum, optimum and maximum word space widths; for the number of permitted consecutive hyphens at line endings and whether or not to break capitalized words. Different line lengths and typefaces will affect what is desirable here, a wider column will need far less variation than a narrow one. The programs also allow for variation in letterspace, but there are rarely good reasons to resort to using it: letters should seldom be spaced out to compensate for a poorly chosen relationship of type size and leading to line length.

Plantin tracked 0, break capitalized words, word space 50/70/150%

For justified setting, values can be specified for minimum, optimum and maximum word space widths; for the number of permitted consecutive hyphens at line endings and whether or not to break capitalized words. Different line lengths and typefaces will affect what is desirable here, a wider column will need far less variation than a narrow one. The programs also allow for variation in letterspace, but there are rarely good reasons to resort to using it: letters should seldom be spaced out to compensate for a poorly chosen relationship of type size and leading to line length.

Plantin tracked 0, word space 85/110/250%, inter-character space 0/0/4%, unlimited hyphens

For justified setting, values can be specified for minimum, optimum and maximum word space widths; for the number of permitted consecutive hyphens at line endings and whether or not to break capitalized words. Different line lengths and typefaces will affect what is desirable here, a wider column will need far less variation than a narrow one. The programs also allow for variation in letterspace, but there are rarely good reasons to resort to using it: letters should seldom be spaced out to compensate for a poorly chosen relationship of type size and leading to line length.

Although the differences in these settings are subtle, over a full page they contribute greatly to both easy reading and a more even visual texture: the versions with narrower word space are uniformly better. All these examples were set in Quark XPress 4·1.

A disruptive, vertical stacking of word spaces is known as a river

This is JUSTIFIED text, the conventional way of setting copy for books since *c*.1450. The even right-hand edge is achieved by altering the width of the word space from one line to the next and by allowing words to be hyphenated. If the line length is too short (see page 111) the word spaces on adjacent lines can create unsightly vertical holes, known as rivers. The size of word space, how much it can vary in size, and the frequency of hyphenation are controlled by H&J settings. The designer should edit these rather than trust a program's defaults.

7 Paragraph articulation

A paragraph represents one unit of thought and as such, one needs to be distinguished from another. The amount of articulation a designer gives the paragraph break should come directly from a sympathetic understanding of the text. The basic typing convention is to use a single line space. Some designers follow this practice, arguing simplicity in its favour. Although it requires the minimum of effort to implement, it can give the impression that the text is a series of fragments rather than a whole.

¶The neatest way to indicate the beginning of a paragraph is an indent, which derives from the omission of the symbol (¶) that was originally used. Older typography books always suggested an indent of one em (*ie* equal to the type size) but a value equal to the leading is often clearer. Paragraphs starting 'full out' (that is, without an

indent and with no extra leading like this one) may be indistinguishable from the previous paragraph if the latter ends with a full, or almost full, line.

In addition to a line space, an indent or full out paragraphs, there are other possibilities. This paragraph has a hanging indent (occasionally called 'an exdent'). ¶Paragraphs can simply run on with the break indicated by a paragraph symbol or some other mark.

Drop-lines could also be used. Circumstances and invention will suggest other ways.

8 Column depth

It has been noted that many examples of fine printed books throughout history have column depths of around 40 lines, but constraints of page size and format are often a limiting factor. As with all these decisions, the nature of each specific job should be the guide rather than blind acceptance of a norm. In books which are text only, the comfort of the reader should be paramount, while the presence or necessity for running heads, folios, footnotes, captions or illustrations are all factors that will need consideration.

In other kinds of book, space may not be at a premium nor may there be as much text. Space in these cases can be used more freely, with type occupying only part of the page area. A common mistake when first designing is to try and fill space rather than to use it meaningfully.

This idea of column depth is nonsensical when applied to web usage. Text, as well as being linear in narrative structure, can also be linear in arrangement, harking back to the papyrus rolls used before the emergence of books.

9 Position of the text block on the page

From an aesthetic standpoint, there are several ways of approaching this decision. A design can be arrived at from the outside in, working back from the format of the page and establishing the margins. Jan Tschichold made a detailed study of the way that medieval scribes and early printers derived

the position of the text block using the diagonals of the single page and the double page opening to create balanced pages. This is explained in more detail on page 125.

This apparently simple symmetry which characterized the work of the early printers is still very much used today, albeit with much reduced marginal proportions. Although it could be dismissed as traditional, for many types of printed matter it works well: if I sit down to read at the end of a long day or on the bus I want to read without the interruptions of gratuitous aesthetics.

Asymmetry gives a different – some would argue, contemporary – feeling to a book, and can be very useful in allowing space for a marginal column to contain notes and images. Compared with the balance inherent in the traditional symmetrical approach, an asymmetrical design can be far more dynamic and support a greater variety of elements within the one related design. In many books both symmetry and asymmetry work together: in this one, for example, individual pages are treated asymmetrically, while the spread forms a symmetrical whole.

10a Format

Format concerns the shape and size of a job, whether that be the trimmed size of a book or the number of pixels and their aspect ratio on a computer monitor (see also 10b on page 148).

In some cases the format (and even the medium) may be entirely unknown at the start and only becomes clear after a careful analysis of the needs of the material and a consideration of the target audience. In other cases, particularly in publishing where books need to fit in with an existing list, the format can be a given: something outside the designer's control.

Between these two extremes lies a range of practical considerations concerning paper and press sizes for print and aspect ratio for screen. These latter concerns are discussed under 10b on page 148. Much general commercial printing utilizes the metric ISO paper sizes (A4, A3, etc.). Their use confers several benefits to the designer: a wide range of paper and board is available in several of the key sheet sizes and many printing presses are sized accordingly; the sizes are related and their proportions constant; and they constitute a worldwide, easily understood standard. While an 'A' sheet size is often the starting point, the final designed work does not have to be. As can be seen on page 123, other, perhaps more harmonious or practical proportions for books can be arrived at by trimming one or more edges.

When considering format, one should also look at the role illustrative material might play in the work. While some illustrations may be supplied as computer data, transparencies are still common and they have their own range of formats – 35 mm (35 × 25 mm); 6 × 7 cm; 6 × 9 cm; 5 × 4 in; and 10 × 8 in – whose proportions can be used to dictate the design. In many cases photographic material may not be cropped and in book work the proportions of the original material can be used to help determine the format and the design.

place words may fly abroa

sound || nor to vary with the

having been verified in proo

ground || this is a printing offic

There is no English word whie

reading', so a few English-sp

to mean just that. Others thi

alone, and they use 'informa

not understand typography u

difference in typography' in *Typography papers* 4, p.130 ● A book or a bin

just as there are houses whic

scarcely feel at home in them

imposed and self-imposed co

force each other, the consequ

alytics; the arbitrary is min

then, two typographies, as the

not to perish on waves of
ter's hand ‖ but fixed in time
Friend you stand on sacred

ce Ward, first used on a broadsheet to promote Monotype Perpetua Titling in 1932, reprinted in 'I am a communicator', p.52 ●

offers the sense of 'design for
kers use the word typography
that 'typography' is best left
n design' instead. [...] we will
l we understand reading Paul Stiff, 'Spaces and

g can also be too cultivated,
are so well-kept that one can
, *Rightness and lightness: thoughts on the book as object of use*, 1990, p.23 ● When all the
traints thus interact and rein-
t design only synthesizes an-
zed Anthony Froshaug, *Typographic norms*, 1964, p.5 ● ¶There are,
are two worlds; &, apart from

The golden section

When a shape (or number) can be divided and the relationship between the smaller and the larger is the same as between the larger and the whole it represents the golden section. In algebra it is expressed $a : b = b : (a + b)$. Its approximate decimal value is $1 : 1.61803$.

An example in numbers is the Fibonacci sequence – 0 1 2 3 5 8 13 21 34 55 89 144 etc. – a logarithmic spiral of increase where the sum of each pair creates the next ascending number.

A golden section rectangle can be derived from a square, **right**. The square is divided in half, and the diagonal of the half square is used to create an arc. Half a square plus the extra area so described is a golden section rectangle.

A square relates to the golden section rectangle in other ways too. If two squares with sides equalling the rectangle's short side are placed within the rectangle itself, the overlap creates a shape known as the extended golden section (**far right**).

If a square is subtracted from the rectangle a new golden section remains (**main diagram**): the relationship between the square and rectangle is always constant. When squares and rectangles are represented in sequence the length of the side of each succeeding square is a figure in the Fibonacci sequence and a logarithmic spiral appears.

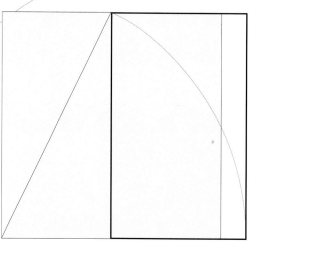

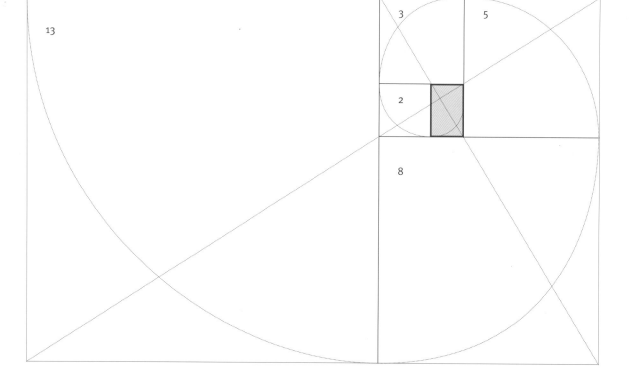

13

3

5

2

8

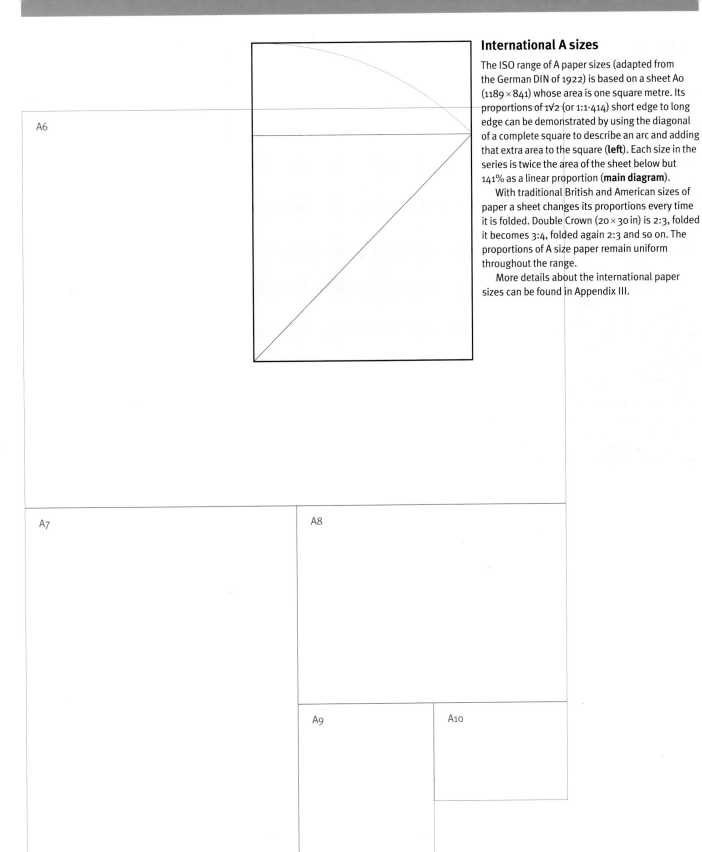

International A sizes

The ISO range of A paper sizes (adapted from the German DIN of 1922) is based on a sheet A0 (1189 × 841) whose area is one square metre. Its proportions of 1√2 (or 1:1·414) short edge to long edge can be demonstrated by using the diagonal of a complete square to describe an arc and adding that extra area to the square (**left**). Each size in the series is twice the area of the sheet below but 141% as a linear proportion (**main diagram**).

With traditional British and American sizes of paper a sheet changes its proportions every time it is folded. Double Crown (20 × 30 in) is 2:3, folded it becomes 3:4, folded again 2:3 and so on. The proportions of A size paper remain uniform throughout the range.

More details about the international paper sizes can be found in Appendix III.

A6

A7

A8

A9

A10

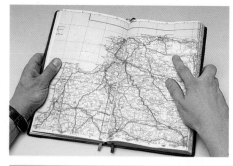

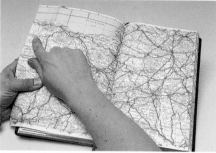

Binding

The methods of binding books and pamphlets affect the way in which they open and their ability to lie flat just as much as the choice of paper or page size and proportion.

Some common methods of bindings are:

Spiral binding (every page is separate and the document can open completely flat).

Perfect binding (every page is separate and glued into a paperback cover).

Section sewn, paperback cover (sheets are folded and gathered into sections which are then thread-sewn before gluing into the spine).

Section sewn, case-bound (sheets bound and sewn as above but held in board covers with the addition of endpapers).

Sometimes, a job requires a non-standard binding. In the example **above**, an atlas (*Readers' Digest AA book of the road* from 1966), the problem of turning the page without getting lost is solved by a fold-out on the right hand edge of each spread. Because this makes the foredge too thick, the sections of the book on either side of the map section are cut short and used for the index.

From the ten elements to unified design

Down the ages, design schools, movements, individuals and even certain printers and publishers have developed their own particular take on the typographic palette, each producing work that demonstrates distinctive visual characteristics. The discerning eye is able to recognize visual authorship and identify a piece of work as being 'Swiss' or 'Dutch', belonging to the Basel School or being by Tomato, and place it in context. Some schools, movements and individuals have sought to impose upon their students or followers a set of principles which must be adhered to. This approach to design training often presents the typographer's palette in an overly prescriptive way, and at worst forces students to absorb the dogma and prejudice of their teacher. A less deterministic approach to design education seeks merely to explain the elements of the palette and enable the design student to develop his or her own solutions.

No two typographers or designers will approach a job in an identical way. Although the palette remains the same, the order and nature of its use will be personal and original. Some begin by making decisions about details such as typeface and size, and then work towards the overall structure by making decisions about space. Others rough out tiny sketches, realizing the whole in miniature, review them on paper and establish the big picture before deciding on the detail.

On the following 22 pages we present a selection of work illustrating a variety of approaches to some typographic problems. Some have been chosen to illustrate good practice, others show innovative solutions. Still others have been paired to indicate contrasting approaches or results. Rather than show obviously 'new' and 'exciting' work, we have made effectiveness our main criteria. As far as possible, the examples have been reproduced at their actual size.

Page formats
and the position of the text area

Much of the appeal of books lies in the way they feel: size and proportion are key aspects of this. Since the earliest times certain page proportions have been used more than others and have proved themselves highly effective. A few of the more common ones are shown here.

The divisions of this sample page (with proportions 1:2) are based on Jan Tschichold's studies of medieval manuscripts and early printed books. The diagonals used to determine the text area and position are known as Villard's Diagram – a canon of harmonious division – and can be used with any page proportion.

As shown on this right-hand page, the point at which the diagonals cross is one third across, and one third down the page. The page can therefore be divided into sixths, ninths (as here), or twelfths. The text block then starts one unit in from the spine and down from the head, and three of its corners are defined by the diagonals. See Tschichold's *The form of the book* (pages 36–64) for a fuller description.

In use, this construction is generally adapted after taking account of the extent of the book and its binding: often the text block will need to be moved a little outwards, what matters is the harmonious appearance of the finished book and not how slavishly the diagram has been followed.

We arrived at the format of *Type & typography* after considering the needs of the material – main text, footnotes, side stories, illustrations and captions – and the publisher's suggested size range. Although wider than the 'ideal' formats shown, it allows three columns of text or pictures within the overall text/picture area which is arranged on the single and double page diagonals but with reduced margins.

1:2

5:9

3:5 1:1·61803 (21:34) Golden Section

5:8

2:3

1√2 (1:1·414) ISO A series

3:4

Grids and structures

Much has been written about grids as ways of structuring a book's content. For the generation of post-World War II Swiss designers such as Max Bill, Emil Ruder and Josef Müller-Brockmann, an exploration of the possibilities of grid structures was an honest attempt to order information effectively, a particular problem in a trilingual country. Their work, with its simple use of repetitive columns or squares and text set in ranged-left sans serif type, became the inspiration for the international Modern style.

Of a slightly later generation, Jost Hochuli's work began with similar concerns but, realizing the limitations of what at times proved to be a

Many signs are constructed within an imaginary square, so a square grid seemed appropriate as the design basis for the pages of this book. Each page is divided into 3 x 5 = 15 squares. The length of the side of the square relates to the type size and inter-line spacing (leading) of the marginal (caption) column: 11 lines of 7 on 10 point, measured from the top of the ascenders of the first line to the base line of the last. The firm which did the typesetting operates on the basis of the Didot point system (fractionally larger than the American-British point). Since the squares are not optically filled out, the foredge and gutter margins can be relatively narrow. To prevent the main column of text from appearing too wide or standing too close to the foredge or gutter, it has been made narrower than the width of two squares plus intervening space. For the same optical and practical reasons, the marginal columns have been displaced to the left in relation to the grid. (In all cases, the grid is only an aid to design, not an article of faith!) The positioning of the double-page spread is asymmetrical in relation to the central axis of the binding, but this is noticeable only in exceptional cases.

Letters are signs. When assembled into words, lines and columns they produce new signs, supersigns of a typographical and linguistic kind. 'In terms of sign theory, a page, a double-page spread, indeed the complete printed product, is seen as a structured whole of a higher order, i.e. a supersign, formed by combination of the linguistic and the typographical codes.' (Jegensdorf)

For this reason, the typographical structure of this booklet on 'Signs', that is to say the underlying page grid, is for once

42

revealed and explained. Of the previously published works in the Typotron series, Nos 1, 2 and 6 are also designed on the basis of a page grid, while the others follow a different principle of design.

dogmatic approach to grids, Hochuli began to incorporate other structures and styles. His book, *Designing books*, sums up a lifetime of grappling with meaning and content and giving both of these visible form. *Signs* by Adrian Frutiger (1989) number 7 in Jost Hochuli's Typotron series **(this spread)** discusses grids as part of its text, but stresses the need to modify the design 'idea' and make it work aesthetically.

The handbook of sailing by Bob Bond (Dorling Kindersley, 1980) shows how a simple grid structure can be used in a more everyday context **(pages 128–9)**. Much of the book is a manual with specific topics explained one spread at a time. The main text is set in two columns of justified

Centre mainsheet techniques

Many high performance dinghies are fitted with a centre mainsheet system (see page 50), which gives the helmsman greater control over the shape of the rig than an aft mainsheet. However, because the system is fitted in the centre of the boat, it impairs the helmsman's freedom of movement across the boat and different methods of tacking and gybing are needed from those described in Basic sailing. An alternative method for each manoeuvre,

designed for boats with centre mainsheets and long tiller extensions, is described below. These differ from the standard aft mainsheet methods in that the helmsman crosses from one side of the boat to the other near the transom facing forwards. When tacking he keeps hold of the tiller extension and the mainsheet throughout the manoeuvre giving him constant control. The helmsman moves across the boat without pausing to change hands on the tiller extension,

Tacking

It is important when tacking that the helmsman and trapezing crew coordinate their movements so that the boat is balanced. The crew must move in and out quickly on the trapeze.

1 Helmsman checks to windward. If clear, instructs crew: "Ready about". He unjams mainsheet, and crew unjams jib sheet.

2 Crew replies, "Ready". Helmsman begins to move in and eases mainsheet as crew comes in and unhooks from trapeze ring.

3 Helmsman puts back foot across boat, pushes tiller firmly away. Crew also puts back foot across boat.

Gybing

When gybing, the helmsman takes hold of the mainsheet or falls (the part of the mainsheet running between the pulley blocks) to guide the boom across. This prevents it moving across too violently.

1 Helmsman balances boat as necessary, checks to leeward. If clear instructs crew: "Stand by to gybe". Cleats mainsheet.

2 Helmsman and crew each place back foot across boat. Helmsman revolves tiller extension over and aft to new windward side, leaving tiller central.

3 Helmsman changes hands on tiller extension behind back. Grasps mainsheet or falls. Crew moves into centre of boat, keeping old jib sheet and grasping new one.

so less time is wasted in the middle of the tack. The extra speed gained using these methods of tacking and gybing has resulted in their adoption by many top racing crews. As you are most likely to encounter a centre mainsheet on a high performance boat which is extremely sensitive to changes in the balance of the crew weight, it is important that your movements should be fluid and controlled at all times.

A multi-purchase mainsheet system on a high performance dinghy

4 Helmsman revolves tiller extension forward, moving across boat and holding mainsheet. Crew releases old jib sheet, grasps new one and crosses boat.

5 Helmsman sits down with tiller extension behind back. Grasps tiller extension with hand holding mainsheet. Crew takes new trapeze ring and hooks on.

6 Helmsman releases tiller from behind back and separates mainsheet, holding it in his front hand. Crew grasps trapeze handle, sheets in jib and moves out.

7 Helmsman centralizes tiller and sits out, and adjusts mainsail. Crew continues to move out and sets jib.

4 Helmsman pushes tiller away firmly. Crew balances boat while holding both jib sheets.

5 As boom centralizes, helmsman jerks tiller central and moves quickly to new windward side while crew drops old jib sheet and moves across.

6 Boom crosses to new leeward side. Helmsman grasps and uncleats mainsheet and sits on new windward side.

7 Helmsman trims mainsail and steers onto new course, while crew trims jib as necessary.

to photography because they can be modified more easily to show only essential detail. Navigation through the book is helped by clearly positioned running heads and folios. More than two colours would add to the cost of the book but not increase its clarity or usefulness.

V: Structure **129**

Reading and walking

While not strictly typographic, the guides of A W Wainwright are unique as examples of information design. Wainwright was an accountant born in Lancashire who fell in love with the English Lake District and moved there to live and work. All his free time was spent walking the fells, and he began his series of seven 'pictorial guides to the Lakeland Fells' in 1952 as a way of repaying his gratitude to them. The work took 13 years.

Each book takes a separate geographical area whose characteristics are explained in an introduction, with the remainder of the book discussing each mountain in turn. These are arranged alphabetically and each is numbered as a separate unit.

The size of the book was determined by practicalities: it had to fit into a jacket pocket and early editions (this example is a second impression from 1962) have rounded corners which improved their longevity. The artwork was entirely hand

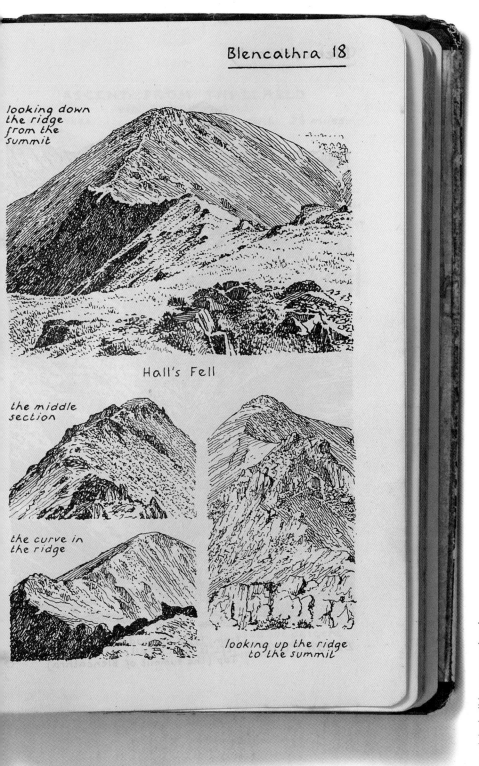

Blencathra 18

looking down
the ridge
from the
summit

Hall's Fell

the middle
section

the curve in
the ridge

looking up the ridge
to the summit

produced (the original editions were printed letterpress from zinc plates) and information is presented in turn using views, maps and the distinctive bird's eye panoramas as shown on **page 130.** All of these are accompanied by the author's own (often very opinionated) writing, and while the pages shown here are set out using extensive runarounds, elsewhere they generally mimic conventional justified typesetting.

Talking about his work to Ken Garland in 1982 Wainwright said, 'I just began with a map or diagram relating to an ascent and then added some text to fill in the spaces around the drawing and so built first a page, then gradually accumulated a chapter dealing with a separate fell ... it didn't occur to me that I needed more than just common sense to build up a chapter, and then a book, as I went along.' (*Information Design Journal*, vol.7, no.1, 1993, p.55).

For reading aloud

This 'Coronation edition' of the *Book of common prayer* (**page 132**) dates from 1905 and was printed using Oxford University Press's Fell typefaces which date from the late eighteenth century. This is clearly designed for show: fine paper, fine printing and fine binding. But while the page proportions and margins adhere to established notions of beauty, the typesetting has no regard for the needs of the text itself. Here is one of the

be clean gone : thou shalt look after his place and he shall be away.

11 But the meek-spirited shall possess the earth : and shall be refreshed in the multitude of peace.

12 The ungodly seeketh counsel against the just : and gnasheth upon him with his teeth.

13 The Lord shall laugh him to scorn : for he hath seen that his day is coming.

14 The ungodly have drawn out the sword, and have bent their bow : to cast down the poor and needy, and to slay such as are of a right conversation.

15 Their sword shall go through their own heart : and their bow shall be broken.

16 A small thing that the righteous hath : is better than great riches of the ungodly.

17 For the arms of the ungodly shall be broken : and the Lord upholdeth the righteous.

18 The Lord knoweth the days of the godly : and their inheritance shall endure for ever.

19 They shall not be confounded in the perilous time : and in the days of dearth they shall have enough.

20 As for the ungodly, they shall perish ; and the enemies of the Lord shall consume as the fat of lambs : yea, even as the smoke, shall they consume away.

21 The ungodly borroweth, and payeth not again : but the righteous is merciful, and liberal.

22 Such as are blessed of God shall possess the land : and they that are cursed of him shall be rooted out.

450

17 For the arms of the wicked shall be broken, ♦
 but the Lord upholds the righteous.

18 The Lord knows the days of the godly, ♦
 and their inheritance shall stand for ever.

19 They shall not be put to shame in the perilous time, ♦
 and in days of famine they shall have enough.

20 But the wicked shall perish;
 like the glory of the meadows
 the enemies of the Lord shall vanish; ♦
 they shall vanish like smoke.

21 The wicked borrow and do not repay, ♦
 but the righteous are generous in giving.

22 For those who are blest by God shall possess the land, ♦
 but those who are cursed by him shall be rooted out.

23 When your steps are guided by the Lord ♦
 and you delight in his way,

24 Though you stumble, you shall not fall headlong, ♦
 for the Lord holds you fast by the hand.

25 I have been young and now am old, ♦
 yet never have I seen the righteous forsaken,
 or their children begging their bread.

26 All the day long they are generous in lending, ♦
 and their children also shall be blest.

27 Depart from evil and do good ♦
 and you shall abide for ever.

28 For the Lord loves the thing that is right ♦
 and will not forsake his faithful ones.

29 The unjust shall be destroyed for ever, ♦
 and the offspring of the wicked shall be rooted out.

30 The righteous shall possess the land ♦
 and dwell in it for ever.

31 The mouth of the righteous utters wisdom, ♦
 and their tongue speaks the thing that is right.

32 The law of their God is in their heart ♦
 and their footsteps shall not slide.

Psalms which, because they are songs, are generally set as verse to aid singing or reading aloud. Here they are presented as prose with each verse as a separate paragraph.

By contrast, the latest version, known as *Common worship* (**page 133**) is shown opened at the same psalm. Designed by Derek Birdsall and John Morgan in 2000, its design may be described as 'text first'. Because the principal use for this prayer book is in church the layout was designed to accommodate the longest prayer on a single page (avoiding noisy mid-prayer page turning) and prayers set line-for-line according to sense or verse structure. To aid the latter requirement, the notional column width is occasionally disregarded to avoid linebreaks.

Daily T̃

No. 40,600 TUESDAY, DECEMBER 31, 1985

U.S. GIVES WARNING TO LIBYA

'Armed reply' to terror

By FRANK TAYLOR in Washington

THE United States declared its readiness last night to take joint international measures against Libya for supporting terrorism and stated pointedly that military action "is always an option."

After at first appearing to be advocating caution and restraint on the part of Israel in response to the terrorist attacks at the Rome and Vienna airports last Friday, the White House hardened its attitude.

Speaking in Palm Springs, California, where President Reagan is on holiday, Mr Larry Speakes, the White House Press spokesman, declared: "Our policy is that you seek out those responsible and . . . have a go at 'em."

Informants suggested that a first move might be to seek United Nations condemnation of the airport attacks as well

MRS Winnie Mandela (right) the black nationalist leader, arguing with police yesterday as she was arrested for entering the Johannesburg area in defiance of a banning order.

Christopher Munnion

More troops for Ulster

By DAVID GRAVES

THE army is to send its spearhead battalion of 550 extra men to Northern Ireland this week to help combat the concerted IRA campaign to wreck police stations along the Irish border.

Men of the 2nd Bn, Royal Anglian Regiment, are expected to move into border areas on

2p on new pr

By GODFREY BROWN,

THE price of bread is t loaf from Jan. 13, th eight weeks. It reflects price of flour, and the

Telegraph

...g quality daily

Tuesday, March 27, 2001 **45p**

Picture: SAM MIRCOVICH

Elderly promised equality in NHS

By Celia Hall
Medical Editor

ELDERLY people will be guaranteed equal treatment by the NHS and social services in care standards for pensioners to be published today.

The National Service Framework for Older People aims to "root out" age discrimination in the NHS and banish ageist policies.

The framework, to be announced by Alan Milburn, the Health Secretary, will be backed by specific funding and will raise the number of operations offered to people over the age of 65.

"NHS services will be provided regardless of age on the basis of clinical need alone," the first new standard says. "Social care services will not use age in their eligibility criteria or policies to restrict access

Design:

Eileen Aboulafi a

Pi Benio

Rose Bro wn

Edward Fella
Benita Goldm an

R. Robert Kanga s
Gary Kul ak

Diane Postula Levin e

Wendy MacGa w

Tom Phardel

Sharon Que

Ted Ramsay

James Sandall
Mark Schwing
John Shannon
Nels on Smith

SusanneStephenson
Sam Tre lla

Joe Zajac

COMMITTEE

Deborah White

Gary Zych

1988 1978 1979 1980 1981 1982 1983 1984 1985 1986 1987 YEARS

MARCH 17 - APRIL 14, 1989

OPENING RECEPTION: MARCH 17, 5 - 8:30PM

ALSO IN THE AREA A:

AREA:

Robert Caskey, Wendy MacGraw, Nelson Smith, Rod Strickland

Eastern Market Opening

Detroit Artists

5-7:30 P.M.

ALSO IN

ALSO

Sheree Rensel

Jo Powers

Lila Kadaj

Bradley Jones

MARK YOUR CALENDARS: Wednesday, April 5, 7:00 - 9:00 P.M. DETROIT PUBLIC LIBRARY Main Library

Friends Auditorium 5201 Woodward Avenue

PANEL DISCUSSION:

Panel Discussion:

ALTERNATIVE SPACE—WHAT IS IT?

Moderator: Gere Baskin, Board Member and Midwest Regional Representative to National Association of Artist Organizations.

PANELISTS: Samuel Sachs II, Director, Detroit Institute of Arts.

Pamela and Timothy Hill, owners of the Hill Gallery, Birmingham Michigan.

Sam Morello, Past President, Buckham Fine Arts Project, Flint, Michigan.

Panel Discussion: Greta Weekley, Artist and one of the original organizers of Detroit Focus.

Lester Johnson

Carlos Diaz

Richard Axsom

(313) 962-9025

DETROIT FOCUS GALLERY

743 BEAUBIEN 3RD FLOOR DETROIT MICHIGAN 48226

AFTER TEN YE ARS: DET-ROIT FOCUS

CURATORS: DETROIT FOCUS EXHIBITIO

Design

Council of Industrial Design 171 March 1963 3s 6d

Kenneth Garland

a special issue

Newspapers

Newspapers have quite a different approach to space compared to many other aspects of design. Because newsprint is expensive, space must be used with great care.

Vast changes took place in the industry during the latter part of the twentieth century, as shown by these two examples. On **page 134** is the last hot-metal typeset and letterpress printed Northern edition of the *Daily Telegraph*, while on **page 135** is the latest computer typeset and offset-litho printed version. Changing technology can account for some of the obvious changes such as the introduction of colour, but increased competition from other newspapers as well as other media such as TV, have forced design changes. The hot-metal version looks clumsy, ill-considered and dated: its remit is clearly to record but not to entertain. In today's version, interior sections – having something of a magazine approach if not look – are signposted prominently above the masthead, which itself has been redrawn. The headline typeface, Telegraph Newface (1990 and exclusive to the paper) has two weights, the regular by Walter Tracy and its bold by Tracy and Shelley Winter. The text typeface is Tracy's earlier Linotype Modern (1969).

Complete freedom

The work of Ed Fella, particularly that for Detroit's Focus Gallery (**page 136-7**) inhabits a world of its own. Described by the British design critic Rick Poynor as 'an expert at the inept', Fella's work may have a function – to promote – and use the standard printing methods of offset litho, but it shows little regard for either subject matter or graphic design niceties.

While in its self-conscious visual exploration it may be the antithesis of 'form follows function', it is engaging, thought-provoking and – after the initial shock – surprisingly clear: it works.

Type as image

Written, carved and printed forms of communication have always made use of the potential for expression. Because the structures of letterforms in the Western alphabet are simple, they lend themselves easily to pictorial or expressive use.

The cover of *Design* (**page 138**, reduced from 284 × 223mm) features lettering by Ken Garland, a modular stencilled form which he used on several jobs during this period. Here the word becomes

CON LA PARTECIPAZIONE DI

MONS. **DON FRANCO TAMBURINI**
GIANFRANCO SABBATINI
GIULIANA CECCARELLI, AUTRICE DELLA TESI
"IL TEMPO DEL CAMMINO" - ABBIAMO INCONTRATO UN PROFETA
CONCLUSIONI DI
S.E. MONS. VESCOVO **GAETANO MICHETTI**

COMUNITA' DI VIA DEL SEMINARIO

IN COLLABORAZIONE CON

FONDAZIONE DON GAUDIANO, ASSOCIAZIONE "AMICI DI DON GAUDIANO"

4 ANNI DOPO RICORDANDO DON GIANFRANCO GAUDIANO SULLA STRADA METTENDOCI IN ASCOLTO

VENERDÌ 10 OTTOBRE 1997, ORE 17.00
PALAZZO LAZZARINI, SALA BORROMEO, VIA ROSSINI 53
INCONTRO DI TESTIMONIANZA SU DON GIANFRANCO GAUDIANO
DAL VANGELO UNA SPERANZA PER LA CITTÀ.
ORE **18.30**
S. MESSA CELEBRATA IN CATTEDRALE DA S.E. MONS. VESCOVO

dolcini associati

the illustration, creating an eye-catching cover design with perhaps a nod towards the composition of A M Cassandré's *Étoile du Nord* poster of 1927.

In the 1950s the Italian typewriter company Olivetti was notable for its stylish products supported by equally stylish publicity under the direction of Giovanni Pintori, head of the publicity department from 1950 to 1967. The company's name, shown on **page 139**, is from one of the press advertisements of the period. It treats letters as abstract shapes, arranging them for aesthetic effect rather than easy legibility. (Another example of Olivetti work can be seen on page 78).

The poster by Leonardo Sonnoli (**page 140**, reduced from 985 × 691mm) makes use of one of the world's most recognizable symbols as a framework within which to arrange text. Using various weights and sizes of Franklin Gothic, there is still a noticeable hierarchy of information announcing the meeting and mass to celebrate the fourth anniversary of Gianfranco Gaudiano held in Vescovo, Italy. Such an arrangement, which might be described as 'pattern-making', depending on your point of view, has a history almost as long as writing itself (see Massin, *Letter & image*).

The *Lord's prayer and the ten commandments* poster of c.1883 (**page 141** reduced from 510 × 382mm) is a celebration of the decorative arts, a formalization of an expressive approach to design. The composition reflects classical symmetry with each element of the text being aligned centrally in a decorative frame. The frames have many forms: porticos, capitals, arches, arcs, circles and triangles, often derived from architectural decoration, and each is visually reinforced by a series of ornamental rules which make use of the repetition of small geometric shapes.

The structure and the level of symbolic ornamentation coupled with the use of strong colour (when first printed the colours would have been far brighter) visually dominate the text. The use of over twenty fonts contributes to the visual complexity of the composition but perhaps also served a commercial purpose as a sample promotional piece for the printer.

The word of God

The contrast in approach to letterform, structure and other aspects of the typographic palette within the Christmas cards on **pages 142–3** (designed by the authors of this book) is marked.

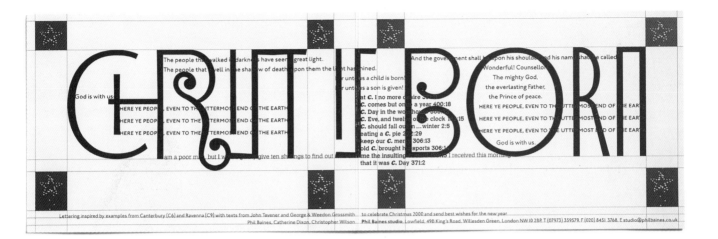

Lettering inspired by examples from Canterbury (C6) and Ravenna (C9) with texts from John Tavener and George & Weedon Grossmith to celebrate Christmas 2000 and send best wishes for the new year
Phil Baines, Catherine Dixon, Christopher Wilson **Phil Baines studio.** Lowfield, 49B King's Road, Willesden Green, London NW10 2BP. T (07973) 359579. F (020) 8451 3768. E studio@philbaines.co.uk

John 1:1 In the beginning was the
the **Word**: was with God
and the was God.

2 He was with God in the beginning,
3 Through him all things came to be,
not one thing had its being but through him.
4 All that came to be had *life* in him
and that was the **light** of men,
a that shines i n the dark,
5 a that darknes s could not overpower.

[6-8]
9 The Word was the true light that enlightens all men; and he wa s coming into the
He was in the **world** that had its being through him,
10 and the did not know him.

11 He came to his own domain
and his own people did not accept him,
12 But to all who did accept him he gave power to become children of God, [...].
With best wishes for Christmas 1992 from Phil, Jackie and Beth
Baines.

The men were amazed... **(top left)** makes use of both documentation and analysis within a painterly geometric composition. Image and text are combined as elements in a playful asymmetric arrangement. The entire composition is considered as a picture containing typographic elements. The relative hierarchies are created in the manner of a drawing with point size, type weight and colour substituting for line width and tone. Areas of density create focal points where text and image converge and are contrasted with areas of white space. Considered alignments of text and image establish relationships between disparate elements and visually bridge the white space. Rules in a second colour support the order of reading and lead the eye from top left to bottom right across the card.

The layout of *For unto you...* **(lower left)** takes the characteristics of the fixed character width typeface Letter Gothic as its starting point.

The modularity of the typeface is reinforced by the consistent box form and the mechanical nature of the letterforms is echoed in the proportional use of type size to articulate the relative importance of each phrase. This mechanistic approach is repeated with rules being used to visualize the leading.

Christ is born **(top right)** makes use of a typeface previously designed for a church commission (see detail on page 102) and was derived from carved letterforms from ninth-century Ravenna and sixth-century Canterbury. Although the most dominant element of the design, it is in fact the last line of the text which begins 'The people who walked...'. That text is arranged partly as a response to the piece of music *God is with us* by John Tavener, from which the words come. A secular text in a contrasting typeface and style intrudes in the centre of the design.

In the beginning... **(lower right)** is the most austere of the four cards. It makes use of 'internal vertical justification', a way of arranging text pioneered by Stephan Themerson in the 1960s. Phrases are set line-for-line but arranged according to repeated words, not conventionally left, right, centred or justified. Hand-set with metal type, the main text is 12pt Bell without leading. To emphasize common words they were repeated two or three times. The 'body' of metal type is clear around 'Word', as is the lack of kerning.

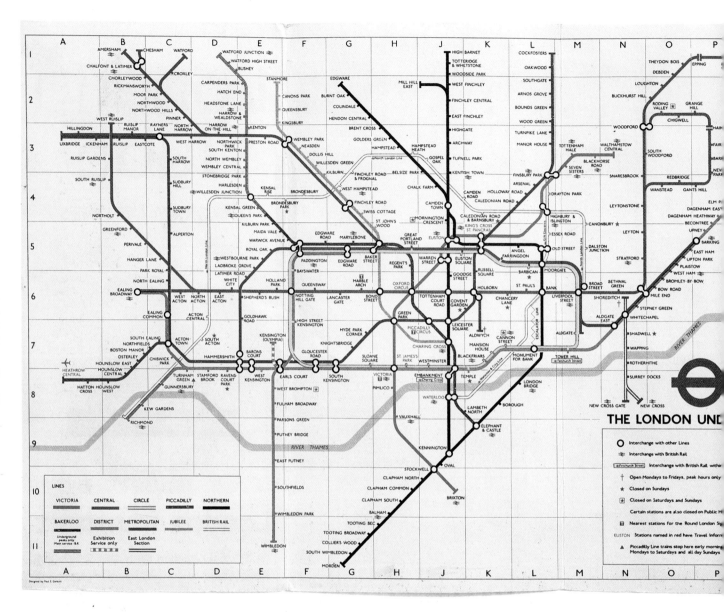

The display of spatial information

Reflecting on the fact that the travelling public primarily needed to know which station was next, or where to change lines, in 1933 Harry Beck produced a diagram for the London Underground showing simply the lines of the network and its stations. The diagram has proved popular with travellers, capable of adaptation over a 60-year period and has been highly influential. A 1979 version is shown here (**page 144**).

The diagram achieves its clarity by distorting distances: the area bounded by the Circle line is perhaps 5 miles across, but the distance from Heathrow (far left) to Upminster (far right) is over 30 miles. The type labelling each of the stations is positioned freely, to support the ease of reading, and the grid under the diagram has no relationship to distance but is for locating the stations when used in combination with an extensive index. The map makes use of colour to identify the lines but has been criticized for the use of black for one of the lines as well as for the text (a problem repeated in the latest version but with blue).

Different approaches to the problem posed by the New York Subway are shown on **page 145**. On the left is a useful journey planner which, like the Underground map, pays no attention to the surface geography while the version on the right can properly be called a map and relates the Subway to the physical realities of rivers, islands and parks.

Road signage

Drivers have only a limited amount of time in which to read and assimilate information. The example on **page 146** is from the US whose signs share a preference for upper- and lower-case typography with Britain. The size, colour and positioning of signs are consistent and the information given is the minimum required for clarity. The typeface is specially designed and has no fussy details which could be misinterpreted. The wide inter-character spacing contributes greatly to legibility from a distance. A version of this typeface is available as Font Bureau Interstate.

The scale of signs on modern roads is designed for legibility from vehicles travelling in excess of 60mph (96kph) and is a far cry from the style of signs which can still be found on many older, unmodernized roads; this example (**page 147**) is from France.

For regulatory signs (those including mandatory, prohibitive and warning instructions) there exists

South Shore
Cape Cod
↓

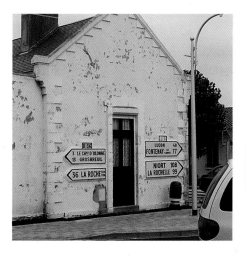

considerable difference between US and European practice. The US favours a literal approach and Europe a symbolic. The symbolic approach was discussed internationally at the 1931 Geneva Convention and became the subject of the Geneva protocol of 1949. This described signs in their form (triangular, circular etc.) and in their content, but not in the details of their drawing. Although quite different from previous UK practice, this protocol informed the traffic sign system designed in 1964 by Jock Kinneir and Margaret Calvert for the Worboys Committee (**page 147**). With minor un-satisfactory modifications by the Department of Transport, it is still in use today.

The New Traffic Signs

Warning signs

Distance to STOP sign ahead

Cross roads

Roundabout

T junction

Staggered junction

Distance to GIVE WAY sign ahead

Side road

Plate below some signs

Sharp deviation of route to left (or right if chevrons reversed)

Bend to right (or left if symbol reversed)

Double bend

Series of bends

Two-way traffic straight ahead

Two-way traffic crosses one-way road

Traffic merges from left

Traffic merges from right

Her Majesty's Stationery Office

Price 6d net

Typography in time: film and new media

With the invention of film and the movie camera, type was freed from the two-dimensional world of print. Early silent cinema used static type in the absence of dialogue, and it was not really until the talkies that type was seen to move on screen. As the potential of the medium began to be explored, designers had to consider ways in which type could be combined with moving images and sound: they had to become increasingly familiar with the grammar of film.

The advent of digital technology has brought with it a convergence of disciplines. Graphic designers, illustrators, animators, sound designers, architects and film-makers share a common digital platform – one that enables text, imagery, sound, three-dimensional visuals and video to be combined. Designers familiar with one area can export their work into another and operate across several disciplines, creating work which is truly multi-disciplinary.

Digital technology has combined many of the features of film and print. While print and film both share a fixed, largely sequential narrative, the development of the interactive CD-Rom and the World Wide Web has led to the popularization of non-sequential narrative. This creates a new frame of reference for typography, one in which the receiver and their circumstances are unknown, and their 'consumption' of the 'message' is uncontrollable. Moreover, the designer must present on the same screen both the information field and the navigation system. The multiplicity of windows increases as users use links to couple together websites and employ search engines to chase keywords. The designer's role is now to facilitate the user in the pursuit of information, rather than to control sequence or narrative in the manner of a book or film.

The early torchbearers of digital technology who predicted the death of print within a decade have been proved wrong. It seems likely that new language technologies will coexist with old, serving to augment rather than replace the traditions of print.

The typographer designing for screen – whether movie, TV or computer – must not only look at the elements of the typographic palette already discussed but also become familiar with the grammar of film. Carrying on from the ten points discussed earlier, this grammar amounts to a further set of elements: 10b, film format; 11, shots; 12, speed and movement; 13, transitions; 14, focus; 15, lighting; and 16, sound.

10b Film format

The proportions of the film frame are referred to as 'aspect ratio'. Film and television are conventionally shot and projected in landscape format but the proportions of the rectangle vary. For television the proportional relationships which determine the basic format are a height of 3 units to a width of 4 units: 3:4 (sometimes expressed 1:1·33). Several widescreen formats have been developed for cinema, the most common being 9:18 (1:1·5). Many televisions are now designed to show widescreen film formats or have facilities that allow the viewer to alter the framing, however, the designer for television should work to the standard 3:4 frame proportions unless otherwise briefed.

Television 3 to 4

Widescreen television 9 to 14

Widescreen film 9 to 18

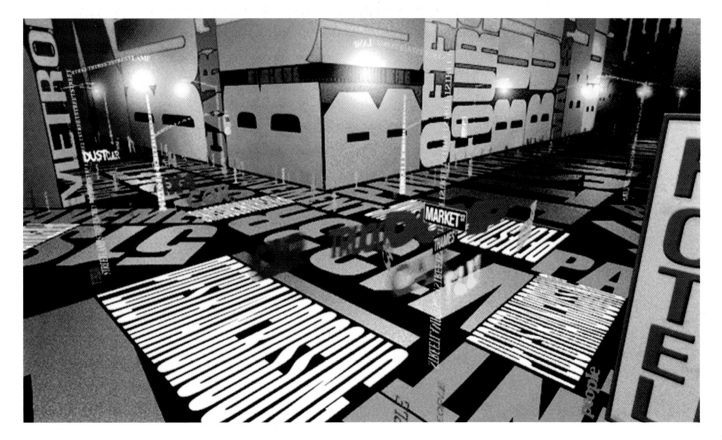

11 Shots

A shot is a piece of film or video of any passage of time which has been exposed continuously without interruption or cut. Simple shots can be categorized by the relationship between camera and subject. These view type as a subject – something which may appear strange to us as we are conditioned to view image as subject. Type generally floats between camera viewpoint and subject on an invisible plane. The nature of type as subject can clearly be seen in the following shots, where the angle of the camera in relationship to the subject changes.

Type in perspective for a music video illustrates how three-dimensional drawn animation programs make use of conventions derived from the grammar of film.

God or profits, the test of one the other sanctity – the comm physically serviceable and, p article of commerce Eric Gill, *An essay on typography*, 1931, p.69 **the functions of public inscri tent than in their form; on a could serve all purposes ade ently functional view of letter style in giving information, as in the environment** Jock Kinneir,*Words and buildings, the art and pr **pography. First it does a pract concerned with artistic form. dren of their age; sometime sometimes function, and in p and function have been felicit aim at simplicity: we therefor**

echanical perfection, and of
ial article at its best is simply
accidens, as serviceable as an
has to be acknowledged that
ons reside more in their con-
litarian level one letterstyle
tely if bleakly. Yet this appar-
, ignores the important role of
ell as the part lettering plays

ring, 1980, p.8 ● There are two sides to ty-
l job of work; and second, it is
th these aspects are true chil-
form has been accentuated,
icularly blessed periods form
sly balanced Emil Ruder, *Typography, a manual of design,* 1981, p.12 ● We
equire simple and clear type faces

184 →

Shots defined by distance

Longshot The camera appears to be distant from the subject.

Midshot A shot that presents a view between longshot and close-up.

Close-up The camera framing is close to the subject.

Shots defined by movement

Pan shot The camera rotates horizontally from a fixed point and may be moved in either direction:

Pan left, and a static subject appears in shot from the left edge of the screen and exits right; pan right and a static subject appears in shot from the the right edge of the screen and exits left.

Swish pan shot This is the same movement as a pan, with the rotation being done so quickly that the subject is blurred.

Tracking shot The camera moves parallel with the subject. The subject may be static (*eg* filming a landscape from a train, where the subject passes through the frame), or may move parallel with the camera (*eg* a car running alongside the train at the same speed). A tracking shot may have a constant or variable speed.

Extreme close-up The camera framing is extremely close to the subject. This shot is sometimes referred to as 'macro', enlarging what can be seen with the naked eye to reveal a detail.

Micro This shot involves magnification of a subject that is invisible to the naked eye.

Zoom shot A lens facility in which the camera appears to move towards (zoom in) or away from (zoom out) the subject.

Tilt shot The camera pivots vertically from a fixed point. Tilt up and the subject appears from the top of screen and exits from the bottom of screen; tilt down and the reverse is the case.

Slow disclosure A shot, often starting in close-up, which initially hides part of the subject; when zoomed out the subject is viewed in a new and unexpected way.

Dolly or trucking shot The camera is moved along rails which can be laid out in a way that enables it to travel through or around the action. The dolly may also support a crane, allowing the camera to rise above the subject. Horizontal and vertical camera movements are combined to provide fluid movement around the subject.

Hand-held The camera is not supported by a tripod but is held in the hand. The viewer is generally aware of the movements of the operator. A recent technological innovation is the Steady Cam, a hand-held camera that is counterbalanced to smooth out the operator's movement and yet retains the freedom to follow action at will.

Shots defined by angle

Low-angle shot The camera looks up at the subject. If the subject is type then conventionally orientated characters appear to recede from the baseline to a vanishing point beyond the cap line.

Eye-level shot The camera is at eye level in relation to the ground plane. This term is clearly illustrated when the subjects are people. When applied to type – which unlike people has no characteristic size – the term is most appropriate when type is presented square to the picture plane rather than distorted.

High-angle shot A shot that looks at a subject from above.

Overhead The camera is placed directly over the subject producing a bird's-eye view.

12 Speed and movement

For the film-maker, speed has at least two meanings: the speed of a subject within a shot, and the speed of film passing through the camera. These two elements combine to determine how the viewer perceives movement.

Film normally passes through the gate of the camera at 24 frames per second, though many digital programs have a frame speed of 25 frames per second. So long as the film projector, video, or computer program replays the frames at the same speed as they were shot, the viewer perceives the speed as that occurring in 'real time'. If a film is shot or projected at fewer than 13 frames per second, the viewer perceives a quick succession of still images in which the subject appears to jump between frames, rather than a continuous smooth movement. (The 'persistence of vision' of the human brain ensures that we see smooth movement at film speeds above 13 frames per second.) The speed of film moving through the camera can be varied.

When watching film we perceive relative speeds within a shot. Being conditioned to the relative speeds of movements, we are aware of a film-maker using slow motion or fast motion effects. However, when a subject moves which in our experience is generally static – such as type – we enter a 'virtual' world with which we are unfamiliar. In terms of type, the speed of movement should be determined by the viewer's ability to read it. Scrolling type, the crawl of film credits, is probably one of the earliest examples of the movement of type on screen. Conventionally centred type scrolls smoothly but slowly – hence the crawl – from the bottom to the top of the screen. Television generally uses fewer credits and, with more innovative films, has made use of horizontal scrolling – type moving from left to right. (While it is possible to read type that scrolls from right to left, the reading experience is akin to chasing type across the screen.)

Type can be made to move within the frame of any shot. Using traditional methods of animation a letterform or drawing would be positioned and shot as a single still frame, then repositioned and shot again. The repetition of this process creates a series of stills which, when run sequentially, would appear to move around the screen. In the simple form the camera remains in a fixed relationship to the subject: only the type moves around the frame. However, by combining a sequence of stills in which the subject and the camera's relation to it are minutely changed frame by frame, a sequence can be created where type movement and camera viewpoint change simultaneously. The viewer is thus given the impression of moving round a moving word or sentence. Designers using combinations of camera and subject movement must make clear decisions about how type will enter and exit the screen. Type may enter from any direction, and at various speeds, as parts of a letterform, as characters, as words or as whole phrases or sentences. Phrases may be formed for a period of time and then revert to their constituent elements. Computer animation – which creates pathways along which type can travel across the screen or through a virtual three-dimensional space – has increased the speed of the animation process, but relies on exactly the same principles as traditional methods.

Speed and movement

Fast motion A subject's movement appears faster than in real time. This can be achieved by slowing down the frame speed while shooting, although this can lead to jerky movement.

Slow motion A subject appears to move more slowly than it would in real time. This is achieved by accelerating the frame rate while shooting. By creating more frames per second and replaying at normal speed, time appears to slow down. Subjects that tend to move extremely fast may be invisible when shot at normal speed. Cameras developed for documenting scientific experiments are capable of shooting several hundred frames per second, enabling us to view speeding bullets, for instance, in slow motion.

Stop-motion film This film is exposed one frame at a time like a conventional still (or photographic) camera. Traditionally animators create the appearance of movement by using this technique. A frame is shot, and a two-dimensional image or a static three-dimensional model is moved marginally, and then another frame is shot. The repetition of this process produces a series of still frames which, when replayed at normal film speed, recreate movement. A simple tripod and an 8 mm camera with a single shot function can be used to create this sort of animation, though for high-quality results a rostrum camera and animation table are necessary. The advent of computer programs has made broadcast-quality stop-motion animation widely available. These involve the designer making a series of single frames (containing type, image or object) and then replaying them in a sequence.

Freeze frame A moving subject or object stops moving and 'freezes'. To do this a single frame is copied many times: and when replayed it appears as a still.

Still A series of frames which present no movement.

Transitions dissolves

Dissolves One shot is merged into another: the existing shot begins to fade as the subsequent shot becomes increasingly distinct. The speed of the dissolve may be varied.

Fade in The shot is initially dark, often presenting a black screen, and progressively becomes visible as the light levels are raised.

Fade out The reverse of fade in: the shot moves from light to dark.

Iris in The shot opens in darkness but reveals a brighter circular image which expands to fill the frame.

Iris out The reverse of iris in: the light circular image progressively diminishes as blackness fills the frame.

Wipe A transition in which the two shots are not superimposed but butted against one another: an existing shot appears to be moved out of frame by the subsequent shot. Wipes can be horizontal, vertical or diagonal and can begin from any of the frame edges or even the centre of the frame, opening like theatre curtains. Wipes can also appear to 'peel' the previous image from the screen and can be used in combination on split-screen sequences. Viewers are generally far more aware of wipes than cuts.

Transitions cuts

Cross-cutting Scenes that have a narrative link but are separated either physically or by time. For example, within a drama a shot of a speeding fire engine might be cross-cut with one of a burning building, thus helping to build up tension.

Cutting on action Two shots in sequence that feature the same action. For example, in a car chase the back of the lead car is viewed skidding round a corner from the chase car; a cut is made part way through the turn, and the same car is presented from a high angle completing the skid and heading to a newly established horizon; the camera holds the frame and the chase car follows the lead car through the shot. The two shots are connected through a single piece of action.

Cutaway A shot that gives context or reaction to the main narrative. For example, in a television interview the interviewee might speak for a considerable length of time; the film editor might cut to a silent but nodding interviewer while running the sound of the subject's voice over the pictures.

Jump cut A shot that has no apparent relation to the shot which precedes it. The two shots can be separated by time or space, dislocating the narrative and leaving the audience momentarily disorientated.

Soft focus All the subjects in the frame are blurred. This effect can be achieved through special lenses or through filters which are positioned between the lens and the subject.

Depth of field The distance between an object in sharp focus at the front of the frame and one in sharp focus at the the rear. When the camera is close to a subject the parts of the same object may pass from soft to sharp focus and back again.

A wide depth of field means most of the subject is in sharp focus. A narrow depth of field means little of the subject is in sharp focus.

Follow focus Should the distance between the subject and the camera change during a shot, the focus is adjusted to follow the subject and retain clarity.

Search focus The camera opens focused on one element within the frame and then, while the framing is maintained, refocuses on another element within the frame, all within a single shot.

13 Transitions

Transitions are the way in which shots are connected: they link sequences together. This can be done in the camera, within a computer program or editing suite, or when using film in the laboratory.

14 Focus

The camera lens can be adjusted to sharpen or soften the focus of any element within the frame. The focus can be changed within a shot, conventionally moving from soft to sharp in order to open a shot, and from sharp to soft in order to close a shot.

15 Lighting

For the film-maker, lighting is a key element in creating the atmosphere within a three-dimensional scene. For the typographer working on screen, computer drawing programs offer a three-dimensional world in which type can be animated and subjected to the same changes in lighting conditions as those used by the film-maker.

16 Sound

Today's designer of screen-based media has to consider how the visual presentation of language can be combined with the aural. Sound elements in film include the spoken word, live sound, sampled sound and music. The sound editing process for screen may link words and pictures to provide a rhythm for the visual transitions.

Lighting

Back lighting Objects are lit from behind and appear as silhouettes.

Front lighting Objects are lit from the front and cast shadows back through the scene.

Spot lighting A light with a focusing facility which creates a spot or illuminated circle on the subject. Objects outside the focus remain in darkness.

Low contrast Most of the frame is made up of mid-tones – neither very dark nor very light.

Flat lighting Objects are lit evenly with a diffused light, and shadows are minimized.

High contrast The dark tones are very dark and the light tones are very bright.

Conventions VI

The styling of details within text

What unifies any work involving typography is the need for the designer to be able to combine a view of the whole with an eye for detail. In the previous chapter we described the various decisions which are made every time type is used, but the results of those decisions are only incomplete designs. While they have a fundamental impact on the attractiveness, usefulness, or legibility of a design, there is still work to be done.

Editing and typographic design are inextricably linked, but each is a distinct discipline. Until twenty years ago the working process for any printed job comprised a set of clearly separated roles (each with its own trade union). Authors wrote; editors edited and prepared final drafts; designers marked up the drafts with instructions for the typesetters; typesetters sent proofs to editors and the designer for corrections and approval, and so on.

Today's technology makes the conception and progress of a job seem like a seamless process. Copy can be continually added to or altered right up to the point of handover to production. This places designers in a different role to before, some aspects of which may cause them anxiety. Designers working for reputable publishers will receive copy that is well prepared and needs only typographic styling: they are free to design. But many clients do not have the knowledge or the ability to prepare so well. They simply do not appreciate the need for consistency or even the correct use of language. As a result the designer is often faced with having to do some editorial work as well as design.

Some of the guidelines contained on the following pages – non-lining figures, small caps, italics – affect the look of a text in obvious ways. Others are more subtle – treatment of *ie*, & or ligatures. But all have a bearing on the texture and colour of a text, and, most importantly, on the ease with which the reader can use a document. A designer who isn't interested in, or can't be bothered to detail text is one who doesn't care about effective communication.

The following guidelines include elements of typographic styling and some points about language usage. It is based on our own evolving practice (which includes work for several large publishers in Britain and the US): there is no single universal style manual either for editorial or typographic detailing. However, the most widely used reference books are *Hart's rules for compositors and readers* and Judith Butcher's *Copy-editing for editors, authors and publishers* in the UK and *The Chicago manual of style* in the US.

In the conventions set out below, the principles and use of particular characters are described. The positions of those characters on a keyboard for the Mac and the PC operating systems are given in Appendices 1 and 2 respectively.

Abbreviations

Contractions – Dr, Ltd, Mr, St, etc. – and common abbreviations such as Co, Inc, Rev do not need a full point in modern usage:

The Rev Peter Leighton visited me at St Martin's School of Art

Abbreviations for dimensions do not need a full point, nor should they be pluralized

51cm *not* 51cms

In abbreviations for 'volume', 'page', 'circa' and 'flourished' a full point without a following space is used ('c.' and 'fl.' are italicized):

Vol.III p.245 *c.*1997 *fl.*1560–80

The abbreviations for 'that is' and 'for example' can look too spotty if used with full points; a neater alternative is to omit the full points and italicize:

ie not i.e. *eg* not e.g.

Acronyms

These are names derived from sets of initials which are pronounced as words in their own right. They are sometimes treated as a normal name with an initial cap only.

Where are the Nato headquarters?

Ampersand

The abbreviation for 'and' is derived from the Latin 'et', whose characters can still be seen in some versions of the character.

& *&* **&** (Swift, Swift italic, Meta)

Today its use is generally confined to lists, where it saves space, and to company names where it clearly indicates a particular rather than a general relationship:

Lavers & Barraud
not Lavers and Barraud

At other periods it was used far more freely within text. Eric Gill's book designs make frequent use of the ampersand to achieve more even right-hand edges for his ranged-left text settings.

Annotation & labelling

Labelling should generally form a secondary level of information to support the illustration, diagram or photograph. The size and weight of type and leader lines should be considered in relation to the weight (or colour) of the line used within the image: generally leader lines should be lighter in appearance than the illustration or image to avoid confusion. There is generally no need to box or underline labels.
See also **captions**

Apostrophe

This is used to indicate that a word is possessive or that there is a missing letter:

It's Andy's hand on page 83.

The correct character (sometimes known as a 'smart quote') should always be used, not a prime.

Phil's *not* Phil's

See also **quotation marks** and **prime**.

Bibliographies

Books, articles and web addresses should be listed as suggested below. In academic work editors will insist on having the author's surname first: a possible compromise may be to use small caps to emphasize the surname. Some publishers also omit the publisher (which doesn't seem very helpful). When giving page references, use p. (without a following space) for a single page, and pp. for more than one.

Robin KINROSS, *Modern typography: a critical history*, London, Hyphen Press, 1992

A second entry by an author is indicated by a single em dash and a comma thus,

—, *Anthony Froshaug*, London, Hyphen Press, 2000

and articles are listed like this,

Phil BAINES, 'Sculptured letters and public poetry', *Eye* 37, vol.10, Autumn 2000, pp.26–37

A consistent standard has not yet been established for websites. In running text they are sometimes shown bracketed by 'less than' and 'greater than' symbols (*eg* <www.thename.com>), but italics would be just as clear and make more typographic sense. The date should always be given and a web article should be treated as any other article:

John D BERRY, 'The hyphenation of justification', *www.creativepro.com*, 7 October 2000

See also **capitals**, **italics**, **figures**.

Brackets and parentheses

An afterthought, a subordinate clause and references can all be contained within parentheses (round brackets):

cast in stucco (1, 2 & 33) or carved

Parentheses can also be used to separate numbers or letters in lists.

Square brackets are usually used to denote an omission or an editorial clarification within a quotation:

'He [Schwitters] lived near my Gran.'

They are also used when brackets are required within parentheses:

it (St[one] utters) was hand-set and printed letterpress

Capitals

~use of

The use of capitals is a complicated issue. The rule in English is that all proper names should begin with a capital, and there is the common practice that within titles all words other than 'the', 'and', 'of', etc., should also start likewise. However, the latter practice can make titles look ugly and in many cases old-fashioned.

Q Do Initial Capital Letters Really Make Headings Clearer?

A No, initial capital letters do not make headings clearer.

A further problem today arises when companies who use lower-case only (or all caps) as part of their identity want them always to appear that like in print. There is no reason for this: their name is different from their signature and should be set in a standard style.

Arguing for clarity, and partly based on French bibliographical practice, the Department of Typography at the University of Reading has for many years advocated a much simpler style of capitalization for book titles and Robin Kinross has written about, and put their ideas into practice (see reading list on pages 174–5). With titles of books, plays or other works of art, only the first capital is used and the title is set in italics to distinguish it from the roman text around. Titles of magazines, because they can be considered as institutions, have initial caps for all words. Throughout this book we follow this practice. See also **intercaps**.

~appearance of

When setting text in capitals some adjustment needs to be made to their spacing – by using tracking – to avoid the letters looking too crowded: typefaces are generally spaced for combined upper- and lower-case usage. Certain words will need more work than others depending on the particular character combinations involved.

CAPITAL LETTERS no tracking: cramped

CAPITAL LETTERS with tracking: elegant

If setting on several lines, care should also be taken with the leading to ensure that the space between lines looks larger than the space between words.

CAPITAL LETTERS NEED SPECIAL TREATMENT

Captions

The simplest position for captions is adjacent to the described image, as this avoids the necessity of inserting a directional such as 'above' or 'left'. To avoid visual clutter on a busy page or spread, however, captions may be grouped together and given a directional or a number.

When it is not possible to place captions on the same page as an image, *eg* with a double-page spread illustration, the caption can be positioned on the preceding page (preferably) or the following page.

More complicated images or diagrams may require alternative strategies. A solution for a group photograph, for instance, might be to provide a schematic diagram accompanied by a numeric listing:

1 Howard Greenhalgh
2 Geoff Fowle
3 Richard Doust
4 Michael Cumming
5 Mike Bennion
6 Andrew Haslam
7 Wendy Baker
8 Mike Nicholson
9 Dave Ellis
10 Amanda Leslie
11 Hannah Tofts
12 Andy Altman
13 & 14 Phil & Jackie Baines

Web and CD-Rom technologies, of course, present a whole new array of captioning possibilities, such as rollover buttons and pop-up caption boxes.

Column, page and paragraph endings

Never end or begin a column or page with a single line of a paragraph (the normal minimum is two or three lines), and try to avoid ending a paragraph with a single word.

A single word at the end of a paragraph is known as a 'widow', and a single word at the top of a page or text column is called an 'orphan'.

There are a number of solutions. 1, If the setting is ranged left, paragraphs can usually be 'massaged' by a judicious use of soft returns. 2, If the copy is newly written, the author or editor should usually be able to write (or cut) a few words. 3, If there are pictures within the column, some subtle resizing can save copy changes. 4, If these fail, as a last resort leave the column or page a line short.

Contractions See **abbreviations**

Dashes

For parenthetical clauses use a dash not a hyphen. Two kinds of dash exist: an en dash

—

and an em dash

—

Their names indicate their length.

En dashes with a space either side are the norm today in Britain and are nearly always better than em dashes with sans serif typefaces:

The reason – which I don't agree with – is that it looks out of place.

Em dashes often look more bookish and tend to work better with older typefaces. They should be used without a space either side. This is the standard American style:

The reason—which I don't agree with—is that it looks out of place.

If using different typefaces within a piece of work, it would be acceptable to use a different style of dash for each: the main guide is to be consistent.

Never use hyphens for this role. Hyphens simply indicate broken or compound words. An en dash is also used within contracted dates and page numbers, where it is employed without a space either side:

1965–96 pp.27–37

En dashes are also used in compound words where the two parts are equal: the dash can either mean 'and', as in Arab–Israeli conflict, or 'to', as in 'the London–Brighton race'. Where the first part of the compound is not a complete word, a hyphen should be used, as in Anglo-Asian.

Dates

As with many details in this chapter, British and US usage differs. British style is to use cardinal numbers (1, 2, 3, etc.) and in the following order:

8 December 1958

US style uses ordinal numbers (1st, 2nd, 3rd, etc.) as follows:

December 8th, 1958

Decimal points

Although a full point is often used for this purpose, a decimal point exists in every font and is often far clearer:

78·5cm *not* 78.5cm

See also **mid-point** and **figures**

Dipthongs

Æ æ Œ œ

These characters are combined for phonetic rather than visual reasons. Æ is part of the Danish, Dutch, Icelandic and Norwegian languages and Œ part of the French. Their use in English is generally reserved for lending a period flavour or for the accurate quoting of archaic texts.
See also **ligatures**

Drop caps Derived from the manuscript tradition, this device is often used at the beginning of a chapter, article or paragraph. Careful attention to space is required to integrate these decorative details with the rest of the paragraph. The cap letter can be any number of lines deep but will integrate well with text if it is positioned on a baseline rather than hanging in space above a white 'pool'. In this example the drop cap is three lines deep and its top has been aligned visually with the x-height of the main text.

Ellipses

…

Ellipsis points, with a space either side, are used to denote omissions in the text, or with a space before to indicate text trailing off. Instead of typing three full points with spaces the special ellipsis character should be used.

Endnotes See **references**

Figures

~ kinds of

There are two kinds, lining:

1234567890

and non-lining: 1234567890

In the vast majority of fonts all figures are designed with identical character widths to enable tabular matter to align correctly: when setting dates the 1 may need to be kerned (see page 112).

Within text, it is best to use non-lining figures if available:

begun in 1991, it's still unfinished
not begun in 1991, it's still unfinished

But use lining figures with capitals:

PELHAM 123 *not* PELHAM 123

Note that not all typefaces have both versions.

Most suppliers of 'classic fonts' produce a matching expert set which contains non-lining figures along with small caps and an assortment of ligatures and fractions. Many contemporary faces, such as Meta or Swift, have a version called caps or SC which have a similar font layout. Some are now starting to supply non-tabular figures.

~ quantities and monetary units

When dealing with quantities it is usual to indicate thousands with a comma, except in dates:

1,000 *not* **1000**

When dealing with monetary units, particularly in financial work, figures should be set ranged right or aligned on the decimal point,

$$£34,710\cdot00$$

$$1,341\cdot90$$

Note also that different countries may have different ways of showing decimals and thousands. English usage is:

3,128·50 but in French it would be 3.128,50

See also **mid-point**.

Folios

This is the correct term for page numbers. If the document needs to be referred to, it needs folios. Position them where they can be seen clearly – never near the back margins – and in a way that suits the style of the document. They rarely need to be larger than the text size. They are often placed next to the running head/foot.

In the past, books used to have two sets of numbers: lower-case roman (i, ii, iii, etc.) was used for the prelims, and arabic (1, 2, 3, etc.) for the book proper. Today it is more usual to use arabic throughout but not show them on either blank or display pages.

Footnotes See **references**

Fractions

Only basic fractions are built into the ISO standard character set, and these are not accessible on the Mac keyboard. One solution is to use superior and inferior figures (carefully edited using preferences) with the solidus (see Appendices 1 & 2) but for longer, more specific work it can pay to create your own fractions using type design software. The following example was created for use at 7pt in *Aboriginal art* in the Phaidon *Art & Ideas* series:

Custom fraction design $19^1{}_3 \times 4^3{}_4$ in

The multiplication sign \times is in the font, with kerning built in. At 7pt – the point size used for that book – the fraction is clearer without a solidus. The following was created in QuarkXPress using the fraction/price facility and is cumbersome by comparison:

Quark-made fractions $19\frac{1}{3}$ x $4\frac{3}{4}$in

Full points (stops)

See **abbreviations** and **sentence endings**

Hierarchies

One of the fundamental jobs of any designer is to analyse the raw material, making judgements about its structure and about how that will be expressed typographically. Most pieces of information have some sort of hierarchy which needs to be articulated clearly.

Maps are an example of design practice where there is an almost universal agreement about the typographic styling for the complex hierarchy of names. For example:

C O U N T R Y N A M E
Outline serif caps tracked

A D M I N . D I V I S I O N S M A J O R
Tracked serif caps

A D M I N I S T R A T I V E D I V I S I O N S O T H E R
Tracked serif caps

NATIONAL CAPITALS MAJOR
Serif caps

National capitals other
Upper- and lower-case sans serif

Administrative centres
Upper- and lower-case underlined sans serif

On a poster, flyer or website hierarchy is necessary but does not always need to conform to a standard pattern: it may use size, alignment or colour, or another aspect of the typographic palette as described in Chapter V. Clarity is the key. In a business document, annual report or book, the hierarchy may be more complicated and may require more subtle shades of coding.

Housekeeping

Any text file should be 'tidied up' before the real design starts. A basic list of items to check, remove or alter as necessary should include: double word spaces, double returns, tabs, ligatures, figures, quotation marks. This process also allows time to read the text and start planning the design strategy.

Hyphenation & justification (H&Js)

This part of a page layout program controls the way the words are allowed to be spaced and to break. For good, even-looking text – even without hyphenation – the program's default H&Js should always be adjusted as necessary by the designer.

Page layout programs allow the user to specify the following: 1, whether or not to hyphenate; 2, how to break words; 3, what the permitted variation in word or letter space should be in justified setting; and 4, the width of the word space in ranged-left setting.

To examine these in order:

1 Some people seem to have an irrational fear about designing with hyphenated text whatever the alignment and regardless of what they may be accustomed to reading. There are several benefits to using hyphenation (although the use of more than two consecutive hyphenated line endings should be avoided for aesthetic reasons). In justified setting hyphenation helps to limit the

variation in the size of the word space from one line to the next; in ranged-left setting it gives a more even right-hand margin; and in both cases it saves space.

2 Before the advent of computers, word breaks were decided by trained typesetters or editors according to etymology (in Britain) or pronunciation (in the US). Nowadays page layout programs have basic hyphenation dictionaries which give guidelines for acceptable breakpoints. They use these breakpoints when allowed and according to the minimum sizes of word specified. Note that there should be a minimum of two letters preceding a hyphen, and three after. Where possible it is best to avoid breaking capitalized words, or ending a page with a hyphen. If you are unsure about how to hyphenate a word, consult a spelling dictionary which will indicate all the acceptable breakpoints.

3 & 4 The width of the word space is defined as part of type design but can be overridden in H&Js, usually by specifying a percentage. The width should rarely be more than 100%, and in many cases a smaller word space looks far better. For justified setting, values can be specified for minimum and maximum word space widths. Different line lengths and typefaces will affect what is desirable here. A wider column containing 12 words will need far less variation than the narrow columns of a newspaper. Programs also allow for variation in letter space but there are rarely good reasons for using this facility: letters should never be allowed to be spaced out (destroying their shape and therefore legibility) to compensate for a poorly chosen relationship of type size to line length.

In a document that contains a number of alignments and/or column widths, different H&Js should be created for each situation.

Hyphens

-

Never use a hyphen as a dash (see **dashes**, page 165). A hyphen only ever indicates broken or compound words:

What a lovey-dovey couple

Hyphens are also useful to avoid ambiguity in a sentence, but they can be over used.

Initials
Initials for people's first names should be evenly spaced, not grouped as a separate item from their surname. Unless otherwise requested by the client, they do not need full points:

P A Baines not P.A. Baines

Qualifications do not need full points:

Catherine Dixon PhD

See also **small caps**

Intercaps
Generally this is a contemporary way of shortening compound names and omitting the hyphen. As the capital has an important function it must be respected:

FontStudio

(Occasionally they provide an excuse for gratuitous bad spelling *eg* QuarkXPress).

Italics
Italics originated as typefaces in their own right but modern-day practice has placed them firmly in the role of an accompaniment to roman. In this they have three main purposes.
1 They denote the titles of artistic works, whether books, newspapers, paintings or plays:

He reads the *New York Times* daily

2 They indicate foreign words and phrases (unless they have become accepted as part of the language: a good up-to-date dictionary will provide guidance here).

but read Bringhurst *en route* today

3 They can also denote a particular tone of voice (but can become irritating if used too much for this purpose):

now that *was* a surprise.

In more formal text it is better to reword the sentence in order to provide the emphasis.

Ligatures

fi fl

These are single characters that represent the two most common overlapping character pairs: fi and fl. Some sans-serif faces have short fs and so do not really need them, but it is better to substitute them anyway in case you change the typeface later.

If running a spell check on a document it is best to do this before inserting ligatures because the dictionaries in some programs do not recognize them.

In some faces and in expert sets further ligatures, for ffi and ffl, also exist:

ff ffi ffl

See also **dipthongs** and **housekeeping**

Marginal notes See **references**

Mid-point
The same character as the decimal point is used in Catalan to indicate separate syllables or letters:

Col·legi d'Aparelladors i Arquitectes

Depending on the design of the typeface the height of this character may not be ideal for both purposes.
See **decimal points**

Omissions See **ellipses**

Ordinal numbers

1st, 2nd, 3rd, etc.
In British and American English these are generally avoided in running text by spelling the word out:

twentieth-century boy

Other languages use abbreviations for these, generally with a lower-case letter in a superior position. In the standard character set only two such characters appear; these can be used for Spanish *segunda* and *segundo*:

2ª 2º

See also **dates** and Appendices 1 and 2.

Page endings See **column endings**

Page numbers See **folios**

Paragraph endings See **column endings**

Paragraphs

A paragraph is a unit of thought and as such, one needs to be distinguishable from another. The paragraph may be shown in a variety of ways. Raw copy from a typist will invariably come with line spaces, but the typographic norm is to use a simple indent. A value equal to the leading – the dominant vertical increment of measure – is a suggested minimum.

Do not use tabs when you want an indent, since a tab becomes a character in the text. Instead use a formatting instruction, which can be altered or cancelled more easily.
See also Chapter V.

Parentheses See **brackets**

Prime

In general typographic use these are a leftover from the typewriter keyboard, where they were used both as apostrophes and quotation marks – showing no difference between open and closed. They should never be used instead of properly designed 'smart' **apostrophes** or **quotation marks**.

The prime is now generally used to denote feet and inches but the size and inelegance of its design in the majority of fonts is a problem. A way round this with roman figures is to use italic primes:

2′6″ long *not* 2′ 6″ long

If both metric and imperial dimensions are used it is preferable to use abbreviations:

a 2·4 × 1·2 m (8 × 4 ft) plywood sheet

Proof correction marks

In the days when the boundaries between the editorial, design and typesetting processes were more clearly delineated, a set of commonly understood proof correction marks enabled all parties to communicate clearly and succinctly about corrections and alterations to the copy. Despite the apparently seamless nature of much of today's design environment, that need for communication still exists. Different countries have their own standard marks; all are a form of shorthand and use marks both within the text and in the margins. The marks shown below are from the most recent British Standard (5261: 1975)

Basic marks

Insert	⟨	subtract or delete	/	error	✕
add	Y	subtract	⌐	queries	?
superior	Y	inferior	∧	leave alone	✓

Typestyle

marginal mark	text mark	as corrected
⊔⊔	italicize	*italicize*
⊔	romanize	romanize
⌇⌇⌇	embolden	**embolden**
≡	caps	CAPS
≢	NOT CAPS	not caps
=	small caps	SMALL CAPS
≠	NO SC	no sc

Spacing, character and line errors

Y	add⟋space	add space
⌐	c⟋2000	c.2000
⌣	clo⌒se up	close up
	⌐reposition⌐→	reposition
⊓	trⁿaspose	transpose
w.f.	Wrong font	Swift
	then. Make new para	
	lines / transpose	transpose lines
	run⌒ on	run on

take
~~back~~ now take back now

take [over] now take over now

Punctuation marks

No word space is used before punctuation marks, but characters with ascenders or overhangs may need some tracking before a closing bracket or a quotation mark.

In running text punctuation has an important role to play in conveying the intended meaning:

at 10 Cornwall Gardens, London he

but in display setting – for posters, letterheads or title pages, for example – line breaks, space or general arrangement can often take its place:

10 Cornwall Gardens
London

Quotation marks and quotations

' ' " "

British style is generally to use single quotes both for quotations and to denote particular usage of certain words. Double quotes create spotty holes in the text and should only be used for quotes within quotes.

'I liked when the car went "beep, beep" suddenly.'

American style is to use double quotes rather than single quotes, and single within double:

"I liked when the car went 'beep, beep' suddenly."

In either case, use quotation marks (sometimes called 'curly' or 'smart' quotes) not the typist's version ('primes'). Note also that British style is to place the punctuation mark within the quotation mark only if the quote is a complete sentence, while American style is to place the punctuation mark within the quote marks in every case.

For quotations of more than four lines it is better not to use quote marks at all, but to set the text differently, for example in a slightly smaller size and indented:

... a walking talking press release. In his own words,

Whatever I do it works for me. Everything I say or do is part of a promotional campaign for *me*, Bailey Savage. I can do no wrong, none whatsoever!

I was surprised and somewhat disappointed by how well the ...

Different languages have their own style of quotation marks. In French, for example:

‹ Ça m'a plu quand l'auto a fait « tut, tut » à tout d'un coup. ›

Spanish,

‚Me gustó cuando el coche hizo „pí, pí" de repente.'

and German,

„Es gefiel mir, als das Auto plötzlich ‚tut-tut' machte."

References

In non-fiction and academic writing there is often a need to refer to works cited within the text or to make further comment separate from the main text. This requires annotation in the main text and then a position and typographic style for the note itself. Notes can sit alongside the text (shoulder notes), below the text (footnotes), be placed at the end of individual chapters or removed to the back of the book (endnotes).

If footnotes are few in number they can be referred to by using standard characters:

* † ‡

but for copious references or when the notes follow the chapter, superior ('superscript') numbers placed at the end of the relevant phrase or sentence are far clearer. These are not part of a standard font but are created in the page layout program and may need some adjustment to balance visually with the text.

cast iron; enamelled steel;[14] and

Note that the superscript number follows any punctuation.

In the notes themselves, which are generally set in a smaller size and with less leading, the numbers are set normally.

14 For a description of this process see ...

Running heads/running feet

Like folios, running heads or feet are necessary in longer documents and the usual book style is to have the book title on the left-hand page and the chapter title on the right. It is often useful to group both folio and running head together. Variations to the content and position of both these elements can be made to suit particular circumstances, but they should always be consistent with the contents page.

See also **folios**

Sentence endings

The common typing practice of using two spaces at the end of each sentence creates white holes in the texture of a text. A single space following the full point is all that is required to allow the punctuation mark to do its work.

sentence creates white holes in the texture of a text. A single space following the full point is all that is needed.

Size

All sorts of things affect legibility; factors affecting text type are discussed in Chapter V. For the large sizes of type needed for signage purposes, a useful rule of thumb is a ratio of cap height to (minimum) reading distance of 1:250, so cap type that is 1cm high can be read 2·5 metres away. This rule should only be used as a starting point, however, as different combinations of typeface, colour, background colour and material will give different results.

Small caps

Small caps are capitals designed with a height approximately that of the lower-case x-height. If available, they are useful for emphasis in bibliographies, for academic qualifications, in post or zip codes and for an additional level of heading or subheading. Never use computer-generated versions, which simply take the capitals and reduce them: they look too light:

Andrew Haslam MA (RCA)
not Andrew Haslam MA (RCA)

Most suppliers of 'classic fonts' produce a matching expert set that contains small caps as well as non-lining figures and an assortment of ligatures and fractions. Many contemporary faces, such as Meta or Swift, have a version called caps or SC with a similar font layout.

Soft returns

These are used for turning over overhanging words in ranged-left copy, or for forcing turnovers in justified copy without creating a new paragraph.

Spine

Once a book is placed on a bookshelf the spine is its only means of identification. If the book is thick enough the type should be arranged horizontally. Generally, however, there is not the space so type must run vertically; in most countries except Germany, the standard is to read downwards so it is legible when the book is lying face up. If there is a great shortage of space the spine should at least show the author's surname and the main title.

Tables

Tables consist of two main elements: the data and the layout, which should support the sense of the data and aid its readability. If the two elements are given the same visual importance there is usually a loss of clarity.

Data dominated by grid = confusion

| 398 | 435 | 86 | 975 | 227 | 945 | 879 | 364 | 765 |

Data supported by grid = clarity
Horizontal rules support the reading of lines:

| 398 | 435 | 86 | 975 | 227 | 945 | 879 | 364 | 765 |

Vertical rules support the reading of columns:

| 398 | 435 | 86 | 975 | 227 | 945 | 879 | 364 | 765 |

In tables with many lines a tinted ground can be used to reinforce each line. The tint should be subtle, as too great a contrast produces a 'zebra' pattern. In the example below ellipsis points are used for omitted figures, and two weights of type – roman and bold – are employed to place emphasis on the columns. The resulting hierarchy could be helpful in timetables or when comparing financial information.

12·00	...	13·00	15·00	16·00
12·13	13·20	**13·56**	14·00
12·36	14·22	15·28	...

Temperature

This is indicated by the degree symbol. When two units of measurement are being used, or where there may be confusion, use initials to clarify. If the numerals are non-lining, small caps look better. A full point is unnecessary.

the April average is 61°F (15°C), but not this year.

Word space

The space between words is defined by the type designer or manufacturer but can be adjusted with the page layout program. Where something more prominent than a normal word space is needed, use an en space (500 units wide).

Glossary

Names in *italics* refer to other glossary entries.

ALIGNMENT 1, This describes the vertical edge of a column of type: *ranged-left*, *justified* etc. 2, It can also refer to how well the characters in a typeface sit on the *baseline*.

ARABIC NUMERALS see *Hindu–Arabic numerals*.

ASCENDER The part of a lower-case letter which projects above the *x-height*.

BASELINE Imaginary line on which letters sit.

BITMAPS 1, Graphic image composed of *pixels*. 2, The on-screen representation of a font image.

BLACKLETTER See *broken script*.

BODY 1, In metal type the rectangle of metal on which the image of a character was cast. 2, In photo or digital type the rectangle is a notional space occupied by the character.

BROKEN SCRIPT Letterforms constructed with a broad-edged pen but emphasizing the transition points between the written strokes.

CAPITALS Letterforms of even height, derived from the Roman 'square capitals'.

CATHODE RAY TUBE (CRT) An electronic device used in some image-setters to transmit the letter images onto the film or paper output.

CENTRED Symmetrical *alignment* of text.

CLARENDON see *slab serif*.

COLD COMPOSITION Any method of typesetting which outputs onto sensitized paper or film. Cold composition is also used to describe forms of 'direct' or 'strike-on' typesetting devices such as typewriters.

COLOUR In typography this usually refers to the overall tonal value of a typeface or block of text.

CONSONANT *Phoneme* of speech spoken with a constricted voice tract.

COUNTER The hollow negative space within a letterform.

COUNTERPUNCH A form of *punch* used to create the *counters* of a type-making punch.

CURSIVE Letters having the flow of handwriting, often associated with *italics*.

DESCENDER Part of a lower-case letter which projects below the *baseline*.

DESIGN The activity, principally mental and analytical, of deciding what the visual and physical appearance of a job should be.

DIALECT A form of speech associated with a particular region which has an identifiable vocabulary, pronunciation and idiom.

DIGITAL Type stored as mathematical formulae in digital form. This replaced photographic font masters from the late 1960s onwards.

DISPLAY TYPE see *headline type*.

EGYPTIAN see *slab serif*.

ETYMOLOGY The study of the origin, derivation and meaning of words.

FACSIMILE A reissue of a historic typeface which takes into account all the imperfections (ink-squash, etc.) and idiosyncrasies of the original model, rather than regularizing them for current taste like a *revival*.

FILMSETTING Often used as a blanket term to describe any form of post-metal typesetting, whether photographically or digitally based.

FONT/FOUNT Originally a font (originally spelt 'fount' in Britain) was a set of characters of a given *typeface*, and of one particular *size* and *style*. Nowadays it is used as another name for a single weight or style of a typeface.

FORMAT The shape or size of a job, whether the physical dimensions of a book or poster, or the size of a monitor or screen.

FORMATTING The activity of applying the instructions to text which gives it its structure and appearance. See also *design*.

FOUNDRY TYPE Metal type for repeated hand setting and therefore cast from a harder alloy than *mechanically composed* type.

FRAKTUR A form of *broken script*.

GIF Short for Graphics Interchange Format, a compressed method of storing *bitmap* images used on the internet.

GOLF BALL A spherical arrangement of raised characters used in some typewriters from the 1960s.

GOTHIC 1, See *broken script*. 2, American term for *sans serif*.

GRAMMAR The rules of a language which describe the use and function of words.

GROTESQUE see *sans serif*.

HEADLINE TYPE 1, Type designed to be noticed: for headlines or small amounts of text. 2, In *mechanical composition* systems, type above 14pt.

HINDU–ARABIC NUMERALS 1 2 3 4 5 etc.

HOT-METAL Type cast on a *mechanical composition* system.

HTML Short for HyperText Mark-up Language, a common way of creating web pages which can include sound and images in addition to text. The text remains 'live' and can be copied and pasted from the pages.

HUMANIST 1, A sub-group of *roman* types sometimes referred to as Venetian and characterized by a sloping cross-bar on the 'e'. 2, A sub-group of sans-serif types showing the influence of humanist and Aldine roman forms.

IDEOGRAM A symbol which represents a concept or idea.

IKARUS Developed by Dr Peter Karow at URW in Hamburg, this was the first typeface digitization program to include an *interpolation* facility.

IMAGESETTER Device for outputting type and page layouts at high resolution (1,000+ lpi) onto paper, film or direct to plate.

INCUNABULA The half century, 1450–1500, following the invention of printing in the West.

INDENT A line of type which starts further from the margin than those above and below, usually used to denote a new paragraph.

INSULAR TRADITION The styles of lettering from the monasteries at the edge of the Roman Empire such as Kells in Ireland and Lindisfarne in England.

INTERPOLATION As the outlines of digital type are mathematical formulae, intermediate weights of a typeface can be calculated and created from two extremes.

IONIC see *slab serif*.

ITALIC Sloped letters, see also *cursive*.

JUSTIFIED A column of text with vertical left- and right-hand edges achieved by allowing the word space to vary from one line to the next.

KERN, KERNING 1, The part of a character which overhangs its body. 2, A tightening up (or an opening out) of the space between pairs of characters applied by the end-user of a font.

KERNED PAIRS A tightening up (or an opening out) of the space between pairs of characters which is built into the font's design by its creator.

LASER Usual, contemporary method of exposing an image in *imagesetters* and other office printers.

LATIN 1, A script principally derived from Roman sources. 2, A type having triangular serifs.

LEADING In metal type strips of lead were inserted between lines to increase space, with most computer software the term is used to describe the space from one *baseline* to the next.

LETTERPRESS Method of relief printing, usually from metal or wood type and *stereotypes*.

LINE-CASTING Hot metal typesetting machine which cast each line as a single piece of metal.

LINING FIGURES 1 2 3 4 5 etc, see also *non-lining figures*.

LINOTYPE The first hot metal *line-casting* machine, see *mechanical composition*. Now a manufacturer of digital fonts.

LITHOGRAPHY see *offset-lithography*.

LOWER-CASE Small letters, uneven in height unlike capitals, and derived from the hand written forms evolved from the eighth to fifteenth centuries. They can occupy three parts: ascenders, decenders and x-height.

MACHINE SET see *mechanical composition*.

MAJUSCULES Name for *capitals* when discussing calligraphy.

MATRIX 1, A brass or copper image of a character from which metal type is cast. 2, Photographic negative used in photosetting. 3, Code page used in digital type design and manufacture.

MEASURE Another name for the line length (in justified setting) or maximum line length (in unjustified setting) specified by a designer for setting type. With most computer software this is the same as the width of the text box.

MECHANICAL COMPOSITION Any form of typesetting system involving a keyboard and a hot-metal caster. The two main kinds are best represented by the *Linotype* and the *Monotype*.

Minuscules Name for *lower-case* when discussing calligraphy.

Modern Typefaces characterized by a vertical shading and an abrupt change from thick to thin stroke.

Monotype *Mechanical composition* system which cast each character as an individual unit.

Mould Used together with a *matrix* to cast metal type. Its *point size* was fixed but its width was adjustable.

Multiple master Typeface format introduced by Adobe in 1991 which allowed the 'morphing' of designs along axes between pre-set master poles.

Non-lining figures 1 2 3 4 5 etc, see also *lining figures.*

Offset-lithography A method of planographic (level) printing invented by Aloys Senefelder (1771–1834). It relies on the fact that grease (on the image areas of a stone or metal plate) attracts ink, while water (on the non-image area) repels it. In offset-litho the image on the plate is 'offset' onto a rubber blanket which makes contact with the paper and thus prints the image.

Old face / old style Types characterized by an oblique stress.

Old style figures see *non-lining figures.*

OpenType An 'envelope' font technology announced by Adobe and Microsoft in 1997 to solve the problems of the cross-platform incompatability of *PostScript* and *TrueType* font formats.

Pantograph A diamond-shaped device of jointed metal rods used to reproduce a drawing at a different scale and capable of reproducing minute detail.

Phoneme A sound which is the smallest unit of speech within a language.

Phonetics The study of sounds which make up human speech.

Photosetting see *filmsetting.*

Pictogram A symbol which represents a person or object.

Pixel Short for 'picture element', the screen dots used to render an image.

Point size Type size does not refer to the visible size of a character but to the *body* – whether real as in metal type, or notional as in digital – on which the character sits. Size is usually expressed in points, of which there are 72 to the inch.

PostScript A page description language developed by Adobe Systems Inc. and introduced from 1983 onwards. Type and images in PostScript format will output on any device with a PostScript interpreter.

Punch A short steel bar onto the end of which a character was engraved (or cut) by hand and at the actual size of the required type. When completed, the metal was hardened and stamped into a bar of brass or copper (a *strike*) to form the *matrix*: from this the type was cast.

Punchcutter The engraver of punches.

Qwerty see *universal keyboard layout.*

Ragged-left see *ranged left.*

Ragged-right see *ranged right.*

Ranged-left *Alignment* of text with a vertical left edge and an *unjustified* right edge.

Ranged-right *Alignment* of text with a vertical right edge and an *unjustified* left edge.

Raster Image Processor (RIP) Output device which renders type or other graphic objects by a series of horizontal scan lines.

Reissue A historic type reissued in its original form and often cast from the same matrices. See also *revival* and *facsimile.*

Resolution The number of lines per inch (or cm) at which a particular device outputs or displays type, or dots per inch (or cm) at which an image or typeface was originally scanned.

Revival An adaptation – often regularized – of an existing design for newer technology or methods of manufacture. See also *facsimile.*

Roman Either 1, Upright as opposed to italic; 2, The normal weight as opposed to the bold; or 3, A seriffed face as opposed to a sans serif. The meaning is generally clear from the context.

Roman numerals I II III IV V etc.

Rotunda A form of *broken script.*

Rustics 1, Compressed capitals with bold terminations appearing from the first century. 2, Letterforms constructed from twigs, introduced in the nineteenth century.

Sans serif Typeface without *serifs.*

Schwabacher A form of *broken script.*

Script 1, A series of symbols which can be combined to describe a spoken language. The Latin alphabet is a script used to notate most European languages. 2, Letterform derived from handwriting, often *cursive.*

Semantics The meaning of language.

Serif Accretion at the end of the stems of *roman* letters thought by some to originate from stone-carving practice.

Set width The width of the em in Monotype hot metal compostion which varied from typeface to typeface.

Size see *point size.*

Slab serif Heavy rectangular serif which may be bracketed to the main stem (*clarendon*) or be un-bracketed (*egyptian*).

Slug Slang for the line of type cast from a *hot metal line-casting* machine.

Spectograph A machine which produces a visual impression of speech.

Stereotyping Usually associated with letter-press newspaper printing. The type was set in metal from which a paper-maché mould (flong) was made. From the flong, a curved metal printing plate – or stereo – was made.

Strike The copper blank struck by a *punch* to create a *matrix.*

Style / typestyle Italic, bold, bold italic etc.

Syllable A single unit of pronunciation containing a vowel sound or a combination of vowel and consonant sounds.

Syntax The study of the structure of language which holds sentences together.

Textura A form of *broken script.*

Tiff Short for Tagged Image File Format, a method of storing images as *bitmaps.*

Tracking A tightening up (or an opening out) of the space between characters applied to complete line or passages of text.

Transitional Typefaces which combine features of *old face* and *modern.*

TrueType A page description language recently introduced for use on the Macintosh. Like PostScript, it is device independent.

Type 1, The physical object, a piece of metal with a raised face at one end containing the reversed image of a character. 2, Abbreviation for typeface.

Typeface A set of *fonts* of related design. Since the end of the nineteenth century the term has referred to a set of related *styles.*

Type height The height of metal type measured between the bed of the printing press and the printing surface of the type itself.

Uncials Literally 'inch-high letters'. Rounded letterforms with a vertical axis and very short *ascenders* and *descenders* which appear from the fourth century onwards.

Unicode An international standard character set first proposed in 1997 to contain all the world's languages.

Universal keyboard layout QWERTY (also QZERTY or AZERTY) layout of typewriter or computer keyboard introduced around 1874.

Unjustified Column of text where the word space remains constant from one line to the next which results in one margin appearing *ragged.* May be either *ranged-left* or *ranged-right.*

Upper-case Name for *capitals* when discussing typography.

Venetian see *humanist.*

Vowels *Phonemes* of speech spoken with an open voice tract, in English a, e, i, o and u.

Vox classification 1954 system for classifying typefaces devised by the French typographer Maximilien Vox.

Wysiwyg Short for 'what you see is what you get' and refers to monitors which render different typefaces, sizes and alignments without the need to show the machine code.

X-height The height of the main part of *lower-case* letters.

Further reading

I: Definition and Other voices

Eric **GILL**, *An essay on typography* (1931), Boston MA, Godine 1988.

R S **HUTCHINGS**, *The western heritage of type design*, London, Cory, Adams & Mackay 1963.

Jock **KINNEIR**, *Words and buildings, the art and practice of lettering*, London, Architectural Press 1980.

Robin **KINROSS** (Ed.) *Anthony Froshaug, typography & texts*, London, Hyphen Press 2000.

Robin **KINROSS**, *Fellow readers: notes on multiplied language*, London, Hyphen Press 1996.

Willie **KUNZ**, *Typography: macro & micro aesthetics, fundamentals of typographic design*, Switzerland/Liechtenstein, Niggli AG 1998.

Ruari **MCLEAN** (Ed) *Typographers on type*, London, Lund Humphries 1995.
An important collection of key writings charting many different aspects of typography, printing and design between 1885 and publication.

Monotype Recorder, 'I am a communicator' (Beatrice Ward obituary issue) vol.44, no.1, Autumn 1970.

Rick **POYNOR**, *Typography now*, London, Booth-Clibborn Editions 1991.

Emil **RUDER**, (*Typographie, ein Gestaltungslehrbuch*, 1967), *Typography, a manual of design*, New York, Hastings House 1981.

Percy **SMITH**, *Lettering, a plea*, London, First Edition Club 1932.

Paul **STIFF**, 'Spaces and difference in typography' in *Typography papers* 4, University of Reading 2000.

Walter **TRACY**, *The typographic scene*, London, Gordon Fraser 1988.

Jan **TSCHICHOLD** (*Typographische Gestaltung*, 1935), Trans. Ruari McLean, *Asymetric typography*, London, Faber & Faber and Toronto, Cooper & Beaty 1967.

Franz **ZEIER**, *Rightness and lightness: thoughts on the book as object of use*, St Gallen, Typotron 1990.

II: Function

Bill **BRYSON**, *Mother tongue*, London, Penguin 1991.

Bernard **COMBRIE**, Stephen Matthews and Maria Polinsky, *The atlas of languages*, London, Bloomsbury 1997.

Peter **COLLINS** and Carmella **HOLLO**, *English grammar: an introduction*, Basingstoke & London, Macmillan Press 2000

David **CRYSTAL** *The Cambridge encyclopedia of the English language*, Cambridge University Press 1995.

Patsy **RODENBURG**, *The need for words: voice and the text*, London, Methuen 1993.

Andrew **ROBINSON**, *The story of writing: alphabets, hieroglyphs and pictograms*, London, Thames & Hudson 1995.

Cal **SWANN**, *Language and typography*, London, Lund Humphries 1991.

III: Form

Lewis **BLACKWELL**, *Twentieth-century type (remix)*, London, Laurence King 1998.
Useful overview of type history related to the wider graphic design context, well chosen examples of work reproduced.

John **CARTER**, Frank **FRANCIS**, Stanley **MORISON** et al., *Printing and the mind of man* (exh. cat.), London, F W Bridges & Sons and the Association of British Manufacturers of Printers' Machinery 1963.
A detailed exhibition catalogue describing key books and technologies from the invention of type onwards.

Edward M **CATICH**, *The origin of the serif*, Davenport, Iowa, St Ambrose University 1991

Catherine **DIXON**, 'Why we need to classify type', *Eye* 18, vol. 5, 1995, pp.86–7.
A short explanation of the problems of typeface classification.

—, 'Alternative type histories', *Point: Art & Design Research Journal* 8, Autumn/Winter 1999/2000 pp.46–56.

—, and Eric **KINDEL**, *Typeform dialogues* (book & CD-Rom), London, Hyphen Press, forthcoming.

Friedrich **FRIEDL**, Nicolaus **OTT** and Bernard **STEIN**, *Typo: when, who, how*, Cologne, Könemann 1998.
Broad coverage of the subject with pithy biographies of virtually every important figure and company. Hundreds of illustrations, many unfamiliar.

Nicolete **GRAY**, *A history of lettering*, Oxford, Phaidon Press 1986.
A comprehensive overview of lettering history and development.

—, *Lettering on buildings*, London, Architectural Press & New York, Reinhold 1960.
This book established the subject as one worthy of serious study.

—, with Ray Nash, *Nineteenth-century ornamented typefaces*, London, Faber & Faber (second edition) 1976.
Definitive account of a century of invention within type design.

Justin **HOWES**, *Johnston's Undergound type*, London: Capital Transport 2000.
An affordable introduction to London's influential Underground type.

Georges **JEAN**, *Writing: the story of alphabets and scripts*, London, Thames & Hudson 1992.

John **SOUTHWARD**, *Modern printing, section 1, the composing room*, London: Raithby, Lawrence & Co. 1898.

James **SUTTON** and Alan **BARTRAM**, *An atlas of typeforms*, London, Lund Humphries 1968; reprinted (in a slightly smaller format) 1989.
An excellent large-format pictorial introduction to five centuries of type design. In the original edition most examples of work are reproduced actual size.

Daniel Berkeley **UPDIKE**, *Printing types*, Cambridge, MA: Harvard University Press 1922.

Rudy **VANDERLANS** & Zuzana **LICKO** with Mary E **GRAY**, *Emigré, graphic design into the digital realm*, New York, Van Nostrand Reinhold 1993.

Theodore Lowe **DE VINNE**, *Plain printing types*, New York: The Century Co. 1900.

IV: Manufacture & design

Andrew **BOAG**, 'Typographic measurement: a chronology', *Typography Papers* 1, University of Reading 1996, pp.105–21.
Detailed and definitive.

—, 'Monotype and photosetting', *Journal of the Printing Historical Society*, New series no.2, 2000, pp.57–77.

Bruce **BROWN**, *Brown's index to photocomposition typography*, Minehead, Greenwood 1983.

Warren **CHAPPELL** (revised and updated by Robert Bringhurst), *A short history of the printed word*, Vancouver, Hartley & Marks, 1999.
A useful, if at times overly nostalgic, overview of commercially used printing processes and their effects.

EMIGRÉ 15 ('Do you read me?') 1990.
The cutting edge of type design in 1990: interviews with Barry Deck, Jeff Keedy and Zuzana Licko.

Dave **FAREY**, Colin **BRIGNALL** et al., *Letraset and stencil cutting*, New York, International Typeface Corporation, St Bride and London, Printing Library 1996.

Anthony **FROSHAUG**, *Typographic norms*, Kynoch Press, Birmingham and D&AD, London 1964.
Visual explanation of the relationship of spacing material for metal type and introductory text explaining the values of standardization and constraints in design. Although reprinted in Robin Kinross, *Anthony Froshaug: typography & texts* (see list for I: Definitions …) it is worth trying to see the original.

Michael **HARVEY**, *Creative lettering today*, London, A & C Black 1996.

Peter **KAROW**, *Digital formats for typefaces*, Hamburg, URW Verlag 1987.
Detailed explanation of the situation at that time by the inventor of the Ikarus type design system.

Monotype Recorder: All the leading typeface and typesetting equipment manufacturers produced copious amounts of literature to promote and

explain their goods, and none did this more successfully than Monotype. The issues listed below are particularly relevant to the discussions in this chapter.

'"Monotype" matrices and moulds in the making', vol.40, no.3, Autumn 1940.

'Filmsetting in focus', vol.43, no.2, Summer 1965.

'The Dutch connection', new series, vol.9, (undated).

'One hundred years of type making' (centenary issue), new series, no.10, 1997.

James **Moran**, *The composition of reading matter*, London, Wace & Co. 1965.

John W **Seybold**, *The world of digital typesetting*, London, Seybold 1984.

Fred **Smeijers**, *Counterpunch: making type in the sixteenth century, designing typefaces now*, London, Hyphen Press 1996.
Along with Tracy's *Letters of credit*, one of the two best books ever written on the subject.

Walter **Tracy**, *Letters of credit*, London, Gordon Fraser 1986.

—, *The typographic scene*, London, Gordon Fraser 1988.

Lawrence **Wallis**, *A concise chronology of typesetting developments, 1886–1986*, London, Wynkyn de Worde and Lund Humphries 1988. Detailed and definitive.

—, *Modern encyclopedia of typefaces, 1960–90*, London, Lund Humphries 1990.

—, *Typomania: selected essays on typesetting and related subjects*, Severnside 1993.

Web Much useful information about current technical specifications and standards can be found at the websites of the major software and type manufacturers. Among these are:
adobe.com
agfamonotype.com or *agfamonotype.co.uk*
microsoft.com/typography
pdfzone.com
typeright.org
typeart.com
unicode.org

V: Structure

Alan **Bartram**, *Making books: design in British publishing since 1945*, London, British Library, and New Castle, USA, Oak Knoll Press 1999.

Robert **Bringhurst**, *The elements of typographic style*, Point Roberts, USA, Hartley & Marks, second edition 1997.

Carl **Dair**, *Design with type*, University of Toronto Press, 1982 (orig. pub. 1967).

Geoffrey **Dowding**, *Finer points in the spacing and arrangement of type*, Point Roberts, USA, Hartley & Marks, revised edition 1995.

Harold **Evans**, *Editing and design, a five volume manual of english, typography and layout: book five, newspaper design*, London, Heinemann 1973.

Ken **Garland**, 'Lead kindly light: a user's view of the design and production of illustrated walkers' guides', *Information Design Journal*, vol.7, no.1, 1993, pp.47–66.
Excellent overview.

Eric **Gill**, *An essay on typography*, London, Lund Humphries, and Boston, Godine 1988 (orig. pub. 1931).

Jost **Hochuli** and Robin **Kinross**, *Designing books: practice and theory*, London, Hyphen Press 1996.

Ellen **Lupton** and J Abbot **Miller**, *Design/writing/research: writing on graphic design*, London, Phaidon Press 1999.

Massin, *Letter and image*, London, Studio Vista 1970.
A comprehensive look at lettering in art as well as design, over 1,100 illustrations: fabulous.

James **Sutton** and Alan **Bartram**, *Typefaces for books*, London, British Library 1990.
The introduction gives a useful overview of the practice of book design, with many annotated examples.

Jan **Tschichold**, *The form of the book: essays on the morality of good design*, London, Lund Humphries 1991.

Web Useful information about the needs of dyslexic readers can be found at *www.interdsy.org* and *www.bda-dyslexia.org.uk*

VI: Conventions
Grammar and use of language

G V **Carey**, *Mind the stop: a brief guide to punctuation with a note on proof-correction*, Harmondsworth, Penguin 1976 (orig. pub. 1939).

Ernest **Gowers**, *The complete plain words*, revised by Sidney Greenbaum and Janet Whitcut, London, HMSO 1986 (orig. pub. 1954).

More general matters of style and detailing

Alison **Black**, 'Breaking up is hard to do', *Information Design Journal*, vol.7, no.1, 1993, pp.93–4.
Useful summary of the arguments about hyphenation.

Robert **Bringhurst**, *The elements of typographic style*, Point Roberts, WA, Hartley & Marks, second edition 1997.

Geoffrey **Dowding**, *Finer points in the spacing and arrangement of type*, Point Roberts, WA, Hartley & Marks, revised edition 1995.

Hart's rules for compositors and readers at the University Press, Oxford, Oxford University Press, 39th edition 1983.

Jost **Hochuli** and Robin **Kinross**, *Designing books: practice and theory*, London, Hyphen Press 1996.
Much good advice on the detailing of text, the integration of text and image, and on different formats.

Robin **Kinross**, 'Large and small letters: authority and democracy', *Octavo* 5 1988, pp.2–5.
A useful survey of the pros and cons of lowercase typography and the functional aspect of capitals.

—, *Modern typography, a critical history*, London, Hyphen Press 1991.
Excellent overview which avoids well-trodden paths. Ideas about orthography are summarized on p.199.

James **Sutton** and Alan **Bartram**, *Typefaces for books*, London, British Library 1990.
Concise introduction to book design and useful notes on detailing on pp.282–3.

Jan **Tschichold**, *The form of the book: essays on the morality of good design*, London, Lund Humphries 1991.

Edward R **Tufte**, *Envisioning information: the visual display of quantitative information*, Cheshire, Conn., Graphics Press 1990.

—, *Visual explanations, images and quantities: evidence and narrative,* Cheshire, Conn., Graphics Press 1990.

Magazines and periodicals
Many of the magazines referred to in the lists above have an international perspective and distribution. Chief among them are *Baseline* (GB), *Communication Arts* (USA), *Dot, dot, dot* (D), *Emigré* (USA), *Fine Print* (USA), *Eye* (GB), *Graphis* (CH), *Typography Papers* (GB) and *Typographische Monatsblätter* (CH).

In addition, there are many general graphic design magazines published weekly or monthly which cover business, design trends and practical issues, *eg Creative Pro* (USA), *Creative Review* (GB), *Graphics International* (GB) and *Step-by-step Graphics* (USA). Some of these also have online versions.

Organizations
Among the main organizations devoted to typography are:

Association Typographique International (ATypI) *atypi.org* Originally founded in 1957, ATypI has an international membership of manufacturers, designers, educators and users of type. The organization promotes an interest in all aspects of typography and type design and campaigns for copyright protection. In addition to an annual conference there are occasional publications free to members.

International Society of Typographic Designers (ISTD). UK-based organization with membership by selection. Involved in educational initiatives with its student awards scheme; holds a regular lecture program and publishes a journal, *Typographic*, three times a year.

Type Directors Club *tdc.org* Founded in 1946, the TDC has an international membership and offices in New York. It organizes an annual competition and publishes a yearbook.

Timechart of type designers part 1 1400–1900

the first types were broken scripts

Johann Gutenberg D c.1394–1468
William Caxton GB 1421–91
Peter Schöffer D d.1503
Henrik Pieterszoon Lettersnijder NL c.1470–1511
Wynkyn de Worde D d.1535

humanist, Aldine, and Dutch taste roman types

Adolf Rusch I fl.1464
Conrad Sweynheym & Arnold Pannartz I fl.1465
Johannes (d.1470) & Wendelin de Spira I
Nicolas **Jenson** I 1420–80
Aldus Manutius I 1450–1515
Francesco Griffo I fl.1494–1518
Ludovico degli **Arrighi** da Vincenza I d.1527
Antoine Augerau F c.1485–1534
Simon de Colines F fl.1520–61
Claude **Garamond** F c.1480–61
Antonio **Blado** I fl.1515–67
Hendrik van den Keere NL c.1540–1580
Jacob **Sabon** F fl.1557–80
Robert **Granjon** F 1513–89
Christopher **Plantin** F c.1520–89
Pierre Haultin F d.1589
Guillaume le Bé F d.1598
Nicholas Briot NL d.c.1626
Jean Jannon F 1580–1658
Cristofel **Van Dijck** NL 1601–69
Bartholomeus Voskens d.1669
Dr John Fell GB 1625–86
Joseph Moxon GB 1627–91
Nicolas Kis H 1650–170?
Peter de Walpergen NL d.170?
J M Fleischma
Wi

Phillipe Grandjean F 1666
Pierre Simon

John **Baske**
Ja

The aim of this diagram is to give an overview of the major figures in typeface design. In order to prevent it from becoming too unwieldy, there is a bias towards designers of text types.

Exactly what constitutes a type designer can be difficult to pinpoint: is it the person who guides the design – financially or artistically – or the person who does the work – whether punchcutting or digitization? Because the answer is seldom clear-cut, and different historians have taken different views on who was responsible, this chart tries to be inclusive and give the prominent names in both categories.

The living are ranged left from their year of birth, the dead are ranged right from the year of their death. Many designers have had types named after them, their surnames are set in **bold**. Designer's country of birth (or contemporary equivalent) both here and in the Who's who (pages 186–7) is indicated by standard international motoring abbreviations as follows:

A Austria
C Cuba
CH Switzerland
CZ Czech Republic
D Germany
E Spain
F France
GB Great Britain
H Hungary
I Italy
IS Iceland
NL Netherlands
ROU Uruguay
S Sweden
SK Slovakia
USA United States of America
YU Yugoslavia
ZA South Africa

Incunabula period

1400 1500 1600 17

176 Type & typography

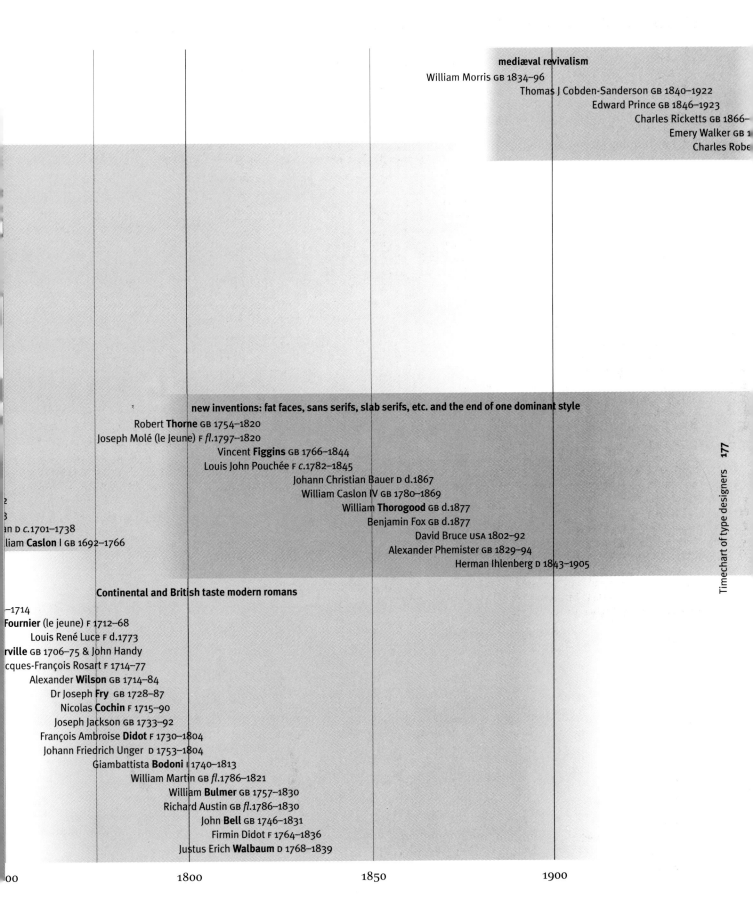

mediæval revivalism

William Morris GB 1834–96

Thomas J Cobden-Sanderson GB 1840–1922

Edward Prince GB 1846–1923

Charles Ricketts GB 1866–

Emery Walker GB 1

Charles Robe

new inventions: fat faces, sans serifs, slab serifs, etc. and the end of one dominant style

Robert **Thorne** GB 1754–1820

Joseph Molé (le Jeune) F *fl.*1797–1820

Vincent **Figgins** GB 1766–1844

Louis John Pouchée F *c.*1782–1845

Johann Christian Bauer D d.1867

William Caslon IV GB 1780–1869

William **Thorogood** GB d.1877

Benjamin Fox GB d.1877

David Bruce USA 1802–92

Alexander Phemister GB 1829–94

Herman Ihlenberg D 1843–1905

an D *c.*1701–1738

liam **Caslon** I GB 1692–1766

Continental and British taste modern romans

–1714

Fournier (le jeune) F 1712–68

Louis René Luce F d.1773

rville GB 1706–75 & John Handy

cques-François Rosart F 1714–77

Alexander **Wilson** GB 1714–84

Dr Joseph **Fry** GB 1728–87

Nicolas **Cochin** F 1715–90

Joseph Jackson GB 1733–92

François Ambroise **Didot** F 1730–1804

Johann Friedrich Unger D 1753–1804

Giambattista **Bodoni** I 1740–1813

William Martin GB *fl.*1786–1821

William **Bulmer** GB 1757–1830

Richard Austin GB *fl.*1786–1830

John **Bell** GB 1746–1831

Firmin Didot F 1764–1836

Justus Erich **Walbaum** D 1768–1839

00 1800 1850 1900

mediæval revivalism

Charles Ricketts 1866–1930
Emery Walker 1851–1933
Charles Robert Ashbee 1863–1942
Lucien Pissaro 1863–1944

with the revival of interest in historic types and the possibilities of mechanization comes the notion that there are styles of type design in which to

Theodore Low
De Vinne USA 1828–1914
Bertram Grosvenor Goodhue
USA 1869–1924
Robert Weibkind D 1870–1927
Linn Boyd Benton USA 1844–1932
Rudolf **Koch** D 1876–1934
Joseph W Phinney USA 1848–1934
Jakob **Erbar** D 1878–1935
Frank Hinmam Pierpont USA 1860–1937
George Auriol F 1863–1938
Frederic Warde USA 1894–1939
Peter **Behrens** D 1869–1940
Oswald Bruce Cooper GB 1879–1940
Arthur Eric Rownton **Gill** GB 1882–1940
George William Jones USA 1860–1942
Emil Rudolf **Weiß** D 1875–1943
Edward **Johnston** ROU 1872–1944
Fredric **Goudy** USA 1865–1947
Ernst F Detterer D 1888–1947
Morris Fuller **Benton** USA 1872–1948
Heinrich **Jost** D 1889–1948
John Henry Mason GB 1875–1951
Walter Tieman D 1876–1951
Sol **Hess** USA 1886–1953
Charles Malin F 1883–1955
Will Ransom USA 1878–1955
William Addison Dwiggins USA 1880–1956
Chauncey H Griffith USA 1879–1956
Paul Renner D 1878–1956
Friedrich Hermann Ernst Schneidler D 1882–1956
Bruce Rogers USA 1870–1957
Jan Van Krimpen NL 1892–1958
George H Trenholm USA 1886–1958
Allesandro Butti I 1893–1959
Oldrîch Menhart CZ 1897–1962
Sjoerd Hendrik de Roos NL 1877–1962
Thomas Maitland Cleland USA 1880–1964

1909 Dick Dooijes
1910 Robert Harling GB
1912 Sem L Hartz NL
1913 Walter J Diethelm CH
1914 Karl Erik Forsberg S
1916 Max Caflisch CH
1917 Freeman Craw USA
1918 Albert Kapr D
1918 Hermann **Zapf** D
1918 Gudrun Zapf-Von Hesse D
1919 Victor Caruso USA
1921 Chis Brand NL
1921 Walter Baum D
1921 Günther Gerhard Lange D
1922 Hans Eduard Meier CH
1925 Gustav **Jaeger** D
1926 José **Mendoza** y Almeida F
1927 Ed **Benguiat** USA
1928 Wim Crouwell NL
1928 Adrian **Frutiger** CH
1929 Mike Parker USA
1930 Karl **Gerstner** CH
1930 Georg Salden D
1931 Michael Harvey GB
1931 Rosemary **Sassoon** GB
1932 Alfred Boton F
1932 Manfred Klein D
1934 Bram de Does NL
1936 Margaret **Calvert** ZA
1936 André Gürtler CZ
1937 Matthew Carter GB

1938 Ed Fella USA
1938 Hans-Jörg Hunziker D
1939 Thomas Paul Carnase USA
1940 Colin Brignall GB
1941 Volker Kuster D
1942 Jean Alessandrini F
1942 Gerard Unger NL
1943 Dave Farey GB
1943 Bernd Möllenstädt D
1943 Antonio de Spigna I
1945 Charles Bigelow GB
1945 Sumner **Stone** USA
1947 Erik Spiekermann D
1947 Robin Nicholas GB
1948 Gunnlauger Briem IS
1948 David **Quay** GB
1950 Ron Carpenter GB
1950 Kris Holmes USA
1950 Adrian Williams GB
1951 Freda Sack GB
1952 Nick Shinn CDN
1953 Max Kisman NL

1954 Jovica **Veljović** YU
1955 David Berlow USA
1955 Jeff Keedy USA
1955 Joseph Treacy USA
1955 Rudy VanderLans NL
1956 Petr van Blokland NL
1956 Cynthia Hollandsworth USA
1956 Marc Jamra USA
1956 Carlos Segura C
1956 Robert Slimbach USA
1957 Neville Brody GB
1959 Carol Twombly USA
1959 Shelley Winter GB
1960 Martin Majoor NL
1961 Zuzana Licko CS
1961 Peter Matthias Noordzij NL
1961 Thierry Puyfoulhoux F
1961 Pierre di Sciullo F
1961 Fred Smeijers NL
1962 Barry Deck USA
1962 Michael Gills GB
1962 Frank Jalleau F
1963 Luc(as) de Groot NL
1963 Rian Hughes GB
1964 Frank Heine D
1964 Enric Jardi E
1964 Jean François Porch
1964 Cornel Windlin CH
1966 Just van Ru
1967 Eric Va
1967 Jon Bar
1968 Ste
1969
1969
1969

Carl Dair CDN 1912–67
Victor Hammer A 1882–1967
Stanley Morison GB 1889–1967
A M Cassandre F 1901–68
Louis Jou E 1881–1968
Konrad Bauer D 1903–70
Lucien **Berhard** D 18
Jan Tschic
Jackson
Hans/Giova

178 Type & typography

work, type design is no longer exclusively contemporary; type designers increasingly independent of manufacturers or become manufacturers

Reynolds Stone GB 1909–79
Max Miedinger CH 1910–80
Herb **Lubalin** USA 1918–81
Alfred Fairbank GB 1895–1982
Friedrich **Poppl** D 1923–82
François Ganeau F 1912–83
Charles **Peignot** F 1897–1983
Leslie Usherwood GB 1932–83
Roger Excoffon F 1911–84
George **Trump** D 1896–1985
Robert Hunter Middleton GB 1898–1985
Enric Crous-Vidal E 1908–87
Imre Reiner H 1900–87
Marcel Jacno F 1904–89
John Peters GB 1917–89
Berthold Wolpe D 1905–89
Joseph Blumenthal USA 1897–1990
Warren Chappell USA 1904–91
Otl Aicher CH 1922–92
Jock Kinneir GB 1917–94
Sem L Hartz NL 1912–95
David Kindersley GB 1915–95
Aldo Novarese I 1920–95
Walter Tracy GB 1914–95
P Scott Makela USA 1960–99
Will Carter GB 1912–2001

ez F

ssum NL
Blokland NL
nbrook GB
ephen Farrell GB
Miles Newlyn GB
Jeremy Tankard GB
Wm Ross Mills CDN
1970 Tobias Frere-Jones USA
1970 Jonathan Hoefler USA
1970 John Hudson GB
1973 Peter Bilak SK

35–1972
hold CH 1902–74
Burke USA 1908–75
ni Mardersteig D 1892–1977
Herbert **Post** D 1903–78
Rudolf Ruzicka CS 1883–1978

Appendix 1

ISO Latin set 1: position of characters on the British and US Macintosh keyboard

Note that although typefaces designed for this set have 256 possible character positions, not all of them are accessible from the Mac keyboard. In addition, only characters *not* shown on the keys themselves are listed below. Where characters have more than one function the information is duplicated.

Accented characters

Char	Keys 1	Keys 2
Å	Shift + Alt + A	
å	Alt + A	
Á	Alt + E	Shift + A
á	Alt + E	A
À	Alt + `	Shift + A
à	Alt + `	A
Â	Alt + I	Shift + A
â	Alt + I	A
Ä	Alt + U	Shift + A
ä	Alt + U	A
Ã	Alt + N	Shift + A
ã	Alt + N	A
Ç	Shift + Alt + C	
ç	Alt + C	
É	Alt + E	Shift + E
é	Alt + E	E
È	Alt + `	Shift + E
è	Alt + `	E
Ê	Alt + I	Shift + E
ê	Alt + I	E
Ë	Alt + U	Shift + E
ë	Alt + U	E
Í	Alt + E	Shift + I
í	Alt + E	I
Ì	Alt + `	Shift + I
ì	Alt + `	I
Î	Alt + I	Shift + I
î	Alt + I	I
Ï	Alt + U	Shift + I
ï	Alt + U	I
Ñ	Alt + N	Shift + N
ñ	Alt + N	N
Ó	Alt + E	Shift + O
ó	Alt + E	O
Ò	Alt + `	Shift + O
ò	Alt + `	O
Ô	Alt + I	Shift + O
ô	Alt + I	O
Ö	Alt + U	Shift + O
ö	Alt + U	O
Ø	Shift + Alt + O	
ø	Alt + O	
Õ	Alt + N	Shift + O
õ	Alt + N	O
Ú	Alt + E	Shift + U
ú	Alt + E	U
Ù	Alt + `	Shift + U
ù	Alt + `	U
Û	Alt + I	Shift + U
û	Alt + I	U
Ü	Alt + U	Shift + U
ü	Alt + U	U
Ÿ	Alt + U	Shift + Y
ÿ	Alt + N	Y

Accents

acute

´ Alt + E (GB) Shift + Alt + E (US)

breve

˘ Shift + Alt + >

circumflex

ˆ Shift + Alt + N (GB) Shift + Alt + I (US)

dotless i

ı Shift + Alt + B

dieresis (umlaut)

¨ Alt + U (GB) Shift + Alt + U (US)

grave

` Alt + ` (GB) Shift + Alt + ` (US)

macron

¯ Shift + Alt + <

overdot

˙ Alt + H

ring

˚ Alt + E (GB) Alt + K (US)

tilde

˜ Shift + Alt + M (GB) Shift + Alt + N (US)

Apostrophe

’ Shift + Alt + }

Apple

(on system fonts)

 Shift + Alt + K

Bullet

• Alt + 8

Copyright

© Alt + G

Dashes

em dash

— Shift + Alt + -

en dash

– Alt + -

Decimal or mid point

· Shift + Alt + 9

Dipthongs

Æ Shift + Alt + ' æ Alt + '

Œ Shift + Alt + Q œ Alt + Q

Ellipses

… Alt + ;

En space

ie 500 units wide

Alt + Space

Fraction bar

'Whole fractions' cannot be accessed on the Mac, use the solidus (not the 'virgule' or forward slash) as the bar when creating your own

⁄ Shift + Alt + 1

Ligatures

fi [Shift] [Alt] [%5]

fl [Shift] [Alt] [^6]

eszett (German long and short s combined)

ß [Alt] [S]

In some faces and in expert sets further ligatures for ffi, ffl exist, positions are usually specific to each particular manufacturer.

Mathematical and other symbols

American number symbol (GB)

[Alt] [#3]

ascii circumflex

∧ [Alt] [I]

approx/equal

≈ [Alt] [X]

degree

° [Shift] [Alt] [*8]

delta

△ [Alt] [J]

division

÷ [Alt] [?/]

epsilon

∑ [Alt] [W]

greater than or equal to

≥ [Alt] [>]

infinity

∞ [Alt] [%5]

integral

∫ [Alt] [B]

less than or equal to

≤ [Alt] [<]

logical not

¬ [Alt] [L]

lozenge

◇ [Shift] [Alt] [V]

mu

μ [Alt] [M]

not equal to

≠ [Alt] [+=]

omega

Ω [Alt] [Z]

ordinal a

ª [Alt] [(9]

ordinal o

º [Alt] [)0]

partial difference

∂ [Alt] [D]

per thousand

‰ [Shift] [Alt] [E] (GB) [Shift] [Alt] [R] (US)

Pi

∏ [Shift] [Alt] [P]

pi

π [Alt] [P]

plus or minus

± [Shift] [Alt] [+=]

Pound sterling (US)

£ [Alt] [#3]

solidus (fraction bar)

⁄ [Shift] [Alt] [!1]

square root

√ [Alt] [V]

Mid or decimal point

· [Shift] [Alt] [(9]

Monetary symbols

Cent

¢ [Alt] [$4]

Euro

€ [Alt] [@2]

Florin

ƒ [Alt] [F]

Yen

¥ [Alt] [Y]

Punctuation marks

open Spanish exclamation mark

¡ [Alt] [!1]

open Spanish question mark

¿ [Shift] [Alt] [?/]

Quotation marks

' [Alt] [}]] ' [Shift] [Alt] [}]]

" [Alt] [{[] " [Shift] [Alt] [{[]

Guillemets (used pointing out in French and Italian, in German they point in)

‹ [Shift] [Alt] [#3] › [Shift] [Alt] [$4]

« [Alt] [\|] » [Shift] [Alt] [\|]

open Spanish quotation marks

‚ [Shift] [Alt] [)0] „ [Shift] [Alt] [W]

Reference marks

dagger

† [Alt] [T]

double dagger

‡ [Shift] [Alt] [&7]

paragraph (pilcrow)

¶ [Alt] [&7]

section

§ [Alt] [^6]

Registered trade mark

® [Alt] [R]

Soft return

this creates a new line without it giving a new paragraph format

[Shift] [Return]

Temperature

degree

° [Shift] [Alt] [*8]

Trademark

TM [Shift] [Alt] [@2]

Appendix 2

ISO Latin set 1: position of characters on the Windows 95/98 keyboard map

Only characters *not* shown on the keys themselves are listed below. Where characters have more than one function the information is duplicated.

Accented characters

Char	Keys
Å	Alt `!1` `(9` `&7`
å	Alt `@2` `@2` `(9`
Á	Shift Control Alt `A`
á	Control Alt `A`
À	Alt `!1` `(9` `@2`
à	Alt `@2` `@2` `$4`
Â	Alt `!1` `(9` `$4`
â	Alt `@2` `@2` `^6`
Ä	Alt `!1` `(9` `^6`
ä	Alt `@2` `@2` `*8`
Ã	Alt `!1` `(9` `%5`
ã	Alt `@2` `@2` `&7`
Ç	Alt `!1` `(9` `(9`
ç	Alt `@2` `#3` `!1`
É	Shift Control Alt `E`
é	Control Alt `E`
È	Alt `@2` `)0` `)0`
è	Alt `@2` `#3` `@2`
Ê	Alt `@2` `)0` `@2`
ê	Alt `@2` `#3` `$4`
Ë	Alt `@2` `)0` `#3`
ë	Alt `@2` `#3` `%5`
Í	Shift Control Alt `I`
í	Control Alt `I`
Ì	Alt `@2` `)0` `$4`
ì	Alt `@2` `#3` `^6`
Î	Alt `@2` `)0` `^6`
î	Alt `@2` `#3` `*8`
Ï	Alt `@2` `)0` `&7`
ï	Alt `@2` `#3` `(9`
Ñ	Alt `@2` `)0` `(9`
ñ	Alt `@2` `$4` `!1`
Ó	Shift Control `O`
ó	Control Alt `O`
Ò	Alt `@2` `!1` `)0`
ò	Alt `@2` `$4` `@2`
Ô	Alt `@2` `!1` `@2`
ô	Alt `@2` `$4` `$4`
Ö	Alt `@2` `!1` `$4`
ö	Alt `@2` `$4` `^6`
Ø	Alt `@2` `!1` `^6`
ø	Alt `@2` `$4` `*8`
Õ	Alt `@2` `!1` `#3`
õ	Alt `@2` `$4` `%5`
Š	Alt `!1` `#3` `*8`
š	Alt `!1` `%5` `$4`
Ú	Shift Control Alt `U`
ú	Control Alt `U`
Ù	Alt `@2` `!1` `&7`
ù	Alt `@2` `$4` `(9`
Û	Alt `@2` `!1` `(9`
û	Alt `@2` `%5` `!1`
Ü	Alt `@2` `@2` `)0`
ü	Alt `@2` `%5` `@2`
Ÿ	Alt `!1` `%5` `(9`
ÿ	Alt `@2` `%5` `%5`
Ý	Alt `@2` `@2` `!1`
ý	Alt `@2` `%5` `#3`

Accents

Accent	Keys
acute ´	Alt `!1` `*8` `)0`
cedilla ¸	Alt `!1` `*8` `$4`
circumflex ^	Alt `!1` `#3` `^6`
dieresis (umlaut) ¨	Alt `!1` `^6` `*8`
macron ¯	Alt `!1` `&7` `%5`
tilde ~	Alt `!1` `%5` `@2`

Apostrophe

' — Alt `!1` `$4` `^6`

Archaic characters

eth
ð — Alt `@2` `$4` `)0`

Eth
Ð — Alt `@2` `)0` `*8`

thorn
þ — Alt `@2` `%5` `$4`

Thorn
Þ — Alt `@2` `@2` `@2`

Bullet

• — Alt `!1` `$4` `(9`

Copyright

© — Alt `!1` `^6` `(9`

Dashes

em dash
— — Alt `!1` `%5` `!1`

en dash
– — Alt `!1` `%5` `)0`

Decimal point

also used as a midpoint for punctuation

· — Alt `!1` `*8` `#3`

Dipthongs

Æ — Alt `!1` `(9` `*8`
æ — Alt `@2` `#3` `)0`
Œ — Alt `!1` `$4` `)0`
œ — Alt `!1` `%5` `^6`

Ellipsis points

… — Alt `!1` `#3` `#3`

Fractions

¼ — Alt `!1` `*8` `*8`
½ — Alt `!1` `&7` `*8`
¾ — Alt `!1` `(9` `)0`

Ligatures

eszett (German long and short s combined)

ß `Alt` `@2` `@2` `#3`

Mathematical and other symbols

broken bar

¦ `Control` `Alt` `` ` ``

degree

° `Alt` `!1` `&7` `^6`

divide

÷ `Alt` `@2` `$4` `&7`

greater than or equal to

mu

µ `Alt` `!1` `*8` `!1`

ordinal a, eg 2ª (Spanish: segundo)

a `Alt` `!1` `&7` `)0`

ordinal o, eg Nº (archaic english: number)

o `Alt` `!1` `*8` `^6`

per thousand

‰ `Alt` `!1` `#3` `&7`

plus or minus

± `Alt` `!1` `&7` `&7`

superior 1

1 `Alt` `!1` `*8` `%5`

superior 2

2 `Alt` `!1` `&7` `*8`

superior 3

3 `Alt` `!1` `&7` `)9`

Mid or decimal point

· `Alt` `!1` `*8` `#3`

Monetary symbols

Cent

¢ `Alt` `!1` `^6` `@2`

Currency

¤ `Alt` `!1` `^6` `$4`

Euro

€ `Control` `Alt` `$4`

Florin

ƒ `Alt` `!1` `#3` `!1`

Yen

¥ `Alt` `!1` `^6` `%5`

Punctuation marks

open Spanish exclamation mark

¡ `Alt` `!1` `^6` `!1`

open Spanish question mark

¿ `Alt` `!1` `)9` `!1`

Quotation marks

' `Alt` `!1` `$4` `%5`

' `Alt` `!1` `$4` `^6`

" `Alt` `!1` `$4` `&7`

" `Alt` `!1` `$4` `*8`

Guillemets (used pointing out in French and Italian, in German they point in)

‹ `Alt` `!1` `#3` `)9`

› `Alt` `!1` `%5` `%5`

« `Alt` `!1` `&7` `!1`

» `Alt` `!1` `*8` `&7`

open Spanish quotation marks

‚ `Alt` `!1` `#3` `)0`

„ `Alt` `!1` `#3` `@2`

Reference marks

dagger

† `Alt` `!1` `#3` `$4`

double dagger

‡ `Alt` `!1` `#3` `%5`

paragraph (pilcrow)

¶ `Alt` `!1` `*8` `@2`

section

§ `Alt` `!1` `^6` `&7`

Registered trade mark

® `Alt` `!1` `&7` `$4`

Soft return

this creates a new line without it giving a new paragraph format

`Shift` `Return`

Trademark

TM `Alt` `!1` `%5` `#3`

faces. The closest to our mod
serif'

Jan Tschichold, *Typographische Gestaltung*, 1935, Trans. Ruari McLean, *Asymetric typography*, 1967, p.13 ●

has, in fact, very little to do w
istics of design. Typographer
at any given moment by mea
but in practice they find no dif
when it is unfashionable and
sons for defending it when it
at their best, letters may be
flowers, almost as shapely a.
almost as ordered, regular an

Percy Smith, *Lettering, a plea*, 1932, p.1 ● . In all permament f
pographers only purpose is
author. [...] it is not allowable
the reader's comfort in order t
or to illustrate

Stanley Morison, 'First principles of typography' 1936, in Ruari M

n needs is 'grotesque' or 'sans
e fashion status of typefaces
intrinsic quality or character-
ften justify their preferences
of aesthetic rationalizations,
ulty in condemning a typeface
nding equally convincing rea-
ashionable R S Hutchings, *The western heritage of type design*, 1963, p.13 ● Yet
lmost as comely as slender
heltered trees, or conversely,
evere as geometrical patterns
ms of typography [...] the ty-
express not himself, but his
a printer to relax his zeal for
atisfy an ambition to decorate

Appendix 3

Who's who of designers mentioned in this book

Richard **Austin** c.1768–1830 (GB) Punchcutter for John Bell, the Wilson Foundry in Glasgow and William Miller in Edinburgh. 1819, opens Imperial Letter Foundry in London. Revivals of his types: Bell, Fry's Ornamented.

Jonathan **Barnbrook** b.1966 (GB) Graphic designer and type designer. 1996, launches Virus to market his own type designs, which include Prototype 1990, Manson/Mason 1991, Apocalypso 1997.

John **Baskerville** 1706–68 (GB) Printer and type 'designer', Birmingham. Many revivals of his type known as Baskerville.

John **Bell** 1746–1831 (GB) Printer and publisher of newspapers and cheap editions of the classics. 1788, set up British Letter Foundry, types cut by Richard Austin.

Linn Boyd **Benton** 1844–1932 (USA) Inventor (with R V Waldo) of Benton Automatic Punchcutter in 1885 and type designer (Century 1895 with T L de Vinne). Father of M F Benton.

Morris Fuller **Benton** 1872–1948 (USA) Type designer at American Type Founders. Son of L B Benton. Types include Alternate Gothic and Franklin Gothic 1903, News Gothic 1908, Century Schoolbook 1924.

David **Berlow** b.1959 (USA) Type designer for Mergenthaler Linotype 1978–82 and Bitstream Inc. 1982–9 before founding Font Bureau with Roger Black. Types include Numskull 1990, Yurnacular 1992 and many revivals such as the Grotesque series 1989–93, Giza 1994.

Robert **Besley** fl.1845 (GB) Typefounder, introduced the first so-called Clarendon.

Peter **Bilak** b.1973 (SK) Designer. Types include Eureka 1998–9, Eureka Sans 2000.

Derek **Birdsall** b.1934 (GB) Graphic designer, founder Omnific 1983.

Giambattista **Bodoni** 1740–1813 (I) Punchcutter, printer and publisher. Many revivals of his types known as Bodoni.

Chris **Brand** b.1921 (NL) Type designer, calligrapher, teacher. Types include Albertina 1964 (digitized by Frank E Blokland in 1996).

Neville **Brody** b.1957 (GB) Graphic designer and type designer. 1990 launches FontFont (original type designs exclusive to the FontShop network) with Erik Spiekermann. 1991 launches experimental font magazine Fuse with Jon Wozencroft. Types include Industria 1990, Blur 1991.

William **Bulmer** 1757–1830 (GB) Printer and typographer associated with William Martin.

Aaron **Burns** 1922–91 (USA) Graphic designer. Founded ITC with Rondthaler and Lubalin in 1970. Editor of U&lc, its promotional journal.

Matthew **Carter** b.1937 (GB) Type designer Mergenthaler Linotype (USA), Linotype (GB). In US founded Bitstream with Mike Parker 1981, Carter and Cone with Connie Cone in 1992. Types include Snell Roundhand 1966, Bell Centennial and Galliard 1978, Charter 1987, Sophia and Mantinia 1993, Georgia, Miller and Verdana 1998.

William **Caslon I** 1692–1766 (GB) Typefounder and punchcutter, founder of dynasty. Set up a foundry in 1722 which eventually became part of Stephenson Blake. William II 1720–78; William III 1754–1833; William IV 1780–1868 introduced first sans serif type in 1815. Revivals of his type: Caslon (many versions), Big Caslon.

Thomas J **Cobden-Sanderson** 1840–1922 (GB) Bookbinder, publisher and type designer. Type: Doves Press (with Emery Walker) 1901.

Barry **Deck** b.1962 (USA) Graphic designer. Types include Template Gothic 1990 and Caustic Biomorph 1992.

François **Didot** 1689–1757 (F) Typefounder, printer and publisher, founder of dynasty. Eldest son: François Ambroise 1730–1804, punchcutter, publisher and printer. 1785, reworks Fournier's point system. Second son: Pierre François 1732–95, typefounder, printer and publisher. Sons of François Ambroise: Pierre 1761–1853, takes over printing workshop 1789; Firmin 1764–1836, takes over typefoundry 1789, cutter of first Continental modern romans.

Christoph van **Dijck** 1601–69 (NL) Punchcutter and typefounder. Revival of his types: Van Dijck.

Catherine **Dixon** b.1970 (GB) Designer, writer and teacher: Central Saint Martins College of Art & Design, London.

Roger **Excoffon** 1911–84 (F) Graphic designer and type designer: Fonderie Olive. Types include Chambord 1945, Mistral 1953, Antique Olive 1962–66.

Ed **Fella** b.1938 (USA) Graphic designer, illustrator and teacher: California Institute of the Arts. Typeface: Outwest on an 15° ellipse 1993

Vincent **Figgins** 1766–1844 (GB) Punchcutter and typefounder, introduced the first Egyptian type in 1817 and many display faces.

Pierre Simon **Fournier** (le jeune) 1712–68 (F) Punchcutter, typefounder, printer. 1737 published his point system for measuring type bodies based on earlier work by Jean Truchet at the Academie of Sciences. Revivals of his types: Fournier, Barbou.

Tobias **Frere-Jones** b.1970 (USA) Type designer. Types include Interstate 1993–4.

Anthony **Froshaug** 1920–84 (GB) Designer, author, teacher, principally at the Central School, London 1952–3 and 1970–84; Ulm 1957–61 and Royal College of Art 1961–4.

Adrian **Frutiger** b.1928 (CH) Type designer, Deberney and Peignot (F) and Linotype (D). Types include Univers 1954–7, Apollo 1964, OCR-B 1968, Frutiger 1976.

Claude **Garamond** c.1480–1561 (F) Punchcutter and typefounder, the first to sell type and matrices. Revivals of his type: Granjon (those named Garamond are mostly based on types by Jannon erroneously attributed to Garamond).

Ken **Garland** b.1936 (GB) Graphic designer and writer. Art Editor of Design magazine 1960–3.

Eric **Gill** 1882–1940 (GB) Pupil of Edward Johnston. Sculptor, carver, writer, Catholic convert, type designer. Types include Gill Sans 1927–9, Perpetua 1929–30, Joanna 1930–1.

Phillipe **Grandjean** 1666–1714 (F) Punchcutter: Imprimerie Royale. Type: Romain du Roi 1702.

Robert **Granjon** 1513–89 (F) Punchcutter and typefounder. Granjon's types were the model for Plantin, Times New Roman and Galliard.

Chauncey H **Griffith** 1879–1956 (USA) Type designer, Mergenthaler Linotype. Types include Ionic 1924, Excelsior 1931, Bell Gothic 1938.

Francesco **Griffo** 1450–1518 (I) Punchcutter, principally for Aldus Manutius. Revivals of his types: Bembo, Dante, Poliphilus.

Johann **Gutenberg** c.1394–1468 (D) Printer: inventor of movable metal type in Mainz with financial backing from Johann Fust.

Robert **Harling** b.1910 (GB) Writer, graphic designer and editor (Alphabet & image, Image and House & garden). Types include Playbill 1938, Chisel 1939.

Jonathan **Hoefler** b.1970 (USA) Type designer. 1989 opens Hoefler Type Foundry. Types include Hoefler Text 1991–3, Didot 1992, Pavisse 1996.

Jean **Jannon** 1580–1658 (F) Punchcutter and printer. His Caractères de l'Université were wrongly attributed to Garamond and form the basis for many revivals with Garamond's name.

Edward **Johnston** 1872–1944 (GB) Calligrapher, type designer and teacher: Central School of Arts & Crafts and Royal College of Art, London. Types: Imprint (with F E Jackson, J H Mason and G Meynell) 1913, Johnston 1916.

George W **Jones** 1860–1942 (GB) Type designer and printer. Types include Granjon 1928–31.

Peter **Karow** b.1940 (PL) Developer of Ikarus type design program 1974.

Jeff **Keedy** b.1957 (USA) Graphic designer, teacher at California Institute of the Arts, type designer and writer. Types include Keedy Sans 1989.

Hendrik van den **Keere** c.1540–80 (NL) Punchcutter. Revival of his type: Renard.

Miklós **Kis** 1650–1702 (H) Punchcutter, worked in Amsterdam 1683–5. Revival of his type: Janson and Ehrhardt.

Rudolph **Koch** 1876–1934 (D) Type designer, calligrapher and teacher. Advisor to Gebruder Klingspor type foundry in Offenbach. Types include Wilhelm-Klingspor Schrift 1920–6, Neuland 1922–3, Kabel 1929, Prisma 1931.

Jan van **Krimpen** 1892–1958 (NL) Type designer,

Joh. Enschedé en Zohen. Types include Romulus 1931, Haarlemmer 1938, Spectrum 1942.

Tolbert **LANSTON** 1844–1913 (USA) Inventor, Monotype hot-metal composing machine 1887.

Zuzana **LICKO** b.1961 (CZ) Type designer. Moves to USA in 1968, co-founder (with husband Rudy VanderLans) of *Emigré* magazine in 1984 and Emigé Fonts in 1985. Types include Oakland 1985, Matrix 1986 and Base 9 & 12 1996.

Herb **LUBALIN** 1918–81 (USA) Graphic designer. Founded ITC with Burns and Rondthaler in 1970.

Martin **MAJOOR** b.1960 (NL) Graphic designer, type designer and teacher: Art Academy Arnhem. Types include Scala 1991, Scala Sans 1993.

Charles **MALIN** 1883–1955 (F) Punchcutter: for Gill and Mardersteig among others.

Connor **MANGAT** b.1972? (GB) Type and graphic designer. Types include Platelet 1993.

Aldus **MANUTIUS** 1450–1515 (I) Publisher and printer, his types were cut by Francesco Griffo.

William **MARTIN** c.1765–1815 (GB) Punchcutter and typefounder. Revival of his types: Bulmer.

John Henry **MASON** 1875–1951 (GB) Printer and teacher, Central School of Arts & Crafts, London. Type: Imprint (with F E Jackson, E Johnston and G Meynell) 1913.

José **MENDOZA Y ALMEIDA** b.1926 (F) Designer, type designer, teacher. Types include Photina 1972, Mendoza 1990.

Ottmar **MERGENTHALER** 1854–99 (USA) Inventor, Linotype hot-metal linecasting machine 1886.

Max **MIEDINGER** 1910–80 (CH) Type designer, Haas'sche Schriftgießerie. Neue Haas Grotesk/Helvetica (with Eduard Hoffman) 1957.

John **MORGAN** b.1973 (GB) Graphic designer.

Stanley **MORISON** 1889–1967 (GB) Author and typographer. Typographic Consultant to the Monotype Corporation 1923–67 and *The Times* newspaper 1929–60. Typeface: Times New Roman.

William **MORRIS** 1834–96 (GB) Designer, printer and publisher: Kelmscott Press, author, type designer. 1887 founds Art Workers' Guild. Types: Golden 1890, Troy 1892, Chaucer 1893.

Miles **NEWLYN** b.1969 (GB) Designer. Type: Missionary 1992.

Aldo **NOVARESE** 1920–95 (I) Type designer, mainly at Nebiolo. Types include Microgramma (with A Butti) 1952, Egizio 1955–8, Mixage 1985.

Giovanni **PINTORI** b.1912 (I) Graphic designer for Olivetti in Milan from 1936 and head of publicity department 1950–67.

Louis John **POUCHÉE** fl.1811–30 (F) Typefounder, London, producing decorated types and printer's ornaments.

Paul **RENNER** 1878–1956 (D) Designer, writer, teacher in Munich, and type designer. Types include Futura 1927–9.

Bruce **ROGERS** 1870–1957 (USA) Book designer and type designer: Centaur 1914.

Ed **RONDTHALER** b.1905 (USA) Graphic designer. Founded ITC with Burns and Lubalin in 1970.

Fred **SMEIJERS** (NL) Graphic designer, type designer and author. Types include Quadraat 1992–8, Renard 1996.

Leonardo **SONNOLI** 1968 (I) Graphic designer.

Erik **SPIEKERMANN** b.1947 (D) Information and type designer and author. 1979, founds MetaDesign in Berlin. 1989, founds FontShop, a network of typeface retail outlets, with wife Joan. Type include LoType 1980; Officina (with J van Russum) 1990; Meta 1991; Info 1996.

Jeremy **TANKARD** b.1969 (GB) Type designer. Types include Bliss 1996–2001; Shire types 1998; Enigma 1999; Shaker 2000

Walter **TRACY** 1914–95 (GB) Writer and type designer for Linotype. Types include Jubilee 1954, Linotype Modern/Modern 880 1969, Times Europa 1971, Telegraph Newface 1989.

Jean/Sébastien **TRUCHET** fl.1690s (F) Member of French Royal Academy of Sciences and the first to propose a system of related point body sizes dependant on an official unit of measurement.

Carol **TWOMBLY** b.1959 (USA) Type designer at Adobe Systems Inc. Types include Lithos and Trajan 1989, Myriad 1992, Chaparral Pro 1997.

Gerard **UNGER** b.1942 (NL) Type designer and teacher: Gerrit Rietveld Academy, Amsterdam and Reading University, England. Types include Praxis 1976, Swift 1984–6, Gulliver 1993, Capitolium and Coranta 1999, Vesta 2001.

Daniel Berkeley **UPDIKE** 1860–1941 (USA) Printer: Merrymount Press, and historian.

Rudy **VANDERLANS** b.1961 (NL) Designer and writer. Moves to USA in 1981, co-founder (with wife Zuzana Licko) of *Emigré* magazine in 1984 and Emigré Fonts in 1985. Types include Suburban 1994.

Theodore Low de **VINNE** 1828–1914 (USA) Historian, writer and printer. Typeface: Century with L B Benton 1894.

Bartholomaeus **VOSKENS** d.c.1669 (NL) Punchcutter and typefounder.

Justus Eric **WALBAUM** 1768–1839 (D) Punchcutter and typefounder. Revivals of his type: Walbaum.

R V **WALDO** (USA) Inventor (with Linn Boyd Benton) of Benton Automatic Punchcutter in 1885.

Emery **WALKER** 1851–1933 (GB) Publisher and type designer. Advisor to William Morris. Types include: Doves Press (with Emery Walker) 1903, Cranach Press Roman 1913.

Edward **WRIGHT** 1912–89 (GB) Designer and lettering designer, and teacher: Chelsea School of Art and Central School of Arts & Crafts.

Rick **VALICENTI** b.1951 (USA) Designer, founder Thirst 1988 and Thirstype 1992. Types include Uck'n'pretty 1992.

Maximillian **VOX** 1894–1974 (F) Typographer and writer, 1954 puts forward a typeface classification system which now bears his name.

Appendix 4

ISO paper sizes

The ISO range of paper sizes (adapted from the German DIN of 1922) has three series: A for general printing and stationery; B for posters and wallcharts; and C for envelopes. Proportions remain uniform throughout the range: $1\sqrt{2}$ (or $1:1\cdot414$) short edge to long edge.

A series: paper

This is the most used and is based on a sheet, A0, whose area is one square metre. The weight of paper is derived from this sheet and is given in grams per square metre, abbreviated to gsm.

The A sizes are for finished or trimmed sizes, paper is supplied to printers in SRA sizes which allow for bleed and trimming.

All sizes are given in millimetres.

A0	1189 × 841	SRA0	1280 × 900
A1	841 × 594	SRA1	900 × 640
A2	594 × 420	SRA2	640 × 450
A3	420 × 297		
A4	297 × 210		
A5	210 × 148		
A6	148 × 105		
A7	105 × 74		

B series: paper

B0	1440 × 1000
B1	1000 × 707
B2	707 × 500
B3	500 × 353
B4	353 × 250
B5	250 × 176
B6	176 × 125
B7	125 × 88

C series: envelopes

An envelope of a certain number will take a sheet of A size paper of the same number unfolded. For example C4 is the envelope for A4 and can also be used to take A3 folded once etc.

One other size of envelope exists: DL (220 × 110) which is designed to take a sheet of A4 folded twice.

Index

Numbers in **bold** are illustrations

Picture sources & credits

Note When more than one image appears on a page it is referred to by a column number and, if necessary, a position down the page.

Photographers are listed in brackets: Phil Baines, PB; Catherine Dixon, CD; Eric Kindel, EK; Tim Marshall, TM.

© 1998 Aardman Animations Ltd **13**.

Authors' collections (all photos TM) **8–9; 126–7** courtesy Jost Hochuli; **128–9** courtesy Dorling Kindersley; **130–1; 133** courtesy the Archbishops' Council of the Church of England; **136–7** courtesy Ed Fella; **138** courtesy Ken Garland; **139; 140** courtesy Leonardo Sonnoli; **141–6**.

Phil Baines **Frontispiece** courtesy Susan Skarsgard & Wesley B Tanner (TM); **36** (both) courtesy Ed Fella (TM); **60**/c2/1 & 2; **64**/c1 both; **65**/c1/2; **65**/c3/2 courtesy estate of John Watson; **67**/c1–3 (TM); **66**/c1; **66**/c3 courtesy Book Works & Yvon Lambert (TM); **67**/c1/2 & c2/2; **67**/c3/2 (TM); **69**/c2/2 & 4; **69**/c2/5 photo Ed Barber; **70** (both TM); **83**/c2/2 courtesy Agfa Monotype; **86** (TM); **87**/c1 & 2; **91**/c1 both courtesy Dave Farey; **98** (TM); **102**/c3; **106**/c2 courtesy Jeff Keedy; **124** (TM); **126** courtesy Jost Hochuli; **133; 147**/c1.

Phil Baines & Catherine Dixon **176–9** adapted from a previous (unpublished) work.

Antoine Bardou-Jacquet for H5 **149**.

James Barnes **149**.

Sebastián Campos **65**/c1/3.

Central Lettering Record and the Museum & Study Collection at Central Saint Martins College of Art & Design, London. Uncredited photos are assumed to be by Nicholas Biddulph who founded the Central Lettering Record in 1963, or are scanned direct from originals. **Covers** (TM); **31** (TM); **35; 40; 42**/1 [Lat.3867] &2 [10.959 (E.L.57)] © Biblioteca Apostolica Vaticana; **42**/4 by permission of the British Library, [Ms. Harl 2793]; **42**/5; **44; 45; 47; 54**/c1; **53; 54**/c2 reproduced from André Jammes, *La Réforme de la typographie royale sous Louis XIV, le Grandjean*, Paris, Librairie Paul Jammes 1961; **54**/c3; **55**/c1/3; **55**/c1/3 courtesy FSI, Berlin; **55**/c3/1; **55**/c3/2 courtesy Agfa Monotype; **58**/c1 & 2 (TM); **58**/c3; **59**/c1 (EK); **59**/c2/2 (TM); **59**/c2/3 (CD); **60**/c1 & c2/3; **61** (TM); **62**/c1 (TM); **62**/c1/2 &3; **62**/c2/2; **63**/c1 (TM); **63**/c2/2 & 3; **64**/c2 (EK); **65**/c1/1 courtesy Miles Newlyn; **65**/c3/1; **65**/c3/4 (CD); **66**/c2; **68**/c1/1 (TM); **68**/c1/2 courtesy Fundación Tipográfica Bauer; **68**/c3/1; **68**/c3/2 (CD); **68**/c3/3 courtesy Emigré, CA; **69**/c2/1 & 3 (CD); **72** (TM); **73**/c1/1; **73**/c1/2 courtesy estate of Anthony Froshaug (TM); **74–5** (all); **77** all courtesy Agfa Monotype; **78** (all TM); **79**/c3/1 (TM); **79**/c3/2 & 3; **80**/c1/1 & c2/1 (TM); **80**/c1/2 & c2/2; **81**/c2/1 (TM); **81**/c1/2 & c2/2; **83**/c1 (TM); **84**/c1/1, c1/2, c2/2 & c3/2 (TM); **84**/c3/1; **87**/c3/1 (TM); **90** all; **91**/c2 (TM); **92** all courtesy Agfa Monotype (TM); **94** courtesy Emigré, CA (TM); **95** all courtesy FSI, Berlin (TM); **106**/c3 courtesy Matthew Carter; **132** (TM); **139** (TM); **147**/c2 (TM).

Catherine Dixon **50–2; 59**/c2/1; **62**/c3/2; **82** courtesy Agfa Monotype (TM).

Andrew Haslam **14, 15, 150–60** (TM).

Hyphen Press and Central Saint Martins College of Art & Design **49**.

Andreas Lanhoff **22–3**.

Matt's Gallery, London, courtesy David Troostwyk **63**/c2/1.

St Bride Printing Library, London **64**/c3.

Jeremy Tankard **99** (TM); **100–1**.

The Board of Trinity College Dublin **42**/3 [TCD Ms.58fol.200R].

All unlisted diagrams are by the authors.

Acknowledgements

Students and fellow staff, past and present, have unwittingly acted as guinea pigs for many of our ideas over the years, and their comments and reactions have helped shape this book. Many others have also given specific help and advice, in particular we must thank: Dani Salvadori of Central Saint Martins for her support from the outset; Peter Haslam for his help with grammar and structure; Wendy Baker; Praliné Design; David Tanguy, Regine Stefan and Sebastián Campos for their help with European phonemes in Chapter II; Dr Catherine Dixon, fellow teacher at Central Saint Martins, who allowed us to use her type description system as the basis for Chapter III and helped shape several other sections of the book; Andrew Boag, Dave Farey, Jeremy Tankard and Lawrence Wallis who helped guide us through the intricacies of manufacture which make up Chapter IV; Paul Barritt, composition technician at the London College of Printing, for providing us with Monotype matrix cases and a collection of technical literature; John D Berry, Chris the boy and John Morgan who looked over our shoulders at various stages and made helpful suggestions; Sylvia Backemeyer and Steven Bateman of Central Saint Martins who gave unlimited access to the college's Museum & Study Collection; Liz Leyland and Ian Noble for supporting a new approach to the teaching of typography at LCP; Tim Marshall who sympathetically took all the new photographs; Cleia Smith our Editor at Laurence King who patiently allowed us to blur both deadlines and disciplines in the final stages of production; and finally our families whose tolerance and support has made writing and designing this book possible.

Dedication

to Beth & Felicity Baines, and Blue & Blaise Baker–Haslam